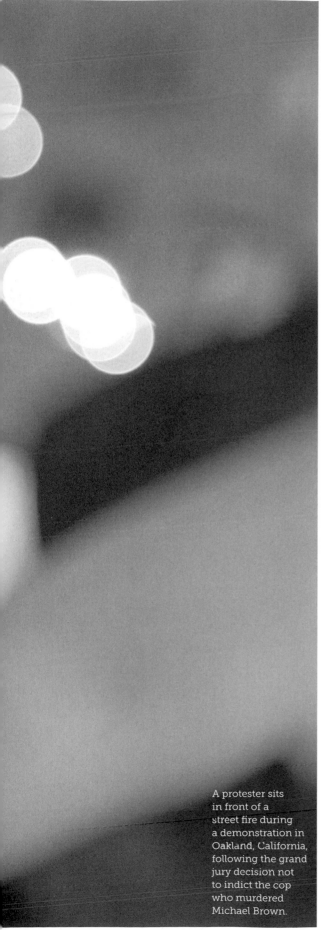

A protester sits in front of a street fire during a demonstration in Oakland, California, following the grand jury decision not to indict the cop who murdered Michael Brown.

OF POETRY & PROTEST

FROM EMMETT TILL TO TRAYVON MARTIN

**EDITED AND COMPILED BY
PHILIP CUSHWAY
AND MICHAEL WARR**

W. W. Norton & Company
Independent Publishers Since 1923
New York • London

For information about permission to reproduce selections from this book, write to
Permissions, W. W. Norton & Company, Inc., 500 Fifth Avenue, New York, NY 10110

For information about special discounts for bulk purchases, please contact
W. W. Norton Special Sales at specialsales@wwnorton.com or 800-233-4830

ISBN: 978-0-393-35273-3 (pbk.)

W. W. Norton & Company, Inc., 500 Fifth Avenue, New York, NY 10110
 www.wwnorton.com
W. W. Norton & Company Ltd., Castle House, 75/76 Wells Street, London W1T 3QT

1 2 3 4 5 6 7 8 9 0

OF POETRY
& PROTEST

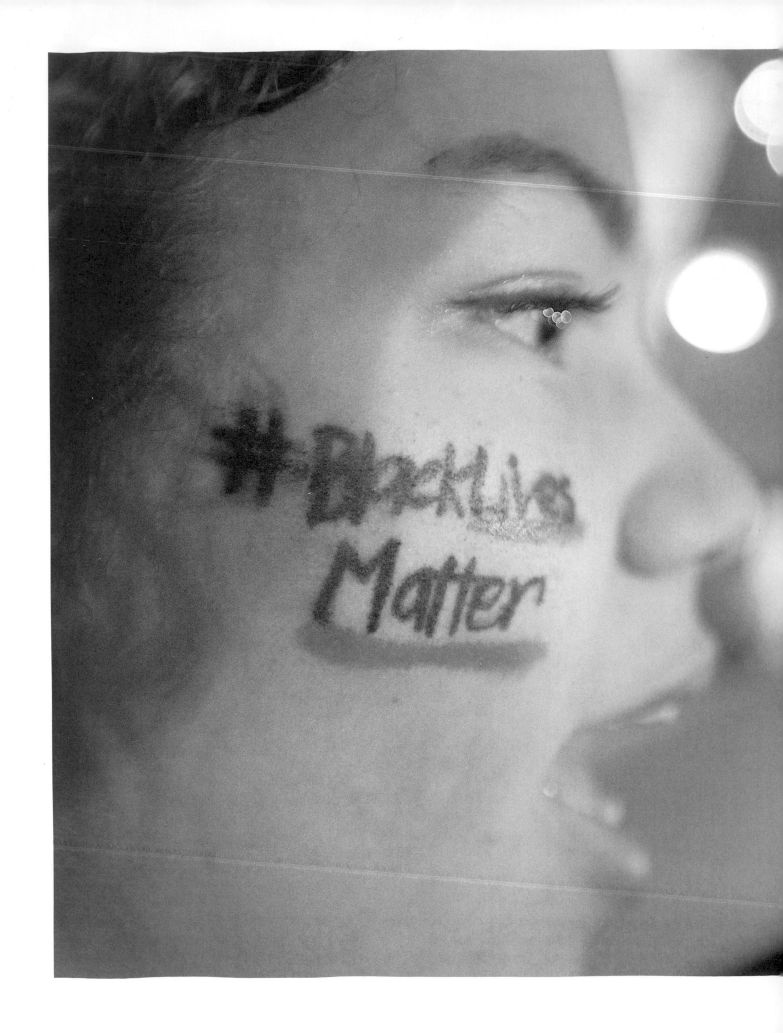

TO ALL
THOSE
WHO HAVE DIED
BECAUSE OF
THE COLOR
OF THEIR
SKIN

Children's Crusade,
photo by Bill Hudson,
AP Photo, 1963

The Children's Crusade:

Birmingham, **Alabama,** May 1963

A scream erupted outside the 16th Street Baptist church as a police captain chased a young black girl down the church steps. Startled, the hundreds of black children who had already assembled grabbed their protest signs and raincoats to shield themselves from the firemen's water hoses. Momentum created by fear and the determination to end segregation propelled the children of Birmingham into the streets. As they walked, they sang:

> Ain't gonna let nobody
> > turn me around,
> Turn me around, turn me around.
> Ain't gonna let nobody
> > turn me around;
> I'm gonna keep on a-walkin',
> > keep on a-talkin',
> Marchin' up to freedom land!

As thousands of children marched into Kelly-Ingram Park, the scene quickly became violent. Upon the orders of Bull Connor, Birmingham's infamous commissioner of public safety, the police—wielding clubs and tear gas—charged into the crowd of adult marchers who joined the children in the park. They sprayed the marchers with tear gas, causing many protesters to fall to their knees as hundreds of screaming children ran past them. Attack dogs lurched from the grips of their handlers and tore into the flesh of marchers who screamed in agony as they dropped their picket signs. The sounds of screams and snarling dogs permeated the 90-degree air. The police ordered the firemen to turn the water hoses on full force. Everyone with black skin was hit, young and old. Water exploded from the hoses into a crowd of children, several of whom were sent flying into the street. Children, old men, and women holding babies stood in shock as they watched the mayhem from the sidewalks as marchers were pressed against the walls like rag dolls under the pressure of the powerful streams of water. Firemen measured the water pressure at one hundred pounds per square inch, a force so vicious that it tore the bark from the trees behind which marchers crouched to seek protection. Small groups of people huddled in doorways holding one another as they turned their backs to the stinging torrent. Hundreds of children, some as young as six, were herded into school buses and taken to local jails. There were so many children that the sheriff's office could not book them as fast as they arrived. They were arrested and marched into a holding facility built to hold no more than 30 people. There were so many children in one room that the exhausted and injured collapsed only to find the floor already covered with other children. Some tried to sleep. Some stood. Some pressed against walls and window-sills. At the end of the room were five toilets. The protests, violence, and arrests continued for four days. By then the jails were so overcrowded that dozens of children were moved to the local fairgrounds. There they began singing as night fell over Birmingham:

> Ain't gonna let no jail cell
> > turn me around,
> Turn me around, turn me around.
> Ain't gonna let no jail cell
> > turn me around;
> I'm gonna keep on a-walkin',
> > keep on a-talkin',
> Marchin' up to freedom land!

–Unknown. "Ain't Gonna Let Nobody Turn Me Around." Public Domain, 1924. MP3.

–Tamara Ginn

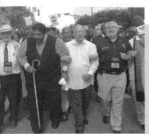

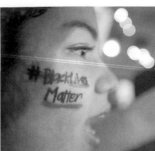

Contents

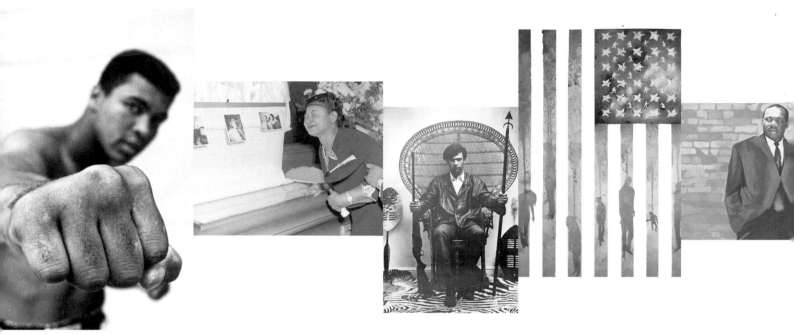

Preface
by Philip Cushway

I love to sit down with a pencil and a blank sheet of paper and imagine myself in an entirely dark room, unsure of what I am seeking. The gestation of this book stems from this undirected "wandering." I playfully wrote out the word "poets" and then, on a whim, quickly sketched out a book that would bring both black and white American poets together in a poetic commemorative, honoring the 50th Anniversary of Martin Luther King, Jr.'s "I Have a Dream" speech. I conceived of a title: "Of Poetry & Protest." I still had no "master plan." I let my impulses lead me and did not censor or guide them.

It was 2013 when I started this book and a new iteration of the Civil Rights Movement was taking place. From the streets of Ferguson, Cleveland, Baltimore and across the country, young people marched, questioning and confronting the continued murders of black youth. Oscar Grant, Tamir Rice, and Trayvon Martin became today's Emmett Till. The protestor's placards bearing the words "Hands Up, Don't Shoot" and "I Can't Breathe" were distilled down to the root of it all: "Black Lives Matter." As events in cities and towns escalated and the protests became more visible, the book and the messages of the poets began to take on a new urgency.

I put together a team of poets, designers, and writers, and with myself acting as a sort of "Producer" (to use a film term), I would shepherd the project as it evolved. As we began to incorporate many of the best and brightest African-American poets from all parts of this country, I discovered that I liked the work of the African-American poets best and decided to include African-American poets exclusively as events on the streets began to change the direction of this book.

> – I hired Michael Warr, an award-winning African-American poet himself, to be the poetry editor responsible for the selection of poems and poets. The results demonstrate the intelligence, judgment and professionalism he brought to the project.

– I was very lucky to find Bob Ciano, winner of more than 300 design awards as well as past assignments as art director for *Time-Life* and the *New York Times*. I knew he had the "chops."

– I wanted candid portraits of the poets—unposed and guileless. For this, I hired Victoria Smith, a local San Francisco photographer. I believe her work serves to illuminate the vast multiplicity of poets and styles in this book.

I decided to incorporate elements that I felt would provide the historical and cultural underpinnings from which these poems arose and to present them in an accessible way to all readers. I included an interview with Harry Belafonte that provides an honest discussion of what growing up black in America really entails. Michael Warr suggested we commission Amiri Baraka to write an essay, so we did. I discovered an essay by Jeannine Amber on "the Talk," which was also incorporated. I carefully selected photographs depicting the struggles of civil rights, from children being marched off to jail in 1963 Birmingham to the streets of Ferguson, Cleveland, and Baltimore.

My objective was to treat the book as a work of art where all of the elements combine into an aesthetic, cohesive work—a book that would contain reverberating elements that appeal to nontraditional readers of poetry. With all of the components in this book, the photography, poetry, cultural iconography, and unbelievable history, I believe there is something for every reader. From the iconic photo of Mamie Till-Mobley at the funeral of her son, Emmett Till, to the images of modern-day racial discord, this nontraditional anthology binds it all together, and, in so doing, we have made a book of poetry unlike any other.

And finally, I wish to thank Jill Bialosky, our editor at W.W. Norton & Company for her guidance and patience in the creation of this book.

One Day this Book Will Be a Relic Chronicling a Period of Insanity and Inhumanity, I Hope...

You will not find a poem in these pages written by the poet who imprinted her literary DNA on my soul when I stumbled upon her writing in *Three Thousand Years of Black Poetry: An Anthology*. After that discovery, I needed to have her words within reach so that I could return to them at will, so I was compelled to steal the thick blue hardcover book out of my high school library in San Francisco. You will not find the poem by that towering word dealer who struck me so hard with the force of her language that I prematurely began to call myself a poet.

Of Poetry & Protest: From Emmett Till to Trayvon Martin was to be an anthology made of living poets, which is why the timeless and searing poetry of Gwendolyn Brooks, my first poet mentor, is absent. The term "living poets" took on expanded meaning for this project when we lost Amiri Baraka and Wanda Coleman, two world-class writers who skillfully wielded their poetic swords on behalf of the exploited and oppressed. In the last months of their lives they were so engaged in this project that it is difficult to imagine this book without Amiri's "Protest Poetry" essay, which we commissioned, and Wanda's "Emmett Till," which we requested. Both poets radiate from these pages. So does Gwendolyn Brooks.

What you will find of Mrs. Brooks in *Of Poetry & Protest* is that more than any other writer she is cited as an influence and mentor by the poet contributors in the biographical statements they wrote on their evolution and purpose as poets. Gwendolyn's literary code is embedded here. She serves as a cross-generational conduit connecting three generations of poets who appear in this collection both as teacher and student, mentor and mentee, as writers who have influenced each other's work, and as poets practicing and sharing writing styles that might be considered polar opposites. One poet drops "graduated tercets" while another spits the lit equivalent of an improvisational riff. These same poets might fluidly move in and out of formal, free, and blank verse when it serves the purpose of the poem.

Gwendolyn Brooks' unwavering commitment to Black people also flows in the veins of this collection through the poets. Their poems are pumping, beating, and channeling that same commitment in each poet's own way. I choose to assemble these poems as if they were the steel beams inside a skyscraper holding the edifice upright.

Of Poetry & Protest: From Emmett Till to Trayvon Martin is unapologetically political. It sees, hears, and absorbs the political in its myriad voices, tones, comprehensions, forms, experiences, performative-interpretations, and experimentations, no matter how far beneath or above the scrutinizing radar, recognizing that beauty can be found in the whisper, the scream, or in silence.

It might even be found in claims of apoliticality. These poets in their black diversity and creative individualism are collectively joined through the transformative work of truth-telling and the underlying desire and demand to stop rampant and unjustified police killings.

As we finalized *Of Poetry & Protest* during the summer of 2015, the murders continued unabated. The most recognized victims from the killing fields of 2014 and midway through 2015 remained Tamir Rice (age 12), Michael Brown, Tony Robinson, Walter Scott, Freddie Gray, and Eric Garner. The daily tally on the website *killedbypolice.net* reveals that the annual spree of police killings in America began January 1, 2015, like some evil clockwork, with at least one killing that day and as of today, July 18, 2015, three more killings were recorded for a total of 634 so far this year. That is the "total" of all police killings, based on media reports. As of this writing, there was no comprehensive official data from the federal government.

We also know that of those killed, Blacks were more than twice as likely to be unarmed when killed by the police as whites. *The Guardian* reported "that 32% of black people killed by police in 2015 were unarmed, as were 25% of Hispanic and Latino people, compared with 15% of white people killed."

Of Poetry & Protest, which exists because of the conditions reflected in these statistics, acknowledges the interconnection between today's headlines and the history of slavery, Black Reconstruction, the Civil Rights and Black Power Movements, through today's Black Lives Matter movement. The murders of Emmett Till and Trayvon Martin represent a horrendous and inhumane continuity that must be broken. To be broken, the daily terror must be exposed just as Mamie Till-Mobley made the momentous and difficult decision to leave open the casket of her mutilated son for the world to witness, so must today's terror be opened to the world and portrayed in all its gut-wrenching layers, legal and extralegal, cultural and intellectual, in plain view of the national conscience.

We hope to expose and project poetic consciousness on the issue of police killing more broadly in the Public Square. This book had to be expansive in size and design as well as content. When concentrated on the contemporary and future condition of Black people, these exposés need to illustrate the complexity of Black life. A cacophony of choices and voices is not simply needed but necessary. We hope that a swirling, shifting stratification of difference is evident.

As a lifetime practitioner in the arts brandishing creativity sometimes as a subtle and often blunt instrument for radical commentary and dreams of sculpting social transformation, I think of this book as a singular tool in a toolbox of many tools that will be lifted to help fix what ails America. It is my intention to reflect a universe in which it is impossible for poets and poetry to exist in a social vacuum. Ultimately, there is no protective divide between the acts of the poet and acts of the society and system in which they create. The frequently automated brutality, unrelenting inequality, and senseless, unjustified, amoral police killings, confront and endanger each of us in some way at some point. This book is as much a call to action as it is a call to embrace the relevance and humanity of its creative content.

I want *Of Poetry & Protest: From Emmett Till to Trayvon Martin* to be a book for the ages, as any editor, writer, book designer, or publisher would. I envision future school kids waving through the "pages" of this book on a holographic "screen" that floats in midair, enthralled by the text, the images, and the personal journeys of the writers, while perplexed and disbelieving of the need to condemn sanctioned murder, in the same way that most of us today cannot imagine a past when Americans picnicked at public lynchings in broad daylight. I hope that one day this book is a relic.

—Michael Warr, Poetry Editor, July 2015

HOW PARENTS RAISING BLACK BOYS TRY TO KEEP THEIR SONS SAFE

THE TALK

BY JEANNINE AMBER
MONDAY, JULY 29, 2013

Certain events have a way of changing everything, reorganizing life into an unforgettable before and after. For New Orleans residents, it was the hour the levees broke and their city began to flood; for New Yorkers, it was the terror of Sept. 11, 2001.

Before, there is an order to things. After, there is a danger that feels imminent, unpredictable, and wild.

For black parents, the new demarcation between before and after was the moment we watched George Zimmerman walk free after being tried in the shooting death of Trayvon Martin, an unarmed 17-year-old. Before the jury announced its not-guilty verdict, black parents understood what we were up against as we sought to protect our sons. We knew our boys, adored and full of promise, might be treated like criminals by police even though they had committed no crimes. We were painfully reminded of this danger by the deaths of other people's sons, like Sean Bell, who was shot and killed on the morning of his wedding in 2006 by New York City police who incorrectly thought there was a gun in his car; or Oscar Grant III, who was fatally shot in 2009 by a transit cop in Oakland, Calif., while restrained and facedown; or unarmed college student Kendrec McDade, who was killed in 2012 when San Francisco police saw him clutching his waistband and assumed he had a firearm. To gird against the danger that could result from our boys being profiled, we gave our sons the Talk.

At kitchen tables, during drives to school, and in parting words as we sent them off to college, we shared a version of the same lessons given to young black men for generations: "If you are stopped by a cop, do what he says, even if he's harassing you, even if you didn't do anything wrong. Let him arrest you, memorize his badge number, and call me as soon as you get to the precinct. Keep your hands where he can see them. Do not reach for your wallet. Do not grab your phone. Do not raise your voice. Do not talk back. Do you understand me?" Parents in communities besieged by gun violence might add a coda, admonishing their sons to come home right after school, close the blinds, stay inside.

These warnings weren't always heeded, and sometimes they weren't enough. But they allowed parents to feel that we gave our children a measure of protection against a threat we could identify. When confronted by violent gangs or overzealous law enforcement, we knew these rules of engagement might help keep our sons safe. But in George Zimmerman we saw a new danger, one that seemed utterly lawless.

We may never know exactly what happened the night Zimmerman shot Trayvon, but black parents know this: A neighborhood-watch man saw a brown-skinned teenager—a boy who could have been one of ours—wearing a hoodie pulled up against the rain, and assumed he was up to no good. That suspicion set into motion a chain of events that left the boy dead. How do we protect against that? Do we tell our children to run if they are being followed? Or should they stop and turn around? Do we tell them to defend themselves as Trayvon appears to have done or to get on the ground like Oscar Grant?

Police are trained to ascertain risk, yet studies have shown they are likely to shoot at an African-American suspect faster than at a white one. What about the untrained civilian? Armed with bias and a handgun, how likely is he to see a threat where none exists?

Before Trayvon, we had the Talk to guard our children against danger.

After Zimmerman's acquittal in his death, we realize with anguish there may be little we can do to protect them.

during search for missing
three (above)
Arrests, NO CONVICTIONS

July, 1964 - Lemuel Penn,
 Negro, 33
 Athens, Georgia
Official in school system
of Washington, D.C. Shot
to death in his car from
passing car when returning
to Washington from training
for army reserve in Georgia.
Klansmen arrested, NO CON-
 VICTIONS

Summer, 1964 - man, Negro
 New Orleans, Louisiana
Shot to death at bus stop
 from passing car
No arrest, NO CONVICTION

September, 1964 - Herbert
 Orsby, Negro, 14
 Canton, Mississippi
Found drowned wearing CORE
 tee-shirt; last seen in
 pick-up truck with white
 men.
No arrest, NO CONVICTION

December, 1964 - Frank Mor-
 ris, Negro, 52
 Ferriday, Louisiana
Burned to death in his shop--
covered with gasoline by
white men, set afire, and
forced to remain inside.
No arrest, NO CONVICTIONS

December, 1964 - Man and wo-
 man, Negro
 New Orleans, Louisiana
Shot to death in motel
No arrest, NO CONVICTION

January, 1965 - Ollie B.
 Shelby, Negro, 18
 Jackson, Mississippi
Badly beaten and shot to
death by police officers in
Hinds County Jail.
No arrests, NO CONVICTION

January, 1965 - Marshall
 Scott, Jr., Negro, 43
 New Orleans, Louisiana
Put into solitary confine-
ment in New Orleans
jail with pneumonia; died
without medical attention
No arrests, NO CONVICTIONS

February, 1965 - Jimmy Lee
 Jackson, Negro
 Marion, Alabama
Shot to death by state troo-
 pers during demonstration
 for voting rights
No arrests, NO CONVICTIONS

February, 1965 - John Lee,
 Negro, 31
 Goshen Springs, Miss.
Found dead on country road
 with signs of beating--
 had attended civil rights
 meetings
No arrests, NO CONVICTIONS

February, 1965 - Donald Ras-
 berry, Negro, 19
 Okolona, Mississippi
Shot to death by his planta-
 tion boss.
NO CONVICTION

March, 1965 - Rev. James Reeb
 white, 37
 Selma, Alabama
Beaten to death after parti-
 cipating in march for
 voting rights
Four arrests, PENDING

March, 1965 - Viola Gregg
 Liuzzo, white, 38
 Lowndesboro, Alabama
Shot to death from passing
 car while transporting
 demonstrators from march
 for voting rights
Four whites arrested, PEN-
 DING

"A Partial list
of Racial
Murders from
1963 to 1965."
Wisconsin
Historical Society.

February 2012 - **Remarley Graham,**
　African American, 18
　The Bronx, New York
After being chased into his home on suspicion of
drug possession, Remarley Graham was shot and
killed by an undercover NYPD Officer.
　NO CONVICTION

February 2012 - **Trayvon Martin**
　African American, 17
　Sanford, Florida
Trayvon Martin, unarmed, was shot and killed by
George Zimmerman while Martin was walking home
in a gated community.
　NO CONVICTION

March 2012 - **Wendall Allen,**
　African American, 20
　New Orleans, Louisiana
Wendall Allen, unarmed, was shot and killed by an
NOPD officer. The officer was convicted and served
four years for murder.
　CONVICTION

March 2012 - **Ervin Jefferson**
　African American, 18
　Atlanta, Georgia
Ervin Jefferson, unarmed, was shot and killed by two
security guards.
　NO CONVICTIONS

March 2012 - **Bo Morrison**
　African American, 20
　West Bend, Wisconsin
Bo Morrison, unarmed, was murdered by a neighbor
after leaving a party of underage drinkers.
　NO CONVICTION

March 2012 - **Rekia Boyd**
　African American, 22
　Chicago, Illinois
Rekia Boyd, an unarmed bystander at a party, was
murdered by an off-duty officer who fired into a
group of people in a dark alley.
　NO CONVICTION

June 2012 - **Christopher Brown**
　African American, 17
　Baltimore, Maryland
Accused of throwing a rock at the house of an
off-duty BPD officer, Christopher Brown was chased
and subdued by the officer and later died as a result
of asphyxiation.
　NO CONVICTION

August 2012 - **Cjavar Galmon,**
　African American, 18
　Tangipahoa, Louisiana
Cjavar Galmon, unarmed, was murdered while holding
his hands in the air as he approached officers to tell them
they were arresting the wrong man.
　NO CONVICTION

April 2014 - **Eric Garnor**
　African American, 43
　New York City, New York
Accused of selling cigarettes, Eric Garner was placed in
an illegal chokehold and he repeatedly told police officers
he could not breathe. Garner later died. After the coroner
ruled his death a homicide, the grand jury decided not to
indict the officer.
　NO INDICTMENT

April 2014 - **Dontre Hamilton**
　African American, 31
　Milwaukee, Wisconson
A police officer was attempting to frisk Dontre Hamilton
when a fight broke out. The police officer shot and killed
Hamilton.
　NO CONVICTION

August 2014 - **John Crawford III**
　African American, 22
　Beavercreek, Ohio
While shopping in a Walmart store, John Crawford was
carrying a toy gun from the store. Someone reported a
'man with a gun.' When police arrived, they shot
Crawford almost instantly without warning.
　NO INDICTMENT

November 2014 - **Tamir Rice**
　African American, 12
　Cleveland, Ohio
Tamir Rice was shot and killed by a police officer after
being seen in a park with a toy gun. The officer was
deemed emotionally unstable when released from his last
police job.
　OFFICER CHARGED

April 2015 - **Walter Scott**
　African American, 50
　North Charleston, North Carolina
Stopped for a broken taillight, Walter Scott fled and was
shot eight times in the back and then handcuffed.
OFFICER INDICTED

April 2015 - **Freddie Gray**
　African American, 25
　Baltimore, Maryland
Freddie Gray was arrested and later fell into a coma after
being transported by police. Gray died a week later of
injuries to his spinal cord. Charges were filed against six
police officers after Gray's death was ruled a homicide.
　OFFICERS CHARGED

July 19, 2015 - **Samuel Dubose**
　African American
　Cincinnati, Ohio
Samuel Dubose was stopped for a missing license plate
and later shot by a police officer while Dubose was
unbuckling his seat belt.
　OFFICER INDICTED

Harry Belafonte

"Black Power" and the Impact of Words

There had always been a quest for power. The struggle in the Civil Rights Movement was a constant reflection of a certain amount of powerlessness that had permeated Black life, Black culture, and Black aspiration. People were constantly in touch with the idea that we were in need of power.

Given Dr. King's position on the movement and seeing it as all-encompassing not just for Black needs but for the needs of all of those in the underclass, or the poor peoples of our country, [he] was careful in how he used racial definitions to characterize the movement. So no one ever really talked to the idea of Black power as such. It carried with it a host of definitions that for many were unsafe. When it arrived, and when it was used as effectively and as powerfully as [it was by] Rap Brown or Stokely Carmichael, it touched something that was irreversible.

There were those who were afraid of it because it suggested anger and a kind of psychological aggression. A goal was very clearly defined: Black Power. From this day forward, we were going to be doing something that infused the idea that Black people would no longer be powerless. Whatever we may have achieved, even if we achieved civil rights, one did not necessarily achieve power as we've come to understand it.

Black Power also did something beyond just setting a new dimension for the movement. It gave everybody a single place to be. In the use of the word "Black," the Black Power Movement said, "Black is really Black." And using that as the base, we accept the fact that all gradations of that color are acceptable under the term "Black." So it became very unifying. Light-skinned Blacks didn't have to sit back any longer. It was a weird kind of thing to see emerge.

Everybody finally had a word, [and] could feel some universality. It was also a word that came out of a realizable and recognizable Black source. Anybody can debate where the [word] negro comes from. Anybody can debate where the [word] colored comes from. But Black Power came from a nitty-gritty place, a vibrant movement where some people [were] taking charge of their lives. It was terrifying for a lot of White folks. Even for a lot of Black folks. But it was also very healing for most.

What Dr. King Feared Most

The first time [the] flames became visible, it was an unbearable experience for those of us who had sought to pursue the guidelines set down by Dr. King. The person for whom it was the most troublesome was Dr. King himself. The thing that he had feared most, that violence would erupt, that it would become a major player in the course of our history, was very troublesome. He felt wretched over trying to find the miracle that would make the difference because he felt he had failed. He so believed in his objectives that he also saw himself as having to be omnipotent. That he would somehow be able to get over. The Detroit riots were the beginning of a series of events that took him on a special course.

On a number of major campaigns, whether it was the March on Washington, or Birmingham, or Selma, or the Poor People's Campaign, Dr. King would convene journalists, opinion-makers, [and] leaders. Dr. King used that time to give a firsthand definition

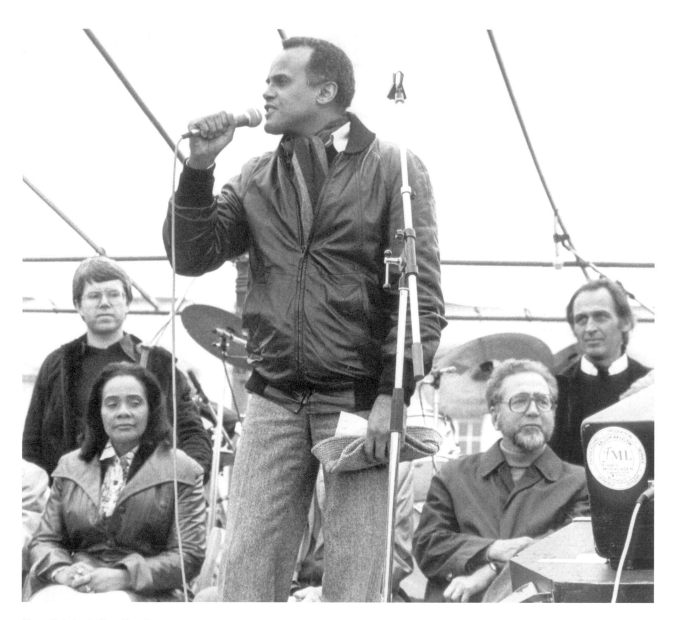

Harry Belafonte (front) and
Coretta King (L), at a peace
demonstration, 1981, photo by:
Egon Steiner/picture-alliance/
dpa/AP Images

[of] what the campaign was about, what he hoped to achieve, the reason behind it, the tactics, and what would unfold in the event of certain encounters. It gave allies to the movement, and [for] those prepared to ask objective journalistic questions, an opportunity to hear from King directly.

Before coming to the meeting in New York at my home, Dr. King had to meet with a group in Newark at a place called New Ark, where Imamu [Amiri] Baraka had headquartered himself. At the end of that meeting, when everybody had left, Dr. King was highly, highly agitated. You could tell when he paced. His shoes were off, his tie was open, he was walking up and down the living room and talking. I heard him

say "I'm very, very concerned." He was looking at all the riots and all the aggression that were beginning to emerge, and he said "This integration movement is beginning to unfold things that I had never quite envisioned and I wonder if we are not in fact integrating into a burning house."

It was the first time that I had heard him utter anything that suggested that there was another dimension. We were all going to have to go someplace else. He knew that the Civil Rights Movement itself would have to give way to something much more profound: economic rights. That's why he began to talk about the Poor People's Campaign. He saw the amalgamation now coming, moving away from just Blacks and

Whites looking to integrate [and] bringing the people together in a much more fundamental way around issues that affected everybody regardless of race, class, color, or ideology.

The Black Panthers Arrive

The Black Panthers did cause quite a tremor in the movement. It wasn't so much that it was a group called the "Black Panthers" and [that] they appeared to be "very militant" and were prepared to bear arms. The problem really was that there was such an inordinate level of intelligence that made up all those young men and women. Eldridge Cleaver [author of "Soul on Ice"], Hampton, Bobby [Seale], all of them. These young men spoke with such rich vocabulary, such passion, and depth of commitment that Dr. King often said that were I able to co-opt those minds into my cause there is no question that victory would be swift and eternal.

As events unfolded, as the Black Panthers used themselves to show the cutting edge of violence, and the insidiousness of [the] police, and investigations and the FBI, they [the Black Panthers] became a living instrument through which all these unholy alliances of institutions lock[ed] together to serve notice on Black people. They were catalysts to a whole new set of information. The murder of Hampton yielded [new] information. The [Black Panthers] in Oakland had to come out undressed to show, in the event they were killed, that they were not bearing arms. The Black Panthers devised ways to show the corruption. The oppressive system became very meaningful and very real.

The Pervasiveness of Surveillance

Dr. King talked about it constantly. There is no way for the Federal Bureau of Investigation to have conducted its affairs the way it conducted its affairs if it was not specifically hostile to the movement and everything it represented. For J. Edgar Hoover to find some moral basis on which he would contain himself from doing the evil that he did...there was no way. He was too corrupt. He was too evil. His utterances, public as well as private, were too racist. Every facility available to the FBI was being used to discredit the movement. Certain events that happened in SNCC [were] the result of an informer in the group, or the result of direct intervention through wiretapping and other surveillance. There were times when we spoke to one another from safe phones. I certainly did with Dr. King, especially during the years of the trial. The full dimension of that reality did not become clear to us until we had access to...the Freedom of Information Act.

The very people whom we saw as allies to our cause were also involved in wiretapping. To think of the Kennedys and people in the Justice Department, in the Civil Rights Division, tapping us when we were in what we considered to be open concert with them. There was nothing that we ever said or didn't say to Bobby Kennedy, that wasn't reflective of what we were saying in private. Dr. King was very much on the table. I mean he was upfront. We weren't trying to overthrow the government. There were no reasons for us to break up into cells. We weren't consorting with the enemy, whoever that would have been.

Peace Versus "Patriotism"

The Peace Movement was looking for a central place in which to be able to bring its energies. Dr. King became the catalyst for all of it. I just wanted to broaden the base. Certainly SNCC [the Student Nonviolent Coordinating Committee] was very active in moving that campaign along. Dr. King had no problems with the issue. What bothered him was the fact that so many Black people got caught up in this wave of concern about legitimate Black aspiration for freedom in this country and the question about our patriotism.

Dr. King had come to accept the fact that, from a moral position and an ethical position, the [Vietnam] war was inhuman and unacceptable, but also from a technical position. Since the war was clearly illegal [and] unconstitutional, how were the Blacks of this country ever going to be able to have the resources to do what had to be done if in fact integration was to come about, if the government was spinning off all of these funds and monies into these illegal activities. The fact that Blacks were the first to be drafted and were numerically the largest number serving in Vietnam and dying in larger number[s] per

capita than anyone else, [made] the whole thing a campaign that Dr. King was prepared to go through with, with the understanding that the true patriot, the real American, [was] the one who was doing the country the greatest service.

After the Riverside speech *The New York Times* and *The Washington Post* were scathing in their denunciation of Dr. King. *The Washington Post* in particular was really quite aggressive in its language and sought to discredit Dr. King on every level. Dr. King was not so much concerned about what those articles said about him personally as about what they would do to the mood of the movement. This was not just a criticism as to a point of view on the war it now sought to discredit him. When he saw it connected to the movement, and all that was coming, he was quite vulnerable.

The Presence of Death

I had often discussed death with Dr. King. One time on NBC when I hosted *The Tonight Show,* Dr. King was one of the guests. Dr. King was late to the show and he said, "I'd like you to forgive me for being late...the plane was late and the driver was trying to get here on time. He was cutting some corners and beating some lights." That made me say to him, 'Look, young man, I'd rather be Dr. Martin Luther King late than be the late Dr. Martin Luther King.'" It was with that handle that I then said to Dr. King, "Death is very much in your arena. Death is very present in your life. It is very present in the lives of anyone who is a follower of yours. How do you come to grips with it?" And he went on to give a full explanation as to his view of death and this was particularly revealing because Dr. King had a psychological problem in that he had a tic, a hiccup. He would get this tic and he would suffer with it for a given period of time. It was quite difficult and obviously psychological. After a while we discovered that this wasn't there anymore, and I said to Dr. King, "What happened?" And he said, "I've come to grips with death."

He had come to grips with [death] because he believed that he could not clearly make decisions if a preemptor was a concern for life. He had to put in place not only the possibility of his own death but the death of his wife, the death of his children, the death of those who were his followers, the death of those who may be in a march, at any moment. I think

that's when he said, "I've been to the mountaintop." I don't know that he was alluding to anything terribly specific, although he could have been. I think he was alluding to a host of conclusions and decisions that he had arrived at because he saw a new day where he was going, and where the movement was going, and what had to be done. I think that's what he saw on the mountaintop.

Had Dr. King been given another three years, the movement would have been in an entirely different place than where it found itself at the time he was assassinated. I think that Dr. King in the Poor People's Campaign, with the garbage workers in Memphis, was on a thrust that was going to give a new and a much broader meaning to the movement. Yes, there were still the civil rights issues to be clarified. There was still the Civil Rights Bill to be passed. All that was fairly evident. We had to take the movement, however, since it had been clearly around the issues of segregation, integration, and civil rights; we had to carry it now to its next logical and more dimensional level that had not yet been put in place. We were just in the process of doing that. Had Dr. King had three more years of refining the leaders and the people who came to be for all these diverse areas, the movement would have been, and the country would have been, qualitatively different.

There was a sense at Dr. King's funeral that we were at a moment in history that was very, very unique. Those hundreds of thousands of people who came to express their loss and their grievance and their grief [had] a sense of oneness that I've never quite experienced anywhere else again. At the March on Washington, you had a great sense of yourself and your power. It's another thing to be in this other environment that's almost as dramatic and dealing with a loss. It brings you closer to your fellow human or how you perceive them. I'll never forget that I was standing at one point next to a writer from *The New York Times* and he was obviously sad. I spoke to him, recalling the article on Vietnam, which helped to fan the waves of discontent and to make people quite angry at us. I pointed out to him that the way in which they had discredited Dr. King was a great disservice to a rich cause. I didn't say it to him in a personal accusation. I said it because I wanted him to understand that none of us were really exempt from a responsibility to that moment by just coming to grieve the loss, there was no cleansing of responsibility. Remember what you did to make this moment realizable, what you did to participate in this, and be cautious about how you use your power.

—Excerpted from an interview with Harry Belafonte,
conducted by Blackside, Inc., May 15, 1989.

PROTEST POETRY

by Amiri Baraka

I have always resented the term "protest poetry" because it seemed to me that it was dropping the poetry I felt closest to in a lead box so it wouldn't contaminate the dull ass mainstream. This was not really clear to me until my Air Force days in Puerto Rico, when I wd send poems to all the prestigious literary journals and they wd come back, rejected, at light speed. *Sewanee, Partisan, Kenyon, Hudson, Southern,* etc.—I wish I'd kept a record, there in Puerto Rico, as an Airman 2nd Class Weather Gunner on a B-36 bomber, mostly pulling guard duty in the hot sun and writing poetry.

But it didn't really dawn on me what was going on until after one of my weekly trips to Viejo San Juan, Puerto Rico, I read a copy of *The New Yorker* there by the poet who I thought was the editor of the magazine, about the suburbs and his dismal ride there, after his New York city toils, yearning for a martini and wondering about his wife's various "comedies" cavorting in those suburbs. Aggh, I thought I couldn't write that stuff. I don't think I'd ever seen a birdbath. Across the street from my parents' apartment over a dentist's office where I spent my high school years, we could see a Chinese restaurant and the various folk that frequented it, especially in the wee hours. We were up the street from the old National Theater, and the Masonic Temple, where every weekend we were saved by Lynn Hope or Bull Moose Jackson, or Little Esther Phillips, The DuWops were screaming from the corner record store and we dug The Orioles, The Ravens, Louis Jordan, Ruth Brown and rubbed bellies with whatever ghetto queens would let us get that close.

I knew I wanted to write about what I knew—my own life. What we knew and carried growing up in Black Newark, in the 30s, 40s, 50s. That stuff in *The New Yorker* wasn't in it. I had to go down the street to Newark-Rutgers, which had just opened, to begin to see what the white world, the academic world, meant by "High Art" and Great Literature, though I had been raised by a social-worker mother, who had gone to Tuskegee and Fisk, and a Postman father, both immigrants from the South.

Certainly I knew the stories of the Black South. All of the older folks in our family told those stories relentlessly. That history was as close to me as my clothes! But my mother was a member of The Book of the Month club so I read *Black Boy* at about 12, and Frank Yerby's *The Foxes of Harrow* when I didn't know he was Black, and *The Rubiyat of Omar Khayam*. Plus my grand-mother would come back from her work doing white ladies hair up in the "more money than us" suburbs. And she'd bring back Rider Haggard, Dickens, Rudyard Kipling, which I'd tried to read. Richard Wright's *Black Boy* I found so heavy that I thought white people must be looking for him to kill him.

So it wasn't "protest poetry" I wanted to write, it was simply to continue the tales about our own lives. I always thought the term "protest poetry" was, to put

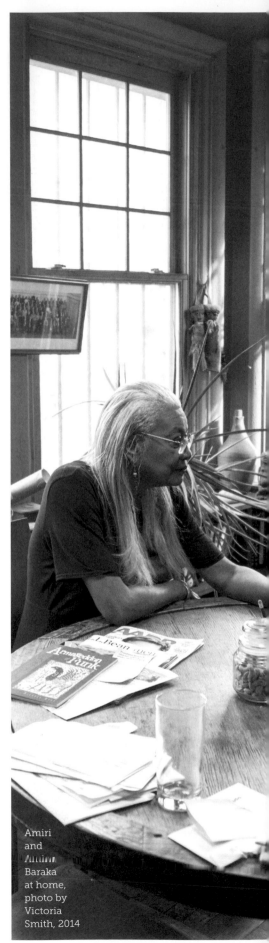

Amiri and Amina Baraka at home, photo by Victoria Smith, 2014

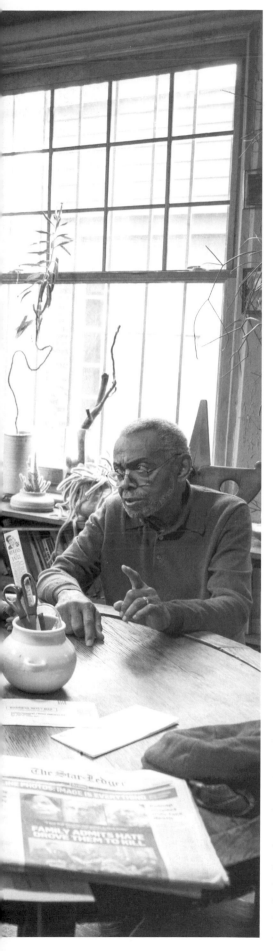

it baldly, "some corny white shit." I was even more incensed when I discovered they were talking about our lives, which if we described them would seem to some as isolated crumb "protest poetry."

Simply to tell the story of how my folks got from the deep South, my mother's people from Alabama, my father's from South Carolina, to this same isolated crumb, now writing for *Kenyon Review* or *Partisan Review,* etc. probably a real victim of slavery, like most petty bourgeois white people and quite a few Negroes who believe that America is cool, except for a few minor defects, or that a literature that is exclusively European or Euro-American is the cat's drawers, even though it cannot deal with the very soul of American life, and certainly not Afro American or Latino life.

For instance, my mother's family lived in Dothan, Alabama, where my grandfather was a young storekeeper. The "jealous crackers," as my grandmother called them, burned the store down. My grandfather tried to build another. That went up in smoke as well. He then built a funeral parlor with a horse drawn hearse, the Americans told him if he didn't get out they would burn it down with them in it, so they fled to Beaver Falls, Pennsylvania and from there to Newark. My father was a young barber and movie theater usher in Hartsville, SC. After an altercation in the movie, he also had to remove himself and ended up in Newark. He always told the tale that he thought he was in New York.

Afro-American literature, despite its characterization by the ignorant, very much like they characterize Afro Americans themselves, as of little value, is one of the most influential and important in the world. Particularly given the context of its creation, in the cauldron of racism, racial violence and dismissal. It reveals American lives, culture and history in a depth that nothing else is able to do.

Of course, the greatest of American writers, Melville, Twain, relate to that depth. *Moby Dick* and *Narrative of the Life of Frederick Douglass* illuminate the 19th century United States in a way nothing else can. Would you call *The Confidence-Man,* "Bartleby, the Scrivener: A Story of Wall Street," "Benito Cereno," or *Billy Budd* "Protest Literature?" Why Not? What about Twain's *Pudd'nhead Wilson* or even *The Adventures of Huckleberry Finn?* The conversations with "Nigger Jim" tell you a lot about this place. Even though some imbecilic Negro professors want to call him a racist for that. What was he supposed to call Jim? "Afro-American Jim?" Twain was talking about real America. Not Negro fantasy in some squeaky-clean lie of US university life.

As long as the oppressed tell their true story it will carry the edge of protest. Like so much else in the warped Anglo-twisted version of American Literature there is an attempt to convince us that any criticism of the historic pathology of US society is wrong-headed.

The *Encyclopedia Britannica,* representing the disease center, the UK, where a lot of the more backward views of the world come from, claimed in its 1994 edition of *Great Books of the Western World* that there were no Black writers that were important enough to include in its naming of great writers. It mentioned DuBois, but disqualified him for talking about the actual world too much. Willa Cather was the only woman writer included, which demonstrates the historic gender and racial bias carried by the literature of the western world, when any unbiased look at the most important literature coming out of the British Isles for the last 100 years has been Irish, e.g., Wilde, Yeats, O'Casey, Joyce, Beckett, Synge, &c &c. Eliot & Pound were Europhilic Americans who stayed too long. William Carlos Williams and Langston Hughes went to Europe but came home. Their writings focus on American culture and are examples of American writing and their closer concerns. Perhaps they were the yeast of a generation of so-called writers of "Protest Poetry" in form and content as well as language and content.

So the main thrust of the term "protest poetry" is to stigmatize the literature that questions the given, the status quo. But wouldn't that include *The Egyptian Book of the Dead,* the old and new testaments of the Bible. Isn't Revelation Protest Poetry?

Elizabeth
Alexander

I was always a poet in that I was interested in concentrated, non-linear language and had an ear for different kinds of speech. I became conscious of being a poet after sharing my diary with Derek Walcott while studying for my masters degree in fiction at Boston University. He looked through the pages, pulled out a "word cloud," wrote it out with line breaks, and said, "You see, you are writing poetry, but just don't know how to do it. Go away until you've written some poems."

Thus my apprenticeship began. I immersed myself in every form of poetry, writing and rewriting poems in every way imaginable. Approaching a poem from every angle and building up an arsenal of approaches to solving the problem of the poem became the underpinning of my work.

Having wide-open eyes has had the heaviest impact on my writing. My reading has ranged from trashy magazines to T.S. Eliot's *The Waste Land*. I exhausted my parents' record collection—Frank Sinatra, Modern Jazz Quartet, Janis Joplin, The Mamas and the Papas, Dinah Washington, The Supremes, Richard Pryor, Duke Ellington. At a young age I flipped through bins of off-price jazz records and spent 90 cents on an album by Betty Carter. Her music is not about melody but what is underneath the melody, just as Thelonious Monk's music is not about some tidy sonorous resolution. That is important to me as a poet. I need to write against the grain as opposed to creating pretty packages that are resolved, tied up in a bow.

Gwendolyn Brooks—the poet genius of the 20th century—went against the grain. She mastered and owned traditional poetic forms and made those forms indelibly her own. She showed me how to be a working artist. She lived a laudable life serving as an elder citizen of poetry of Chicago and of the world. I inherit Ms. Brooks' love for and interest in Black people.

I possess a profoundly Black poetic that is attentive to vernacular speech. The poem has to swing, sing, and feel like an utterance that makes sense, even in its strangeness. My generation re-articulated Black culture and widened the diversity of Black art. We illustrated that all Black experience has Black sounds. My poetics are eclectic, influenced by diversity both poetic and rhetorical, driven by literature and history. My poems remind the reader that although they appear on paper, they are made of flesh.

Elizabeth Alexander holds degrees from Yale, Boston University, and the University of Pennsylvania, where she earned her Ph.D. She is professor of African American Studies at Yale and is a highly respected teacher, literary critic, and mentor as well as a founding faculty member of Cave Canem. She has written six books of poems, two books of essays, and edited several other volumes. Her book of poems American Sublime *(2005) was shortlisted for the Pulitzer Prize, and in 2005 she was awarded the Jackson Poetry Prize. Her poem "Praise Song for the Day" was written and delivered for President Barack Obama's first inauguration.*

Narrative: Ali, a poem in twelve rounds

1

My head so big
they had to pry
me out. I'm sorry
Bird (is what I call
my mother). Cassius
Marcellus Clay,
Muhammad Ali;
you can say
my name in any
language, any
continent: Ali.

2

Two photographs
of Emmett Till,
born my year,
on my birthday.
One, he's smiling,
happy, and the other one
is after. His mother
did the bold thing,
kept the casket open,
made the thousands look upon
his bulging eyes,
his twisted neck,
her lynched black boy.
I couldn't sleep
for thinking,
Emmett Till.

One day I went
Down to the train tracks,
found some iron
shoe-shine rests
and planted them
between the ties
and waited
for a train to come,
and watched the train
derail, and ran,
and after that
I slept at night.

3

I need to train
around people,
hear them talk,
talk back. I need
to hear the traffic,
see people in
the barbershop,

people getting
shoe shines, talking,
hear them talk,
talk back.

4

Bottom line: Olympic gold
can't buy a black man
a Louisville hamburger
in nineteen-sixty.

Wasn't even real gold.
I watched the river
drag the ribbon down,
red, white, and blue.

5

Laying on the bed,
praying for a wife,
in walk Sonji Roi.

Pretty little shape.
Do you like
chop suey?

Can I wash your hair
underneath
that wig?

Lay on the bed,
Girl. Lie
with me.

Shake to the east,
to the north,
south, west—

but remember,
remember, I need
a Muslim wife. So

Quit using lipstick.
Quit your boogaloo.
Cover up your knees

like a Muslim
wife, religion,
religion, a Muslim

wife. Eleven
months with Sonji,
first woman I loved.

6

There's not
too many days
that pass that I
don't think
of how it started,
but I know
no Great White Hope
can beat
a true black champ.
Jerry Quarry
could have been
a movie star,
a millionaire,
a senator,
a president—
he only had
to do one thing,
is whip me,
but he can't.

7

Dressing-Room Visitor

He opened
up his shirt:
"KKK" cut
in his chest.
He dropped
his trousers:
latticed scars
where testicles
should be, His face
bewildered, frozen
in the Alabama woods
that night in 1966
when they left him
for dead, his testicles
in a Dixie cup.
You a warning,
they told him,
to smart-mouth,
sassy-acting niggers,
meaning niggers
still alive,
meaning any nigger,
meaning niggers
like me.

8

Training

Unsweetened grapefruit juice
will melt my stomach down.
Don't drive if you can walk,
don't walk if you can run.
I add a mile each day
and run in eight-pound boots.

My knuckles sometimes burst
the glove. I let dead skin
build up, and then I peel it,
let it scar, so I don't bleed
as much. My bones
absorb the shock.

I train in three-minute
spurts, like rounds: three
rounds big bag, three speed
bag, three jump rope, one-
minute breaks,
no more, no less.

Am I too old? Eat only
kosher meat. Eat cabbage,
carrots, beets, and watch
the weight come down:
two-thirty, two-twenty,
two-ten, two-oh-nine.

9

Will I go
like Kid Paret,
a fractured
skull, a ten-day
sleep, dreaming
alligators, pork
chops, saxophones,
slow grinds, funk,
fishbowls, lightbulbs,
bats, typewriters,
tuning forks, funk
clocks, red rubber
ball, what you see
in that lifetime
knockout minute
on the cusp?
You could be
let go,
you could be
snatched back.

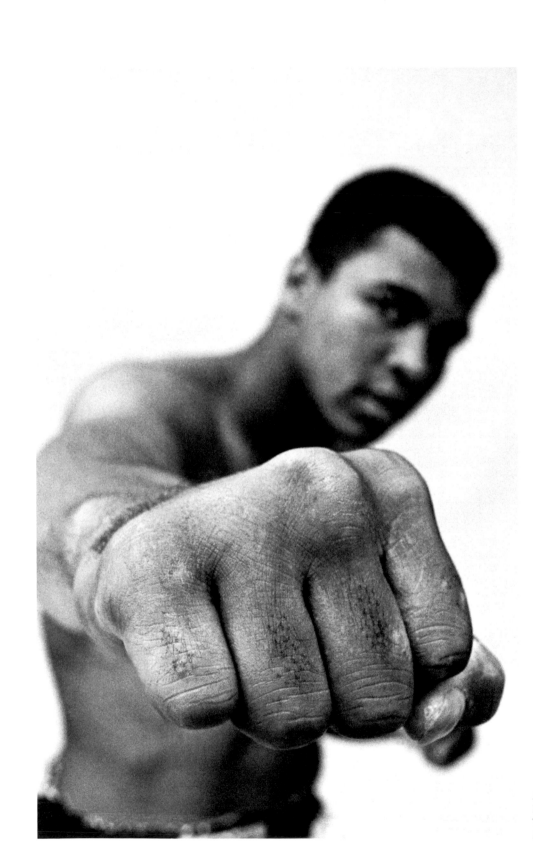

Muhammad Ali,
Photograph by
Thomas Hoepker,
1966

10

Rumble in the Jungle

Ali boma ye,
Ali boma ye,
means kill him, Ali,
which is different
from a whupping
which is what I give,
but I lead them chanting
anyway, *Ali*
boma ye, because
here in Africa
black people fly
planes and run countries.

I'm still making up
for the foolishness
I said when I was
Clay from Louisville,
where I learned Africans
live naked in straw
huts eating tiger meat,
grunting and grinning,
swinging from vines,
pounding their chests—

I pound my chest but of my own accord.

11

I said to Joe Frazier,
first thing, get a good house
in case you get crippled
so you and your family
can sleep somewhere. Always
keep one good Cadillac.
And watch how you dress
with that cowboy hat,
pink suits, white shoes—
that's how pimps dress,
or kids, and you a champ,
or wish you were, 'cause
I can whip you in the ring
or whip you in the street.
Now back to clothes,
wear dark clothes, suits,
black suits, like you the best
at what you do, like you
President of the World.
Dress like that.
Put them yellow pants away.
We dinosaurs gotta
look good, gotta sound
good, gotta be good,
the greatest, that's what
I told Joe Frazier,
and he said to me,
we both bad niggers.
We don't do no crawlin'.

12

They called me "the fistic pariah."

They said I didn't love my country,
called me a race-hater, called me out
of my name, waited for me
to come out on a stretcher, shot at me,
hexed me, cursed me, wished me
all manner of ill will,
told me I was finished.

Here I am,
like the song says,
come and take me,

"The People's Champ,"

myself,
Muhammad.

Amiri
Baraka

When I was about 8 years old I was writing letters to President Roosevelt telling him how to win the war. I included diagrams of new weapons. I started a newspaper around the age of 10 for our organization "The Secret Ten" that met under our porch where we ate "Kits" and drank Kool-Aid. I wrote the whole newspaper, all eight copies. Mostly it consisted of a long cartoon "The Crime Wave" that showed people being stuck up by a hand with a gun that said "Yr Money."

My grandmother brought books home from the rich white lady whose hair she went up in the burbs to do: H. Rider Haggard, Charles Dickens. My mother subscribed to the Book-of-the-Month Club. I read *The Rubaiyat* by Omar Khayyam, Richard Wright's *Black Boy*, and Frank Yerby's *The Foxes of Harrow*.

In Barringer High School I started writing short stories. *The Cat* was one that was published. I wrote all kind of stuff. Epithets, aphorisms, just words. My high school writing teacher, a Ms. Steward, seldom smiled.

I had read Langston Hughes in elementary school and heard the old blues and later DuWop, and ultimately BeBop. In college I began to write poetry; my influences were Garcia Lorca, Bertolt Brecht, Guillaume Apollinaire, and the anthology *One Hundred Modern Poems*. My poetic influences were always changing as I changed. They also included Allen Ginsberg, Margaret Walker, Sterling Brown, Charles Olson, Robert Creeley, Larry Neal, Henry Dumas, Aimé Césaire, Jacques Roumaine, and so many more.

I wrote poetry 'cause I always had something to say. Always.

Amiri Baraka (1934–2014), born Everett LeRoi Jones in Newark, New Jersey, leaves a legacy as one of America's most influential authors. His numerous literary honors include fellowships from the Guggenheim Foundation and the National Endowment for the Arts, the PEN/Faulkner Award, the Langston Hughes Award from The City College of New York, and a lifetime achievement award from the Before Columbus Foundation. He was inducted into the American Academy of Arts and Letters in 1995. In 1994 he retired as Professor of Africana Studies at the State University of New York in Stony Brook, and in 2002 was named Poet Laureate of New Jersey and Newark Public Schools. The award's stipend was rescinded and the post eliminated by the New Jersey Assembly after Baraka read his poem "Somebody Blew Up America," about the 9/11 attacks, at the Geraldine R. Dodge Foundation's annual poetry festival. In January 2007, his award-winning, one-act play Dutchman *was revived at the new Cherry Lane Theatre in New York and received critical acclaim and international attention. His book* Digging: The Afro-American Soul of American Classical Music *was selected as a winner of the 31st annual American Book Awards for 2010. In 2013 he was writing biographies on Max Roach and Pat Patrick, the great saxophonist with Sun Ra's many "Arkestras," and the father of former Massachusetts Governor Deval Patrick. His last book of poetry was* Somebody Blew Up America and Other Poems.

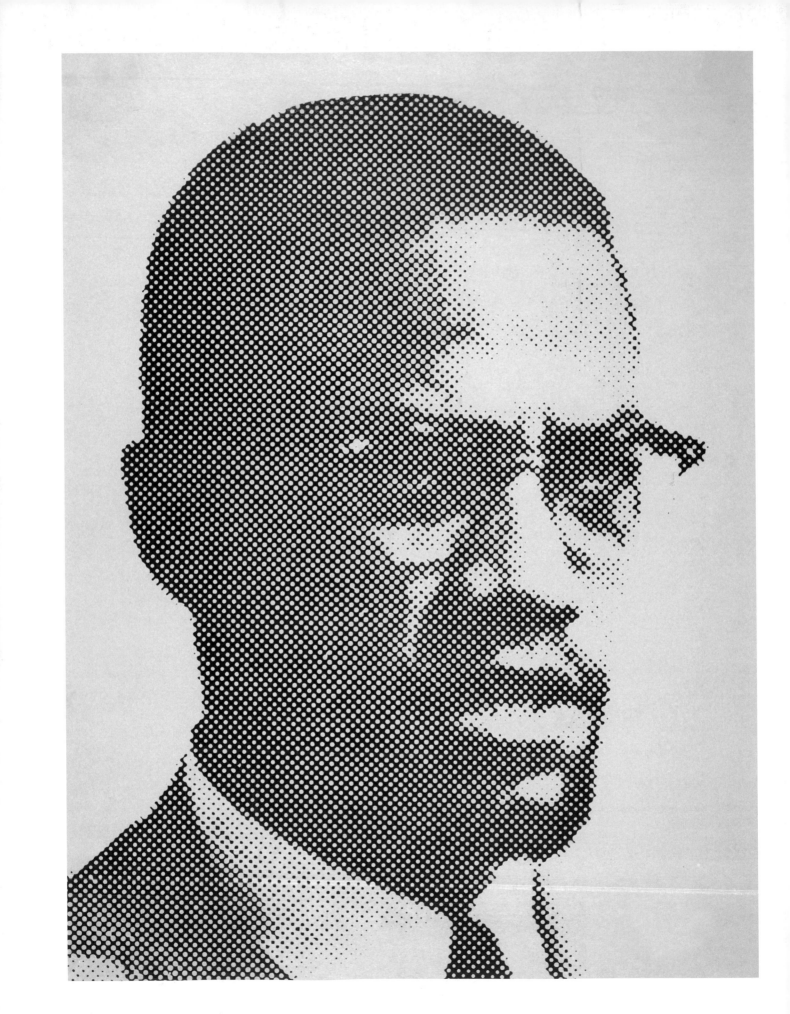

Amiri Baraka

Wise 5

I overheard the other night
standing by the window
of the big house

a nigra say, through an alabaster
mask "the first negro
was a white man."

Slanty red darts angulate the darkness
my hands got cold, my head was sweaty

like a mystery
story
like a gospel
hymn
like the tales
of the
wizards
and the life
of the gods

I did not know
who my father
was

I only barely
knew
my mother

But I knew something that night
about a negro
something even
the tv cant wash
away

I fount out something
about the negro

the wind may blow
the train dont come
the mayor might belch
his mistress might gain weight

But I fount out something that night
about the negro
& the world
got clear

you can hurray all you want to
you can kiss an elephant's ass

But I fount out something
that night, before I slid
back to the field hands' quarters
I fount out something
about
the magic
of slavery

& I vowed not to be
a slave
no more

Malcolm X,
original poster,
artist unknown,
circa 1967

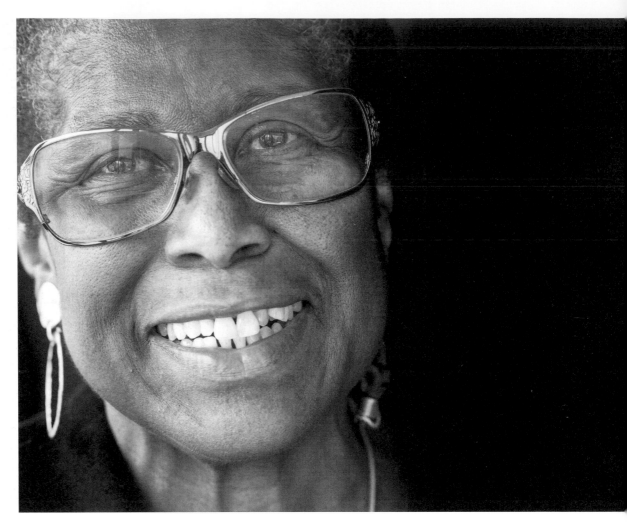

Wanda Coleman

t the age of 5 I was already writing. My first poem was published in a local newspaper at the age of 13. I read everything within reach, starting with my parents' meager home library, which contained the King James version of the *Bible* and the complete works of William Shakespeare. The book I found most fascinating was *Great Ghost Stories of the World*—which I read repeatedly, studied, and tried to emulate in my fledgling work, focused on short stories. It led me to science fiction, philosophy, psychoanalysis, crime & mystery novels, seafaring adventures, the existentialists, poetry, and more.

At home, however, I lived in a Black world and no matter what I read, it did not reflect my life. Langston Hughes, Paul Lawrence Dunbar, and James Weldon Johnson were names that became familiar from the pulpit and at school during Negro History Week, once the local educational taboos against

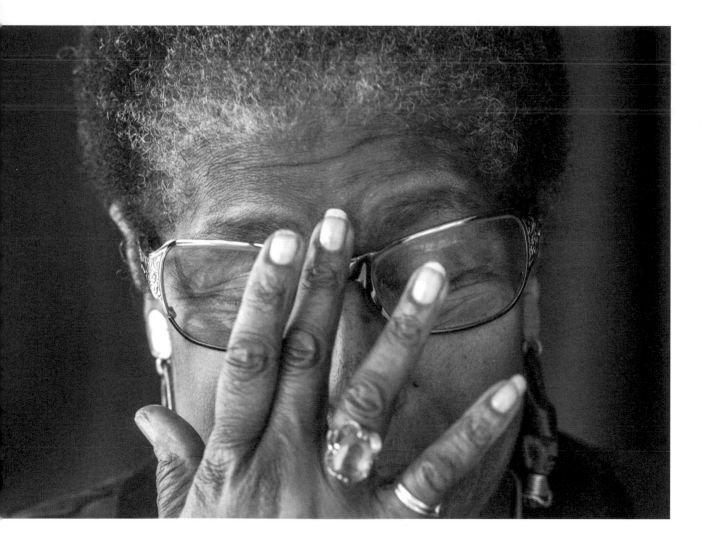

Black literature lifted in the late 1950s. (At my grade school, it was considered "contraband," and students who brought books on campus written by Black men were suspended.) I would have to enter my late teens before gaining greater access to the writings of African Americans, and did not know Los Angeles had at least three bookstores (two Black-owned) that carried Black literature.

When my parents began reading James Baldwin (*Notes of a Native Son*, 1955) and, belatedly, Richard Wright (*Native Son*, 1940), I followed suit; however, their writings, while stimulating and enlightening, did not satisfy my compulsion to capture in writing what I saw of the world. A reissue of *The Souls of Black Folk* (1903) by W.E.B. DuBois brought it home! Truer inspiration would come particularly when I borrowed a copy of *The Street* by Ann Petry. There was my answer! There was my woman's story! There was the entrance to my world as I was struggling to survive in it as a single Black divorcee raising two children alone, and to capture that world in words. Working two to three jobs at a time to support my children, quality writing time was a rarity, yet I found ways to hone my craft. I reached/strived for that Petry-inspired goal ever since, feeling even after five decades that I have not quite achieved it, and that has driven me to keep writing.

Born in Watts and raised in South Central Los Angeles, Wanda Coleman (1946–2013) was the author of 20 books of poetry and prose. She was an Emmy-winning scriptwriter, and former columnist for Los Angeles Times Magazine; *a finalist for poet laureate, California 2005 and 2012, and twice nominee for the USA artists fellowship. Her books from Black Sparrow Books (Godine) include* Bathwater Wine, *winner of the 1999 Lenore Marshall Poetry Prize—the first African-American woman to receive it, and* Mercurochrome (poems), *bronze-medal finalist, National Book Awards 2001. Her collection* The World Falls Away *(Pitt Poetry Series) received the San Francisco State University Poetry Center Book Award (2013).*

Emmett Till

river Jordan run red

rainfall panes the bottom acreage—rain
black earth blacker still

blackness seeps in seeps down
the mortal gravity of hate-inspired poverty
Jim Crow nidus

*the alabama the apalachicola the arkansas the Aroostook
the Altamaha*

killing of 14-year-old
stirs nation: there will be a public wake

works its way underground
scarred landscape veined by rage
sanctified waters flow
go forth

the bighorn the brazos

along roan valley walls blue rapids
wear away rock
flesh current quickly courses thru
the front page news amber fields purple mountains
muddies

*the chattahoochee the cheyenne the chippewa the cimarron
the colorado the columbia the connecticut the cumberland*

waftage

spirit uplifted eyes head heart
imitation of breath chest aheave

that grotesque swim up the styx
level as rainwater culls into its floodplain

the des moins

blood river born

ebony robe aflow
swathed hair of the black Madonna
bereft of babe

the flint

that hazel eye sees
the woman
she fine mighty fine
she set the sun arising in his thighs

the hudson the humbolt the Illinois

and he let go a whistle
a smooth long all-american hallelujah whistle
appreciation. a boy

the james the klamath

but she be a white woman. but he be
a black boy

the maumee the minnesota the mississippi, the missouri
the mohican

raping her with that hazel eye

the ohio

make some peckerwood pass water mad
make a whole tributary of intolerance

the pearl the pecos the pee dee the penobscot
the north platte the south platte the Potomac

vital fluid streaming forth in holy torrents

think about it. go mad go blind
go back to africa go civil rights go go

the red the white the green

run wine

silt shallows the slow sojourn seaward

they awakened him from sleep
that early fall morning
they made him dress
they hurried Emmett down to the water's edge

the roanoke

after the deed
they weighted him down
tossed him in
for his violation

the sacramento the salt the san juan the savannah
the smoke

from the deep dank murk of consciousness a birth
oh say do you see the men off
the bank dredging in that
strange jetsam

the tennessee the trinity

a lesson
he had to be taught—crucified (all a nigger
got on his mind) for rape by eye that
wafer-round hazel offender plucked out
they crown him

the wabash

cuz she was white woman virtue and he
be a black boy lust

the yazoo the yellowstone

oh say Emmett Till can you see Emmett Till
crossed over into campground

spill tears
nimbus threatening downpour
sweetwater culls into its soulplain

come forth the carry the dead child home

at my mouth forking

autumn 1955, lord!
kidnapped from his family visit
lord!
money road shanty
lord!
his face smashed in
lord! lord!
his body beaten beyond cognition

river mother carries him

laid in state
sovereign at last

that all may witness true majesty
cast eyes upon

murder

the youth's body too light
was weighted down in barbed wire & steel

dumped into the river agape a ripple a wave
(once it was human)

aweigh. awade in water bloated
baptized

and on that third day awaft
from the mulky arm of the tallahatchie
stretched cross cotton-rich flats
of delta

on that third day
he rose

and was carried forth to that promised land

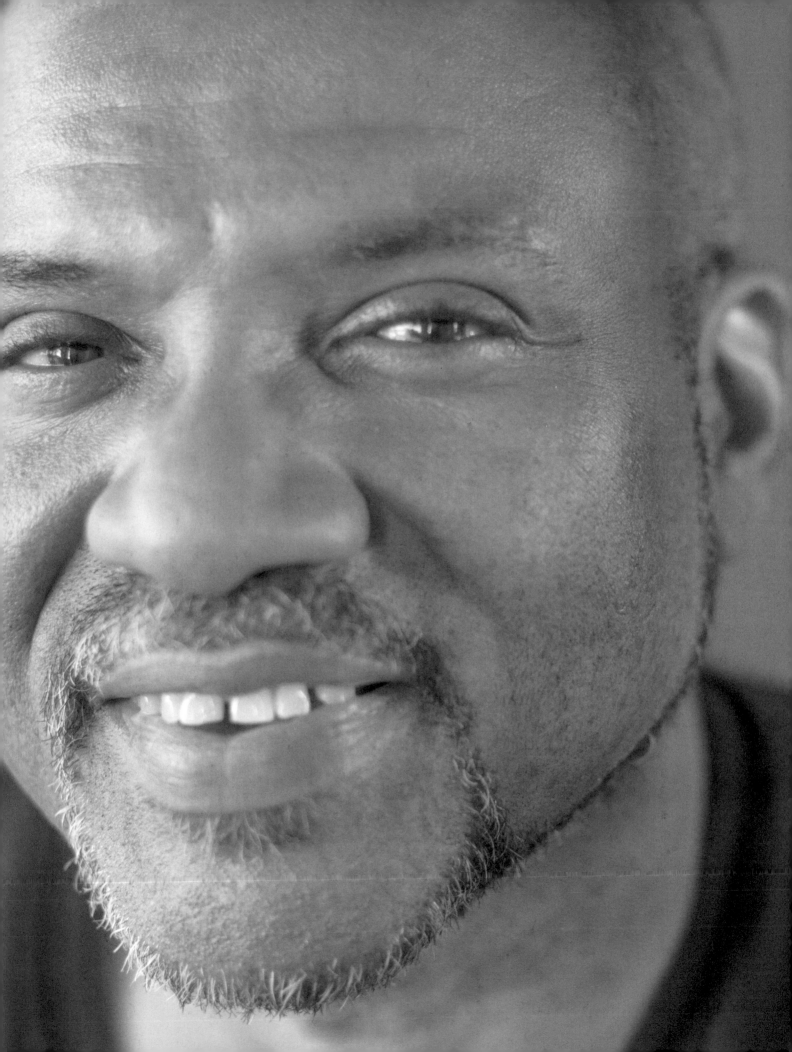

Kwame Dawes

I am not a political poet. I am a political person. And so my poetry becomes political. My poetry seeks to confound silence, and so by speaking into the silence, I am enacting something wholly political if one understands politics to be the business of how power is used in human society. Because I have been powerless and because I have been powerful, I am a political being.

I am a person who lives in a world and who comes of a history that has been shaped by the actions of human beings, many of them by politicians, many of them for political reasons. I grew up in a home in which dreams, ideals, values, even art, were somehow understood to be contained in the philosophies of living that would be termed political. My father said he was a Marxist. He taught us "The Internationale." His friends spoke of revolution. My mother joined the Ghanaian Workers Brigade—it was a job, but it was also a part of a political way of living in the world. She was an artist. Their politics guided their economic and moral choices at home and outside of the home.

Darkness and hopelessness, for me, are found in inarticulateness, the impotence that comes from not being able to voice experience and feeling with sincerity and without pretension. I have found in the making of poems a way to preserve the things in the world that have moved me—what Bob Marley called "the beau-ties" as well as the "unbeautiful" things, the inexplicable things, the alarming and the delightful things.

I think that a poet who writes love poems in the middle of war is a political poet.

Poetry teaches me how to make this lisping, stammering tongue of mine pray, preach, lament, bear witness, praise, adore, abuse, and voice the discoveries I make about the complexities of living in this world. I am not a political poet because to say I am a political poet would limit both what poetry is and what politics is. I am a political being. I make poems. My poems never ignore who I am, and my poems help me to understand who I am.

Ghanaian-born Jamaican/American poet Kwame Dawes is the award-winning author of 18 books of poetry (most recently, Duppy Conqueror: New and Selected Poems, Copper Canyon Press, *2013) and numerous books of fiction, nonfiction, criticism, and drama, and has edited nine anthologies and numerous books of poetry. He is the Glenna Luschei Editor of* Prairie Schooner, *and a Chancellor's Professor of English at the University of Nebraska. He is Associate Poetry Editor for Peepal Tree Press in the U.K. and Director of the African Poetry Book Fund and Series. Kwame Dawes also teaches in the Pacific MFA Writing program and is a faculty member of Cave Canem. Dawes is the Director of the biennial Calabash International Literary Festival.*

New Day

1

Obama, January 1st, 2009
Already the halo of grey covers his close-cropped head.
Before, we could see the pale glow of his skull, the way
he kept it close, now the grey—he spends little time in bed,
mostly he places things in boxes or color coded trays,
and calculates the price of expectation—the things promised
all eyes now on him: the winning politician's burden.
On the day he makes his speech he will miss
the barber shop, the quick smoke in the alley, the poem
found in the remainder box, a chance to just shoot
some hoops, and those empty moments to remember
that green rice paddy where he used to sprint, a barefoot
screaming boy, all legs, going home to the pure
truth of an ordinary life, that simple place where, fatherless,
he found comfort in the wisdom of old broken soldiers.

2

How Legends Begin
This is how legends begin—the knife slitting the throat
of a hen, the blood, the callous pragmatism of eating
livestock grown for months, the myth of a father, a boat
ride into the jungle, a tongue curling then flinging
back a language alien as his skin; the rituals
of finding the middle ground, navigating a mother's
mistakes, a father's silence, a world's trivial
divisions, the meaning of color and nation-negotiator
of calm, a boy tutored in the art of profitable charm;
this is how legends begin and we will tell this, too,
to the children lined up with flags despite the storms
gathering, children who will believe in the hope of blue
skies stretched out behind the mountain of clouds;
and he will make language to soothe the teeming crowds.

3

Waking Up American, November 5, 2008
She says she never saw him as black, unlike his mother
who said she did. She says she saw him as colorless,
just a man, unlike his white mother who touched his father's
face, the deep brown earth, the glow. She says it's best
to see him as simply a human in this country that shed
long ago the pernicious sting of race, she says, and I
call her a tenderhearted dreamer, a sweet liar, I say,
a white-lie teller who would rather tell this bland lie
before admitting that walking down King Street
the morning after the votes were counted, she was
scared, but proud, so giddy with the wild beat
of her heart, knowing that her country paused
for an instant and did something grand, made a black
man president, such a miracle, such beautiful magic.

4 Punch-line

I have asked this of them year after year, a punch-line
waiting to happen with clockwork consistency—
raise your hand if you can remember a time
you believed that even you could take the presidency;
yes, you, blacks, poor, women, Latinos—was it when
you were four, five, six? And the believers all
would raise their hands. So the second question:
how many now think you have the wherewithal
to be the chief today—and up go four hands:
a dreamer, a liar, a clown, a madman. What went wrong?
How did you all mess up? Well, it's messed up now, it's gone
now that a black man has done it! Cancel class, time to hang
a poor joke; can't complain about oppression no more;
we've got to recalibrate who is the man now, that's for sure.

5 Palmetto

Of course, my home has kept its promise to itself;
the one that made Eartha Kitt, Chubby Checker, Althea Gibson,
James Brown all pack their bags, clean out their shelves,
never to look back, not once. They found their homeless songs,
like people who have forgotten where their navel-strings
were buried. We kept the promise that made those who stayed, learn
to fight with the genius of silence, the subterfuge of rings
of secret flames held close to the heart, kindling the slow burn
of resistance. But good news: despite the final state count,
we know that the upheaval of all things still brought grace
here where pine trees bleed and palmettos suck up the brunt
of blows, and so we can now hum the quiet solace
of victory with a surreptitious shuffle, a quick, quick-step
for you, Smoking Joe, Dizzy, James, and Jesse, slide, slide, now step.

6 Confession

Here is my confession, then, the one I keep inside me—
while the crowds gather in Washington, I will admit this:
it is enough that it happened, more than enough that we see
him standing there shattering all our good excuses: no, not bliss,
not some balm over the wounds that still hurt, but it is enough
to say that we saw it happen, the thing we thought wouldn't,
and we did it even if we did not want to do it. And that is tough,
yes, but it is good and grand and beautiful and new. And,
more, it is enough, no matter what comes next, that a man
who knows the blues, knows the stop-time of be-bop,
who's asked from inside out the meaning of blood and skin,
is, let's just say it, standing there, yes, standing at the top
of the world—it is enough for tomorrow; and yes he is tough
and yes he is smart, but mostly it is sweet and more than enough.

Jazz Life '75,
poster by
Gunther
Kieser, 1975

7

On Having a Cool President
He will not be the buffoon and clown; he's too cool for that.
His cool is the art of ease, the way we drain out tension;
the way we make hard seem easy, seem like it ought.
Cool is not seeing the burn in the fluid grace of execution.
Cool is knowing how to lean back and let it come,
but always ready for it to come. He will be no minstrel show
fool, but a man who shows, in the midst of chaos, unruffled calm.
Like, what-does-he-know-that-we-don't-know?
Like, I-can-be-brighter-than-you-and-still-be-down, cool.
Like some presidential cool; a cool that maybe hasn't been seen
in the White House before. You see, he is a nobody's fool,
kind of cool, the one that makes a gangsta lean look so clean,
kind of cool. That's what we have now, and to be honest,
you can call this cool what you want, me, I call it blessed.

8

Lincoln, January 1st, 1863
I think now of that other Illinois man, pacing the creaking boards
of the musty mansion, cradling a nation's future in his head,
the concussion of guns continuing, the bloody hordes
of rebels like ghouls in his dreams; he, too, avoids the bed;
tomorrow the hundred days will be over, a million
souls will be free, a million pieces of property pilfered
from citizens, a million laborers worth their weight in bullion
promised a new day across the border, a million scared
owners, a million calamities, all with the flow of ink
from his pen. This is the path of the pragmatist who would
be savior, the genius act of simple war, the act to sink
an enemy, and yet hallelujahs will break out like loud
ululations of freedom. Uneasy lies the head…, he knows—
this is how our leaders are born, how we find our heroes.

Toi
Derricotte

My first serious writing began when I was 2. I'd wait by the door for my aunt to come home with colored papers and pencils from the printing press where she worked. I'd draw for hours, believing that everything I drew was real. My parents worked so hard to make our lives comfortable. I thought I had discovered a way to make them happy, to give them the things that they longed for.

The idea that writing has the power to change lives, especially to transform pain, is deeply embedded in my psyche. It has driven my desire to write, and to teach. I often tell students that writing even one poem changes your life. I believe that. As I grow older, I realize that there are some sorrows we carry for generations—the wound of slavery, for example. Black poets must have great ambition. Great art has the power, not only to transform the present, but to transform the past, changing our ancestors' oppression into triumph.

Catholic rituals were my initiation into form and sacredness. I loved the sounds of the Latin prayers and the sense of longing they expressed: "As the hart panteth after the fountains of water, so my soul panteth after you, oh my God." I was 14 when I heard Billie Holiday sing "Deep Song." I knew for the first time I wasn't alone, that there were other human beings out there who spoke my language.

I'd always been terrified of the anger that had wreaked such damage in our family, but when I was in my late 20s and read Sylvia Plath's "Daddy," I saw that anger could create something terrifyingly beautiful. Poetry revealed a safe form, a way to walk the fine line between expressing dangerous feelings and holding them in.

I believe that cofounding the Cave Canem Foundation with Cornelius Eady is the most important contribution I have made to a community of writers. The number of Black poets writing, publishing, and winning prizes has grown dramatically since CC began in 1996. I don't mean to say that this change wouldn't have occurred without CC. In communities like the influential Dark Room Collective, such conferences as Furious Flower, and in poetry and writing groups all around the country, a burgeoning expression of diversity and richness in American poetry had already begun. Now it cannot be stopped.

Toi Derricotte's most recent poetry book is The Undertaker's Daughter. *She has published five poetry collections, and a literary memoir,* The Black Notebooks, *winner of the Anisfield-Wolf Award. Her honors include the 2012 Paterson Poetry Prize for Sustained Literary Achievement, the 2012 PEN/Voelcker Award for Poetry, and fellowships from the National Endowment for the Arts, The Rockefeller Foundation, and the Guggenheim Foundation. Her poems have appeared in* The New Yorker, American Poetry Review, *and the* Paris Review. *With Cornelius Eady, she cofounded Cave Canem in 1996. She is a Chancellor of the Academy of American Poets.*

A Note on My Son's Face

I
Tonight, I look, thunderstruck
at the gold head of my grandchild.
Almost asleep, he buries his feet
between my thighs;
his little straw eyes
close in the near dark.
I smell the warmth of his raw
slightly foul breath, the new death
waiting to rot inside him.
Our breaths equalize our heartbeats;
every muscle of the chest uncoils,
the arm bones loosen in the nest
of nerves. I think of the peace
of walking through the house,
pointing to the name of this, the name of that,
an educator of a new man.

Mother. Grandmother. Wise
Snake-woman who will show the way;
Spider-woman whose black tentacles
hold him precious. Or will tear off his head,
her teeth over the little husband,
the small fist clotted in trust at her breast.

This morning, looking at the face of his father,
I remembered how, an infant, his face was too dark,
nose too broad, mouth too wide.
I did not look in that mirror
and see the face that could save me
from my own darkness.
Did he, looking in my eye, see
what I turned from:
my own dark grandmother
bending over gladioli in the field,
her shaking black hand defenseless
at the shining cock of flower?

I wanted that face to die,
to be reborn in the face of a white child.

I wanted the soul to stay the same,
for I loved to death,
to damnation and God-death,
the soul that broke out of me.
I crowed: My Son! My Beautiful!
But when I peeked in the basket,
I saw the face of a black man.

Did I bend over his nose
and straighten it with my fingers
like a vine growing the wrong way?
Did he feel my hand in malice?

Generations we prayed and fucked
for this light child,
the shining god of the second coming;
we bow down in shame
and carry the children of the past
in our wallets, begging forgiveness.

II A picture in a book,
a lynching.
The bland faces of men who watch
a Christ go up in flames, smiling,
as if he were a hooked
fish, a felled antelope, some
wild thing tied to boards and burned.
His charring body
gives off light—a halo
burns out of him.
His face scorched featureless;
the hair matted to the scalp
like feathers.
One man stands with his hand on his hip,
another with his arm
slung over the shoulder of a friend,
as if this moment were large enough
to hold affection.

III How can we wake
from a dream
we are born into,
that shines around us,
the terrible bright air?

Having awakened,
having seen our own bloody hands,
how can we ask forgiveness,
bring before our children the real
monster of their nightmares?

The worst is true.
Everything you did not want to know.

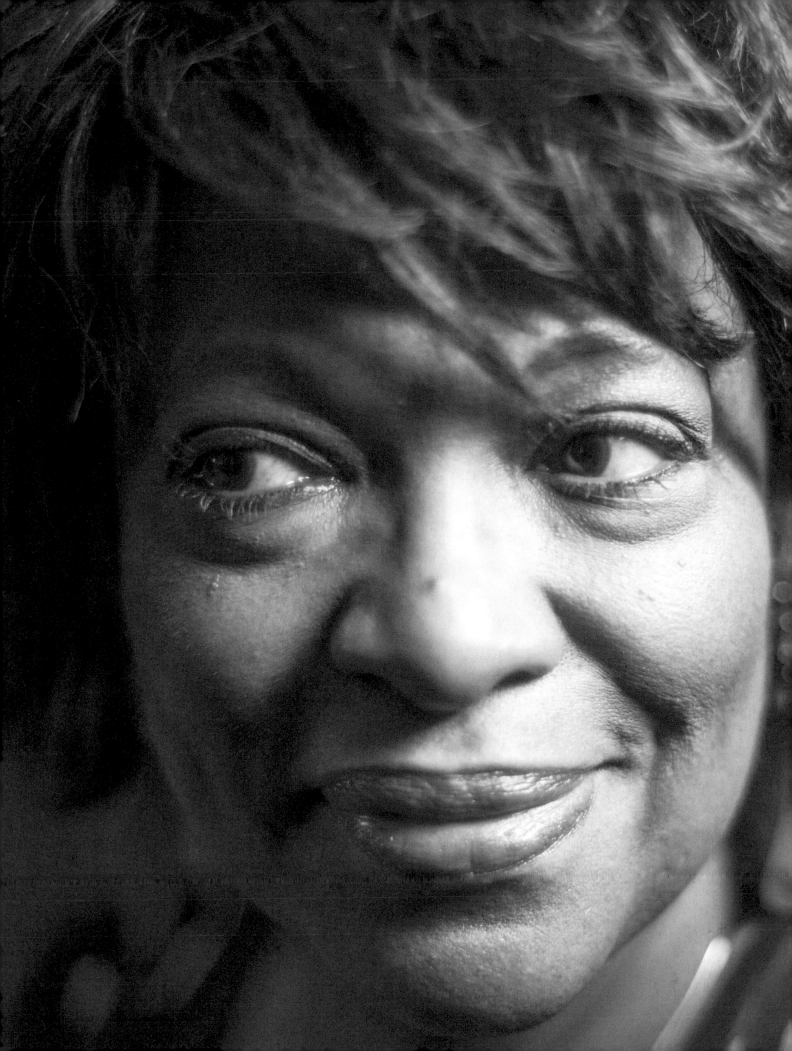

Rita Dove

I grew up in a household of books. That, I think, made all the difference. My father was a research chemist, my mother a housewife, but she had read and memorized Shakespeare in that old school tradition and every so often would quote something appropriate. From an early age, I felt comfortable picking up any book to see what new worlds might await me. My parents figured that if I could grasp something, I was old enough to read it.

When I was a kid I had no motivation to become a "serious" or professional writer because I had never met one; authors were just names frozen on book covers. I didn't think of writing as an occupation, something that one did to earn a living. That changed when I was sixteen; the very first day of eleventh grade school my English teacher walked into class and dissected the first paragraph of Thomas Hardy's *Return of the Native,* how its syntactical cadences matched the mood of the heath and contributed to the descriptive power. Later that semester she arranged for a few of us to attend a book signing by John Ciardi. So I met and talked to a living author; I could read his name on a book as he autographed it, chatting—a normal person. It was revelatory: Writers were real people, after all; this was something possible to achieve.

Still, I hadn't admitted to myself that I wanted to be a poet. There seemed to be no visible means of income for such occupation, so I started college expecting to become "a credit to my race" as a doctor or lawyer or teacher. I knew nothing about MFA programs.

Then, a few weeks into the semester, my advanced composition teacher became ill and was replaced by the fiction writing professor, who strode into the classroom in an electric blue Italian suit exclaiming, "We're going to tell stories, and you'll learn how to construct those stories. When we're done, you'll know everything you need to know about composition." In a way, I was hijacked into the creative writing program! Soon I realized that all I wanted to do was to write.

When I was a junior in college, I finally confessed to my mother that I hoped to become a poet, and she said, "You better tell your father yourself." So I did. To his credit, he simply replied, "I've never understood poetry. Don't be upset if I don't read it." Fair enough, I thought; permission to go forward!

Rita Dove is a former U.S. Poet Laureate and recipient of the 1987 Pulitzer Prize in poetry for her book Thomas and Beulah. *Her most recent poetry collections are* Sonata Mulattica *(2009) and* American Smooth *(2004), and she edited* The Penguin Anthology of Twentieth-Century American Poetry *(2011). Her honors include the 1996 National Humanities Medal and the 2011 National Medal of Arts. She is Commonwealth Professor of English at the University of Virginia.*

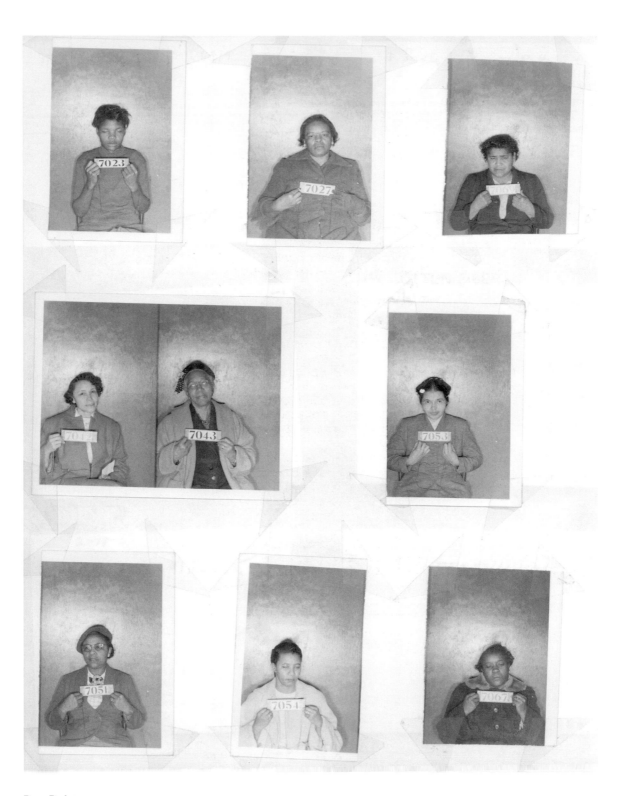

Rosa Parks
arrest photo,
Montgomery
County
Archives,
1956

The Enactment

Can't use no teenager, especially
No poor black trash,
No matter what her parents do
To keep up a living. Can't use
Anyone without sense enough
To bite their tongue.

It's gotta be a woman,
Someone of standing:
Preferably shy, preferably married.
And she's got to know
When the moment's right.
Stay polite, though her shoulder's
Aching, bus driver
The same one threw her off
Twelve years before.

Then all she's got to do is
Sit there, quiet, till
The next moment finds her—and only then
Can she open her mouth to ask
"Why do you push us around?"
and his answer: "I don't know but
the law is the law and you
are under arrest."
She must sit there, and not smile
As they enter to carry her off;
She must know who to call
Who will know whom else to call
To bail her out...and only then

Can she stand up and exhale,
Can she walk out the cell
And down the jail steps
Into flashbulbs and
Her employer's white
Arms—and go home,
And sit down in the seat
We have prepared for her.

I can't remember a time when I didn't think of myself as a poet. I remember making my own poetry-riddled greeting cards for my family when I was first learning to move a pencil across the page to form the letters I desired. I loved language so much I created a dictionary of words I thought English lacked. I loved music, and I loved the way poetry brought music, inventive language, and emotive expression under one tent.

My parents and grandparents also believed in the power of poetry. Thanks to them, I'd memorized many poems by the time I was 7, and I had books signed by Gwendolyn Brooks and Nikki Giovanni by age 16. I spent the first 15 years of my life 20 miles from Disneyland, and my high school years in the home of the Iowa Writers' Workshop and the International Writers' Workshop. I understood the gears and cogs and breakdowns, the boring bits that went into creating the magic I loved. I'm not sure I ever believed that being a poet would be glamorous, or even particularly thrilling, but I always understood that poetry was something people—real people, living people—did.

Crossing the Mississippi River, I would think of Langston Hughes. Visiting Springfield, Illinois, I'd think of Vachel Lindsay. When I spent summers in Chicago with my grandparents, I'd think of Sandburg and Brooks, and I'd find copies of Dunbar in the room where I stayed. I'd also find my mother's college text-books—Plath and Frost and cummings. (Mother's first English professor, Robert Dana, the man she credits with introducing her to contemporary poetry, became a mentor of mine as well.) Once, while spending a term at Oxford during my junior year of college, I finished a poem by Yeats, set down my book, then heard the same bells he'd just written of, at the same time to which he'd referred. I was delighted, but not surprised, because I'd long since understood that poetry is made by real people in a real world.

When I write, I intend to engage with a real world. I intend to engage the real people who live in it. Poetry matters because poets make it matter. We speak to the world around us today and, if we choose our words wisely, we will speak to tomorrow as well.

Camille T. Dungy is the author of three collections of poetry: Smith Blue, Suck on the Marrow, *and* What to Eat, What to Drink, What to Leave for Poison. *She edited* Black Nature: Four Centuries of African American Nature Poetry, *co-edited the* From the Fishouse *poetry anthology, and served as assistant editor of* Gathering Ground: A Reader Celebrating Cave Canem's First Decade. *Dungy's honors include an American Book Award, two Northern California Book Awards, a California Book Award silver medal, a fellowship from the NEA, and two NAACP Image Award nominations. Dungy is currently a Professor in the English Department at Colorado State University.*

POETRY MATTERS.

POETRY,

LIKE ALL ART,

GIVES SHAPE AND TEXTURE

AND DEPTH OF MEANING

TO OUR LIVES.

BARACK OBAMA

Conspiracy

to breathe together

Last week, a woman smiled at my daughter and I wondered
if she might have been the sort of girl my mother says spat on my aunt
when they were children in Virginia all those acts and laws ago.

Half the time I can't tell my experiences apart from the ghosts'.

A shirt my mother gave me settles into my chest.

I should say *onto my chest,* but I am self conscious—
the way the men watch me while I move toward them
makes my heart trip and slide and threaten to bruise
so that, inside my chest, I feel the pressure of her body,
her mother's breasts, her mother's mother's big, loving bounty.

I wear my daughter the way women other places are taught
to wear their young. Sometimes, when people smile,
I wonder if they think I am being quaintly primitive.

The cloth I wrap her in is brightly patterned, African,
and the baby's hair manes her alert head in such a way
she has often been compared to an animal.

There is a stroller in the garage, but I don't want to be taken
as my own child's nanny. (Half the time I know my fears are mine alone.)

At my shower, a Cameroonian woman helped me practice
putting a toy baby on my back. I stood in the middle of a circle
of women, stooped over and fumbling with the cloth. Curious George
was the only doll on hand, so the white women looked away
afraid I would hurt my baby while the black women looked away
and thought about not thinking about monkeys.

There is so much time in the world. How many ways can it be divided?

I walk every day with my daughter and wonder
what is happening in other people's minds. Half the time
I am filled with terror. Half the time I am full of myself.

The baby is sleeping on my back again. When I stand still,
I can feel her breathing. But when I start to move, I lose her
in the rhythms of my tread.

Cornelius Eady

I was born and raised in Rochester, New York, a destination for many African Americans during the early 20th-century migration. Rochester once had a reputation as a radical frontier town; Susan B. Anthony and Frederick Douglass had lived there, and by the time I was born in 1954 it had become a provincial and conservative place, good for raising kids. I grew up in a tight-knit African-American community on a dead-end street, in a neighborhood once populated by Italians.

I countered my restlessness with books, entrenching myself at the Rundell Public Library, reading everything I could get my hands on, including the works of poets like William Carlos Williams, Amiri Baraka, Pablo Neruda, and Allen Ginsberg. We were too poor to own a record player or albums, so I also spent hours at the library listening to records, sampling everything the library had. I loved what I heard there, as well as the music I heard in my parents' voices at home. I encountered the cadences they'd brought north with them from the South. They spoke a language rich in metaphor. I know that combined exposure to my parents' voices and a diverse catalog of music prepared me in some way to become a poet.

Writing poetry, however, was not what my father thought of as a practical way to make a living. My 7th-grade homeroom teacher Joanna Mason noticed my talent for rhyme and lyrical expression; one of my first efforts was a poem about the assassination of Martin Luther King, Jr. Afterward, people were coming up to me, telling me how they had been thinking exactly what I'd articulated for them in the poem. I realized then that poetry had larger implications.

At my teacher's encouragement, I transferred to Rochester Educational Alternative for my junior and senior years—a free school modeled after the Summerhill method. It was the hippest place in Rochester and I spent almost all my time there, engaged in "marathon writing sessions." After high school, I stayed in Rochester to attend Empire State University, and majored in English with a concentration in creative writing. I began searching for collections of poems in which I might see myself reflected, works by Black poets that might provide a kind of validation. Among others, I ran across a collection of poems by Yusef Komunyakaa. I was thrilled because at that moment, I found myself in books. I then embarked on the creation of my own body of work.

Cornelius Eady's body of work includes eight books of poetry, including Hardheaded Weather: New and Selected Poems *(2008);* Victims of the Latest Dance Craze, *which won the Lamont Prize from the Academy of American Poets; and* Brutal Imagination, *a finalist for the National Book Award. In 1996 he cofounded, with writer Toi Derricotte, Cave Canem Foundation, today a thriving national organization committed to cultivating the artistic and professional growth of African American poets.*

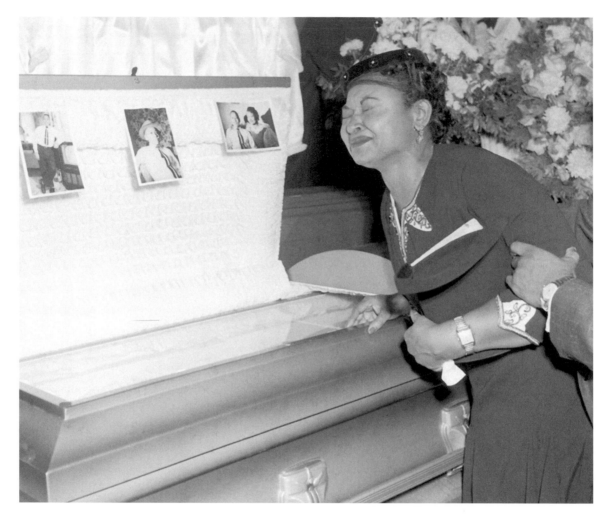

Mamie
Till-Mobley
at the funeral
of her son
Emmett Till,
AP Photo,
1955

Emmett Till's Glass-Top Casket

By the time they cracked me open again, topside,
abandoned in a toolshed, I had become another kind of nest.
Not many people connect possums with Chicago,

 but this is where the city ends, after all, and I float
still, after the footfalls fade and the roots bloom around us.
The fact was, everything that
worked for my young man

 worked for my new tenants. The fact was, he had
been gone for years. They lifted him from my embrace, and I
was empty, ready. That's how the possums found me, friend,

 dry-docked, a tattered mercy hull. Once I held a boy
who didn't look like a boy. When they finally remembered,
they peeked through my clear top. Then their wild surprise.

Kelly Norman **Ellis**

I believe the Southern storytellers of my girlhood made me a poet. My mother and her five sisters were and are amazing storytellers. Their attention to the details of stories was impressive. They would describe a place so vividly that I'd find myself replaying their stories over and over in my head. My grandmother Olivia wrote and was always engaged in a world of words. She passed a love of written language to me through the English Romantic poets. My two sets of grandparents and the mixture of vernacular and standard English they used created a musical sparring in my head. "I'll be there directly" and "Lord willing and the creek don't rise" were spoken by women and men who were highly degreed intellectuals. I learned that communication was about nuance and that choosing the right word or phrase was crucial.

My stepfather and his brothers shaped the music I heard. Like many Black Southern girls, I heard blues, jazz, funk, and pop standards. Music was about listening and breath, transition and tradition.

As a graduate student at the University of Kentucky in the 1990s, I discovered a community of Black poets who wanted to write. My teacher was Nikky Finney.

After leaving poems in her campus mailbox, I waited. The marked-up poems found their way back to my mailbox, and I greedily read the comments. I watched her book *Rice* be born. This book and her hands-on influence would teach me what a poet's life means. Along with Frank X Walker, Mitchell L.H. Douglas and others, I started down the road of a poet. We became the Affrilachian Poets. We workshopped our poems every Monday night without fail. I am convinced I would not be a poet without these people.

Recently I flipped through my copy of Lucille Clifton's book *Good Woman*. I read it repeatedly in graduate school. I even wrote poems in the margins of the book. Lucille Clifton taught me to be intimate with my poems, to disclose and confide without wallowing. She taught me that simple language can convey great complexity.

My poetics are rooted in Southern Black life. The music, the food, the language, the people, and the history are in my skin and in my poems. I can't help it.

Kelly Norman Ellis is chairperson of the Department of English, Foreign Languages and Literatures at Chicago State University. She is the author of Tougaloo Blues *(Third World Press) and* Offerings of Desire *(Willow Books), and co-editor of* Spaces Between Us: Poetry, Prose and Art on AIDS/HIV *(Third World Press). Her work has appeared in* Crab Orchard Review, Sou'Wester, PMS *(Poem, Memoir, Story),* Tidal Basin Review, *and* Calyx and The Ringing Ear. *In 2010,* Essence Magazine *voted her one of its 40 favorite poets. She is a Cave Canem Poetry Fellow and founding member of the Affrilachian Poets.*

Superhero

Lasyrenn's hair like
a rope
my locks are the new golden lasso,
I am Oya rocking hurricanes.
I am the protector of your dead
my mother is Marie Laveau
my daddy Stagolee
I am the earth shaker
protector of women
do u know me?
I'm your mother
say my name
virago
bitch
shrew
I am the squatting
goddess
Supergirl
not a white girl in tights but
the real one-breasted amazon
riding a black unicorn
protector of all the scribbling women
in attics
the one who comes when you call
me
like Eartha's Catwoman
flirt, tease, you want me
I don't have time
I'm into ruining shit
subverter,
transformer,
liberator of
desire.
defender of drag queens, of the butch and the femme

I will come when you whisper
in the dark
when you cry
when you scream like your mother did
I will bring you satisfaction
on a platter
I live in the Chi
no batmobile
I ride the City of New Orleans
like a bullet between my legs
I am protector of
cornbread
and 28 days of the moon
of bruised
plum women
the lynched
the raped.
on my cape is an S
I am the blood
you see when you peel
back skin, the burst of life
in the back of the throat
the forbidden fruit.
my uncle was Shango
so I am protector
of righteous men.
turn down your volume
listen,
I am protector of Black Presidents
of translucent truth.
steel toe boots, gold tooth
locks hot to the touch
you know me
I am
Sapphire.

Thomas Sayers Ellis

Thomas Sayers **Ellis**

lthough I liked to read as a child, my first passion was drawing. My father would bring me blank paper and notebooks to copy the likeness of people and things from our apartment and community in Washington, D.C. I was also surrounded by the oral tradition and by the attempts of my great-grandmother, the Reverend Ida Ellis, to keep the sights and sounds of the Black Baptist Church all around me.

My great-grandmother handed me my first tambourine, my first lesson in rhythm, at a time when I really wanted to be a football player, specifically a great poetic runner like Gale Sayers. Against Bethesda I fumbled three times; after that I became a swimmer, backstroke and freestyle, but hadn't yet mastered the schema of breathing and stroke. My father, a boxer, security guard, and bass player, enrolled me and my younger brother in the Cobra Do Jang school of karate. The visual literacy of drawing, the physical-lyric behavior of running, the percussive meter of the tambourine, the discipline of Tae Kwon Do, all of my unrelated interests remixed themselves into one poetic temperament and the early seeds of genuine Negro heroism.

I enrolled in Paul Laurence Dunbar High School at the height of the popularity of Parliament-Funkadelic, and before I knew it I was a member of the Creative Writing Club, editor of the News Reel, our high school newspaper, and my drawings turned into words, articles, and poems. I was fascinated with what I thought was American history, and many of my early poems were extensions of school assignments. None of those poems were about me, or anyone that I knew. It wasn't until Michael Olshausen, a substitute teacher, read my poems in our school's creative-writing journal that anyone ever commented on my writing. Olshausen gave me a small book of poems by T.S. Eliot and turned me onto the work of Robert Hayden. At that point I realized that life and art were connected.

My reading and love of cinema led me to Cambridge, Massachusetts, where I enrolled in classes at Harvard University, worked as a projectionist at the Harvard Film Archive (where I was a teaching assistant for Spike Lee and studied with Seamus Heaney) as well as a clerk at the Grolier Poetry Bookshop, and cofounded the Dark Room Reading Series and the Dark Room Collective, whose roster grew to include poets Tisa Bryant, John Keene, Major Jackson, Carl Phillips, Tracy K. Smith, Sharan Strange, Natasha Trethewey, and Kevin Young. *The Maverick Room* (Graywolf, 2005), my first collection of poems, was written during this period and while attending graduate school at Brown University.

Thomas Sayers Ellis earned an MFA in 1995, was awarded a Whiting Writers Award in 2005, a Guggenheim Fellowship in 2015, and cofounded Heroes Are Gang Leaders in 2014. His collection of poems Skin, Inc. (Graywolf, 2010) contains both photographs and poems. His influences are many and in his words he is always interested in destroying the false boundaries in art, life, and performance.

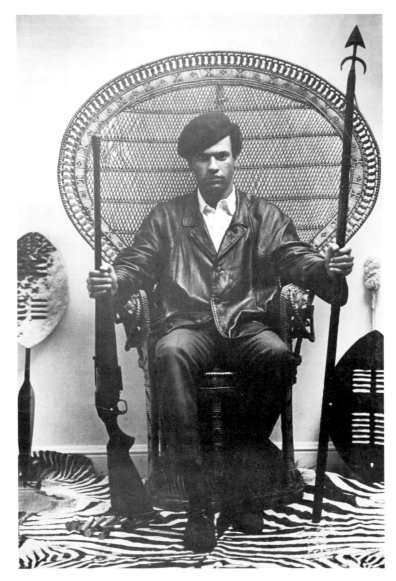

Huey Newton,
Black Panther
Party poster,
circa 1967

The Identity Repairman

AFRICAN

I am rooted.
Ask the land.
I am lyric.
Ask the sea.

SLAVE

America is where
I became an animal.
America is where
I became a nigger.

NEGRO

Trapped here
in Segregation.
Trapped here
in Integration.

COLORED

I am weary of working
to prove myself equal.
I will use education
to make my children superior.

BLACK

My heart is a fist.
I fix Blackness.
My fist is a heart.
I beat Whiteness.

AFRICAN AMERICAN

Before I was born,
I absorbed struggle.
Just looking
at history hurts.

Nikky Finney

When I was a girl, words were my sanctuary and my water pistol. I wanted to fight back, but I never wanted to hurt anyone. I wanted to push back against the popular act of following the crowd, of lacking empathy for others, of seeking power, cloning greed, picking on outliers, and perpetuating cowardice. I didn't understand in high school when my classmates camouflaged themselves and went out into the woods to shoot and kill something as beautiful as a doe. I hated guns and I still do. I wanted to aim at something that I didn't have to kill. I wanted to build up something that might make someone reconsider something they thought they felt absolutely sure about. I wanted to use my hands to wrestle something into the world and not out of the world. I loved the feel and touch of paper. It was a sacred indescribable thing. I believed that words written down on that sacred thing had the power to wrestle new worlds alive. I believed that the right string of the right words pulled taut and just so in the right way could keep you safe and away from the desire to kill anything.

My poetics consist of Black holes. Black hips. Black hands. Black rice. Black love. Black noses. Black alphabets. Black water. Black wine. Black cast iron. Black tenderness. Black pencils. Black lips. Black notes. Black dance moves. Black ladybugs. Black air. Black cows. Black clavicles. Black feet. Black farmers. Black words. Black popcorn. Black sweet potatoes. Black motion. Black light. Black arms, folded and unfolded.

I treasure the hundreds of notes and cards I have received and kept from people of all walks of life, who happened into one of my readings and later felt the need to find me, my address, and confide by mail: "Your poetry reading was my first poetry reading. I had never heard of you before. I had no idea a poem could do that. I had no idea a poem could do that to me."

What is in the news keeps me writing poetry. Just in today, someone has invented a new computer device that we will all soon be wearing on our heads 24/7, but in 25 years there won't be one polar bear left on the planet.

Nikky Finney was born in South Carolina, within listening distance of the sea. A child of activists, she came of age during the Civil Rights and Black Arts movements. At Talladega College, nurtured by Hale Woodruff's Amistad murals, Finney has authored four books of poetry: Head Off & Split *(2011);* The World Is Round *(2003);* Rice *(1995); and* On Wings Made of Gauze *(1985). The John H. Bennett, Jr. Chair in Southern Letters and Literature at the University of South Carolina, Finney also authored* Heartwood *(1997), edited* The Ringing Ear: Black Poets Lean South *(2007), and cofounded the Affrilachian Poets. Finney's fourth book of poetry,* Head Off & Split *was awarded the 2011 National Book Award for poetry.*

Left

Eenee Menee Mainee Mo!
—Rudyard Kipling, "A Counting-Out Song,"
in *Land and Sea Tales for Scouts and Guides*, 1923

The woman with cheerleading legs
has been left for dead. She hot paces a roof,
four days, three nights, her leaping fingers,
helium arms rise & fall, pulling at the week-
old baby in the bassinet, pointing to the eighty-
two-year-old grandmother, fanning & raspy
in the New Orleans Saints folding chair.

Eenee Menee Mainee Mo!

Three times a day the helicopter flies
by in a low crawl. The grandmother insists on
not being helpless, so she waves a white hand-
kerchief that she puts on and takes off her head
toward the cameraman and the pilot who
remembers well the art of his mirrored-eyed
posture in his low-flying helicopter: Bong Son,
Dong Ha, Pleiku, Chu Lai. He makes a slow
Vietcong dip & dive, a move known in Rescue
as the Observation Pass.

The roof is surrounded by broken-levee
water. The people are dark but not broken. Starv-
ing, abandoned, dehydrated, brown & cumulous,
but not broken. The four-hundred-year-old
anniversary of observation begins, again—

Eenee Menee Mainee Mo!
Catch a—

The woman with pom-pom legs waves
her uneven homemade sign:

Pleas Help &hbsp; Pleas

and even if the *e* has been left off the *Pleas e*

do you know simply
by looking at her
that it has been left off
because she can't spell
(and therefore is not worth saving)
or was it because the water was rising so fast
there wasn't time?

Eenee Menee Mainee Mo!
Catch a— a—

The low-flying helicopter does not know
the answer. It catches all this on patriotic tape,
but does not land, and does not drop dictionary,
or ladder.

Regulations require an e be at the end
of any *Pleas e* before any national response
can be taken.

Therefore, it takes four days before
the national council of observers will consider
dropping one bottle of water, or one case
of dehydrated baby formula, on the roof
where the *e* has rolled off into the flood,

(but obviously not splashed
loud enough)

where four days later not the mother,
not the baby girl,
but the determined hanky waver,
whom they were both named for,
(and after) has now been covered up
with a green plastic window awning,
pushed over to the side
right where the missing e was last seen.

My mother said to pick
The very best one!

What else would you call it,
Mr. Every-Child-Left-Behind.

Anyone you know
ever left off or put on
an *e* by mistake?

Potato Po tato e

THE ROOF
IS SURROUNDED
BY BROKEN-LEVEE
WATER. THE PEOPLE
ARE DARK
BUT NOT
BROKEN. STARV-
ING, ABANDONED,
DEHYDRATED,
BROWN & CUMULOUS...

In the future observation helicopters
will leave the well-observed South and fly
in Kanye-West-Was-Finally-Right formation.
They will arrive over burning San Diego.

The fires there will be put out *so well*.
The people there will wait *in a civilized manner*.
And they will receive *foie gras* and *free massage*
for all their trouble, while their houses don't
flood, but instead burn *calmly* to the ground.

The grandmothers were right
about everything.

People who outlived bullwhips & Bull
Connor, historically afraid of water and routinely
fed to crocodiles, left in the sun on the sticky tar-
heat of roofs to roast like pigs, surrounded by
forty feet of churning water, in the summer
of 2005, while the richest country in the world
played the old observation game, studied
the situation: wondered by committee what to do;
counted, in private, by long historical division;
speculated whether or not some people are surely
born ready, accustomed to flood, famine, fear.

> *My mother said to pick*
> *The very best one*
> *And you are not it!*

After all, it was only po' New Orleans,
old bastard city of funny spellers. Nonswimmers
with squeeze-box accordion accents. Who would
be left alive to care?

C.S. Giscombe

I n high school, I discovered the writing of contemporary poets Langston Hughes and Lawrence Ferlinghetti. Both discoveries were accidental—Hughes was a library find, while word of Ferlinghetti's sexual poems trickled down in the cafeteria from older boys in an advanced English class in Catholic school, Dayton, Ohio, mid-1960s. There I also read, for the first time, Baldwin (guided by a priest, one of my teachers); and Coleridge, Shakespeare, and—important for me—a lot of the Child ballads. But before that, my parents, both 1940s graduates of segregated Southern schools, had shared favorite poets with me; my mother's were Shelley and Tennyson, and my father's were Blake and Shakespeare. My parents also suggested the possibilities of music: folk, blues (Lead Belly, the work made popular or at least public by the Weavers, songs collected by the Lomaxes, etc.), calypso, cowboy songs, and jazz (notably Duke Ellington, whose music I warmed to only many years later, but also the singing of Billie Holiday and Ella Fitzgerald). And among their records too were spoken-word discs—Moms Mabley, Redd Foxx and, especially Dick Gregory. Not to mention the talk itself—listened to, overheard, eavesdropped on—of my parents and their friends: Years later Sherley Anne Williams would write of children listening to the talk of adults, how in "the tales of men they told among/ themselves as we sat unnoted/at their feet we saw some image/of a past and future self."

All of these things, I bring with me. Poetry comes out of all that. Stories told and retold and gotten right, with certain words and phrases emphasized and pauses honored, Ellison's familiar definition work ("The blues is an impulse to keep the painful details and episodes of a brutal experience alive in one's aching consciousness, to finger its jagged grain, and to transcend it, not by the consolation of philosophy but by squeezing from it a near-tragic, near-comic lyricism."), the effaced narrator of "Ozymandias" who, having met and listened to "a traveler from an antique land," reports the traveler's quite compelling testimony in speech at once rollicking and measured. And then there is the suddenness of "Ella and her fellas"; the matter-of-fact nature of "Twa Corbies" and the multitude of versions of "Casey Jones," some of which—I've discovered quite recently—are marvelously obscene. "He's got a lean and hungry look to him," my father would say of certain politicians. I recall too Baldwin's assurance to his nephew: "You come from a long line of great poets, some of the greatest poets since Homer. One of them said, 'The very time I thought I was lost, my dungeon shook and my chains fell off.'"

C.S. Giscombe lives in Berkeley and teaches at the University of California. His recent and forthcoming books include Border Towns*,* Ohio Railroads*, and* Prairie Style*.*

Dayton, OH, '50s & '60s

Sat through stories
right through them as if they were told
& I sat through confluence & allegory
through metaphor
through old movies repeated on TV, through leaping blue light
all around the couch
through chance
(through unexpected moments, intimations of sex & music
(through bus trips downtown across the bridge
into downtown Dayton over
the Great Miami
through ceremony kept simple, in & back

By the '50s & '60s we'd been well-ensconced for years
all along the road from Cincinnati Gateway City
to the south, had pushed in downtown Germantown hill
in fact as far as the Miami to the east, Wolf Creek
to the north,
Dunbar's house on Summit overlooked Wolf Creek,
grandly misnamed Riverview Av across the bridge

I'd simply value the humidity
of land alongside water
the steep sides even the levees downtown
(though it's boundaries
(even then-sat through a repetition
of the natcheral confluences
the fact divided finally out of that
self w/self, self on the surface
of other
not mine, thanks

Out abroad of an evening in 1960-something, way
across Wolf Creek w/a white boy my age
he 2 of us-waiting for buses-reclined
on some lawn, at
some intersection: nothing happened
my bus came first
it was a warm clear night among the dark houses
this far up in
(myself this present in the set-up, the sequence
of description, not its demand

How I've wanted to see myself
at the moment of crossing into downtown
over the 3rd St bridge,
in traffic, a pistol
loaded & unhidden on the dashboard or passenger seat,
the radio blaring
—to beat the odds w/ nothing in my life
at loggerheads w/ no man or woman
to have no ritual, no quantity of value here
or over there
no gift at something or for anyone
but approaching as if from
close in
as if from far away, either one
visible

Or simply at large passionate along the drift of streets
through the chant
of things continuing
rhetorical drone of the real doing
for the long stare out of town
back south (or ahead/ at this?

To *Sam Stoloff*
In a dream years later we weren't Black/hadn't been Black
we were Jews in a made-for-TV movie called "Jews"
set near the end of WW2 liberation drawing near:
some of us busted out of camp ahead of the gas—
how many? what percentage?—escaping
over the hills surprisingly green for a war zone, hiding in them
above the lights of hostile countryside:
how far up can you creep, we wondered
how far up on the other?
Tenuous days in which the war was winding down
in which we had to stay between the Germans
to keep moving between them & the barbaric Soviets, "the
advancing & retreating armies":
we were nowhere
we were fluid, the moveable heart circling
we set out, then moved in circles
through the same scenes:
when we got to a big firebombed city w/ no name it was really
Dayton,
I recognized it....

Duriel E.
Harris

Poetry first captivated me through sound. The power of the performed word saturated the air with color and vitality, opening worlds and visions of worlds. I was 5 years old when my mother took me to hear Gwendolyn Brooks' children's reading at the Chicago Public Library downtown. I was 10 when Margaret Burroughs quieted our class with the intensity of "What Shall I Tell My Children Who Are Black" upon a visit to the DuSable Museum. All the while I was reading, writing, and illustrating books, and, during summers, performing poems and original plays with my friends.

At home our house was alternately hushed like a library or enlivened with sound. In waking hours and often far into the night, someone was reading or singing. There were Daddy's newspapers and books for all of us—novels, literary anthologies, biographies, and pedagogical studies—and music from Mahalia to Mozart to Motown.

Sundays especially, LPs from the library and my mother's collection would be playing on the living room hi-fi. Among my favorites were Margaret Walker's "For My People," Nikki Giovanni's "The Reason I Like Chocolate," and Micki Grant's soundtrack *Don't Bother Me, I Can't Cope,* with the insistent "They Keep Comin'" (echoing Sterling Brown's "Strong Men"). The tracks combined into a continuous groove that fortified me, forming the soundtrack for my developing consciousness.

But soon I found myself the protagonist of a narrative different from the one that soundtrack had prepared me for. Reactions to my pubescent girlhood and burgeoning womanhood complicated the triumphant beauty and intelligence of Black achievement with a sexualized hypervisibility that rendered me invisible—injury for which I had no remedy.

Study with Gloria Watkins (bell hooks) during my first year at Yale positioned me to reexamine that hypervisibility and to begin to reinvent myself. Subsequently, a newly founded women of color theatre ensemble endeavored to produce Ntozake Shange's *For Colored Girls.* Performing the choreopoem created a much-needed space of storytelling and transformation, facilitating the celebration of embodied Black female presence. Moreover, it offered form for traumatic experience that had eluded expression, means to understand my emerging consciousness, and inspiration to return to poetry.

Much later, under the tutelage of my dissertation advisor Sterling Plumpp, I began studying improvisation and Black music. Rediscovering Thompson's *Flash of the Spirit* and the fundamental funk aesthetic of Chicago's (Deep) House music, I named my poetics PoMoFunk. Now manifest as PoMoFoMo (Pour-More-For-More) it emphasizes, among other things, the etymology of funk in the Ba-Kongo blessing—*lu-fuki* (the sweat smell signifying the bearer's art).

Cofounder of the avant-garde Black Took Collective, Duriel E. Harris, Ph.D., is the author of two critically acclaimed poetry collections, Drag *(2003) and* Amnesiac: Poems *(2010), coauthor of the 2011 International Literary Film Festival jury selection* Speleology, *and author of the forthcoming sound/poetry compilation* Black Magic. *Her verse-based solo play* Thingification *made its New York debut at the Fresh Fruit Festival in 2013. Harris is associate professor of English at Illinois State University.*

Voice of America

Peckerwood Creek, Alabama (no blacks no jews no gays):
Billy Jack Gaither is dead forever *sissy*
("Blinded by Hatred" 20/20) The way he sees it, killer owns the story
cause he ain't dead
Nina's singin in me and ain't no sugar ain't gonna be no sugar

Mississippi Mississippi Mississippi
Mississippi Got Damn Mississippi
Nina's singin in me and ain't no sugar ain't gonna be none

Remember that
fictive shadow: gritty muddy blue lit: forest hutting
make it dark-dark darker than that and barbed
call that story song, hear that ravenous absence
no secret hunger built to last
Nina's singin and ain't no sugar

Black Gator felled by jungle fever
was no martyr was a misstep
in da dance da dee da daaa
doin it to death
pi_e in the pocket, in the pocket
blood in the pocket book play(s) dozens
cha ching!: dollar signs and since
Nina's singin in me ain't no sugar ain't gonna be no sugar

Ask Mississippi
this set's in the street milk crate in the road
sampled discord dat swingin pulp
obscenity in your living room in the measure
rest to mark *beat* time is an accessory
we cannot afford

Persistent ideology makes itself
known *we are American* and valued
and the church said ; universal truths rest
in the value *use and leisure* placed
on certain inalienable bodies:
Better to reign in Hell, that story

Whatcha want whatcha want two dimes and a nickel
Whatcha want want you, Walk on
Whatcha want whatcha want half a mind to get it
Whatcha want want you, Walk on

If there is one true word uttered here:
nigger—its monstruous possibilities—variations
and axioms: axes: n I g (g) (a) (h) (z)
no sugar

 [5 year old South Africa wards 3 oceans, trades 6 billion bones for submarines.
 Her men are taking their women by force. theirs [italics]
 And who would have thought 3 letters could keep
 still as sleep (each little death) so much blood in them.
 3 letters *praxis* : a free state's pass to pandemic affection.
 The orphan sea will avenge its mother's body.

 Where is Nelson Mandela
 Tear down the shantytown: he's home
 Bring back Nelson Mandela
 Tear down the shantytown: he's home] no sugar

no fallen back into old music, everything a woman
scorned, loose, chaste, plain, shapely
a looker, with a car, a hooker, a nun
tight-tight, ready to pop, born to be ____ed
sanctified, mammy, sapphire, hot
bitchy, tired, tested, tried, true
a digger, a dame, a queen, a skeeze
luck, a chicken, cold, a tease
muse hoochie, muse goddess, moody muse
mule
let go *ya oughta let it go*
woman singin ain't no sugar

Ask somebody
who owns it ain't dead
foot on the neck, that story
Sugar Ditch, Mississippi
rumored kin
Westside Hypewalk #____
Chicago, Illinois *Mississippi*

25 below too cold to ho
25 below too cold to ho
Never too cold to pimp

Money won't change you
In time, Sugar *In time*

Reginald Harris

Many people in my family and my neighborhood talked a lot and sometimes had multiple nicknames. I grew up seeing the world as filled with hyperbole, irony, metaphor, simile—and slightly "off center." How else to explain a universe where my father, Reginald Senior, was continually referred to as "Tim" or "Tiny Tim" because he had been small as a boy, even though he was now 6′ 3″? Growing up around such a kaleidoscope of words leads someone to either play with language or to seek help from a mental health professional when they get older—and here I am, guilty of both.

Spanish-language poets were my "gateway drugs" to poetry, and I go back to Lorca and Neruda regularly. I also remember loving the rhythm and bleak outlook of Eliot's "Prufrock" in high school, the powerful simplicity of Lucille Clifton, the elegance of Gwendolyn Brooks, and the majesty of Robert Hayden. These poets and Auden, Bishop, and the joyous anarchy of the 1950s "New York School"—particularly Frank O'Hara and his "I do this—I do that" poem—live inside me and continue to inspire, letting me know that I can do anything in my work.

I am, however, most deeply influenced by music—starting with the jazz and popular music of the '30s and '40s that the older relatives who raised me listened to, moving forward through an ocean-wide range of genres and styles. My work has to "flow" in some way, or, if it is disjunctive, its jaggedness has to serve a thematic and/or structural purpose. I hope to put people *into* a situation, have them feel what it is like to experience a particular event, in much the way a great piece of music immerses you in its world. For me, poetry bridges the gap between individuals by helping us to live inside the skin of others, and to recognize what we share with each other.

The words keep dancing inside my head, the sounds and voices keep coming, and so I keep writing. I have to let them out, to give voice to those who may not otherwise have a voice, to share sights and visions with others. There are moments when language still gives me a thrill, makes the hair on my arms stand up, takes my breath away. As long as I still feel that, I'll still be in love with poetry.

Poetry in The Branches Coordinator and Information Technology Director for Poets House in New York City, Reginald Harris won the 2012 Cave Canem /Northwestern University Press Poetry Prize for Autogeography. *A Pushcart Prize Nominee, recipient of Individual Artist Awards for both poetry and fiction from the Maryland State Arts Council, and Finalist for a Lambda Literary Award and the ForeWord Book of the Year for his first book* 10 Tongues: Poems, *Harris' work has appeared in numerous journals, anthologies, and other publications. He lives in Brooklyn, pretending to work on another manuscript.*

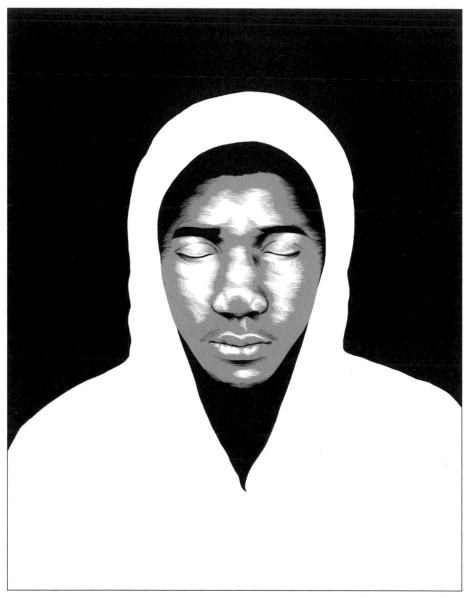

Hoodie,
original
art by
Chris
Koehler,
2014

New Rules of the Road

Make
 No sudden movements
 Like from your neighborhood
 To someplace you don't belong

Keep
Your hands visible at all times
 Above your head In these
 Brand new handcuffs

Speak
 Only when spoken to
 Or not at all You have the right to
 Silence

Have proper ID on you at
 All times
 There is no right
 To travel

Reply only to
 The questions asked
 You have nothing to say
 We want to hear

Give the officer
 Only the materials requested
 You have nothing to show us
 We want to see

Do not leave the vehicle
 Unless told to
 You have
 Nothing

Go quietly
 When arrested
 You are
 Nothing

Do not
 Resist
 You are a
 Thing
Do not
 Run
 You have
 No rights

Do not say you
 Do not fit The Profile

 This is America:
 You *are* the profile

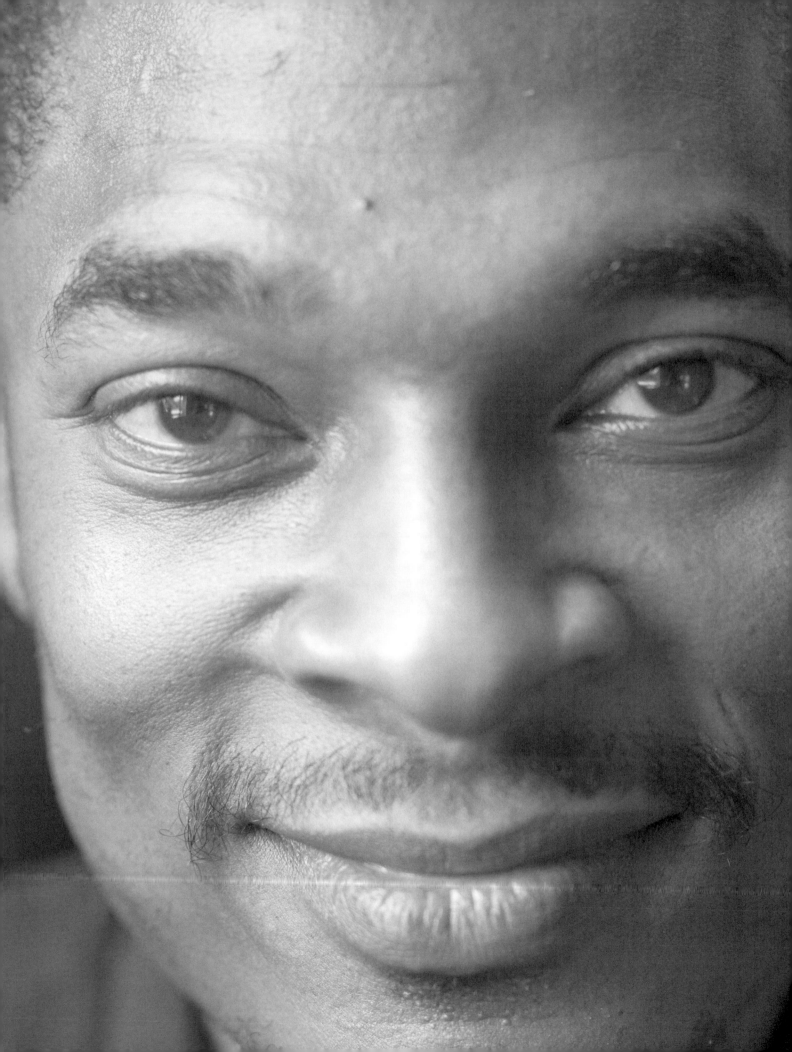

Terrance Hayes

The work of building poems is, like the work of building houses, always hard work, work that yields an almost inexplicable joy. In fact, this joy would be totally inexplicable if the results were not, like houses, such vital forms of shelter, rooms for rumination and company. When I am asked how I discovered poetry, my answer is invariably a question: How did you discover food? Can you remember a decision to eat? Or is it that you understood even before you understood how necessary food is to your life and obeyed that necessity, made eating a practice, a habit? That's how I came to poetry.

I know I was and remain first nourished by the words of others: *Huckleberry Finn, Song of Solomon, What's Going On,* "Good Country People," "A Dream Deferred." I had no sense of genre. I read novels, short stories, poems; I listened to song lyrics and conversations with the same indiscriminate appetite. Gradually, I wanted something like self-determination: I wanted to make for myself the bliss other writers stirred in me. I think it must be the same even now. I can never really explain the joy poetry gives me without talking first as a reader and student and advocate of other people's poems.

When I was a college student, Gwendolyn Brooks' poem "The Mother" made me weep where no painting ever had. Before that sudden, shocking moment of downpour, I'd figured I'd be a painter. Robert Hayden's "Those Winter Sundays" made me reconsider the silences my parents carried in from work. John Keats' "To Autumn" caused, to my befuddlement, an erotic blush. "To swell the gourd, and plump the hazel shells / With a sweet kernel; to set budding more, / And still more, later flowers for the bees..." There was no one to explain why poems emitted such heat, and I think now I'm glad there was no one. I remain in love with the mysteries of language, the multiple shadows a word can cast, the way sound and sense pulse along a current of syntax. My biological father told me, when I met him for the first time, that though I had not known him growing up, I was not a bastard. He told me I came from a long line of loving men and then leaned to kiss me on my 34-year-old forehead. He was half right. I was and remain a proud bastard born of countless poets and writers and teachers. I have made poetry my bastard home. I love this difficult, beautiful house and its food, its rooms and doorways, its inhabitants, seen and unseen.

Terrance Hayes is the author of Lighthead, *winner of the 2010 National Book Award. His other books are* Wind In a Box, Hip Logic, Muscular Music, *and* How To Be Drawn. *His honors include a Whiting Writers Award, a National Endowment for the Arts Fellowship, a Guggenheim Fellowship, and a 2014 MacArthur Fellowship.*

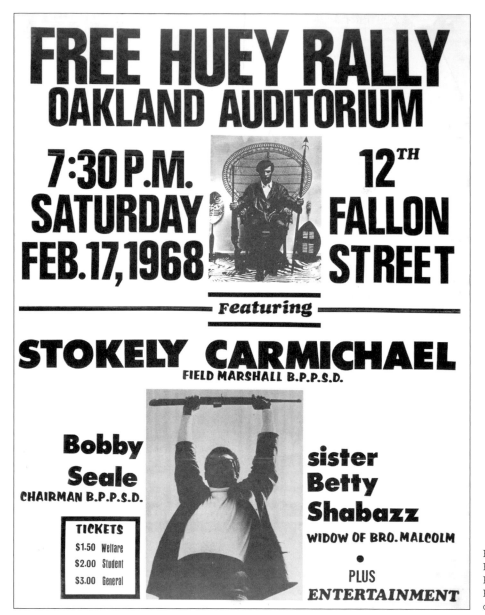

Free Huey Rally, Black Panther Party poster, circa 1968

Some Luminous Distress

(for Betty Shabazz)

Not even tomorrow morning can save us—
 Not even this great American space,
Palatial and white with stars can save me

 Or the burning house engines holler
Off to douse: curtains flaring at the windows
 Like hair, the black woman locked

In bright sleep—None of it.
 Yea, though I walk this stone
Unraveling valley, I shall fear no evil. Do I follow

 The siren, the men with red hats
And hoses—angels on their chariot,
 The yawn of smoke there—

Just over the hill; some luminous distress?
 Why not burn, star bright? I fear no evil,
Nor good will guide me. Only this night

 Which takes my eyes, these limbs
Shedding their secrets,
 Young scabs falling from wounds.

How else do I say it? The leaves
 Are falling. Three blocks from here.
The flame, and somewhere else, the white—

 Palmed child who set it. Do you see
How smoke & absence can blow
 The heart from its branch? Sunday's over,

It's Fall. Only softskin sinners
 And the butterbean moon; the siren's
Dirge just over the hill, the lit sky,

 The limbs black against it.
Where is my shepard and his rod?
 Yea, though I walk... Where ever

This night is headed, I'll follow,
 Where ever I'm going, I've been.

Angela
Jackson

I read my first poem in 1st grade. I loved the magical sounds of the poem, the delightful play of words. I remember bits of that poem still. "Once there was an elephant/ who tried to use the telephant./ Oh, no, I mean an elephone/ who tried to use the telephone." I was happy. I write poems for my own well-being, the well-being of Black people, all people, and the well-being of God's creation. I came from a family of readers. Our house was filled with books, from the Bible to issues of *Reader's Digest*. Anything was likely to fall into my hands. I write because I am a reader. My father brought music to the house, singing his homemade songs and listening to his collection of records. This love of African-American music from blues to R&B to gospel to jazz is in my poetry. I gather the memory of significant sounds.

From the 3rd grade on, I wrote. My first poem was about my mother. "My mother jumps for joy," I read to her. I continued to write through high school, publishing in our class anthology, *MySelf*. I remember a poem about a boy murdered in an alley. "All's well on Walnut Street?" the poem asked. In 8th grade our teacher showed us a film about a Negro woman poet, Gwendolyn Brooks. The possibility was there.

I truly became a poet in college when Hoyt Fuller came to Northwestern University, read my poetry, and invited me to OBAC, the Organization of Black American Culture Writers Workshop. At OBAC, in 1969, I began my life as a poet. OBAC offered raison d'etre, purpose and clarity, greater possibilities. This call to create poems that speak to and from and for the magnificent and maligned African-American people and experience has been my driving wheel.

My influences are as rich as the African Diaspora. I learned musicality from Billie Holiday and Aretha Franklin. I learned poetic devices and language gestures from Gwendolyn Brooks, Robert Hayden, and Langston Hughes. I benefited from the drylongso sensitivity of Carolyn Rodgers and the irony of Mari Evans. I learned by immersion in Black poetry and other poetry. I move out of the way of each poem and let the poem become on its own terms. A poem is a living being and will make its way. In the end, I help it to its final fruition with a sense of strictness and honesty. I write for myself and ourselves because we must be healed and filled with well-being. I write from the heart and head and spirit because in order to transform, these parts must be engaged fully.

Angela Jackson was awarded the Eighth Conrad Kent Rivers Memorial Award from Black World Magazine, *an American Book Award for poetry (1985) and for the novel* Where I Must Go *(2009), a Carl Sandburg Award, and a* Chicago Sun-Times/Friends of Literature *award for Best Poetry (1994) and the Shelley Memorial Award of the Poetry Society of America (2002).*

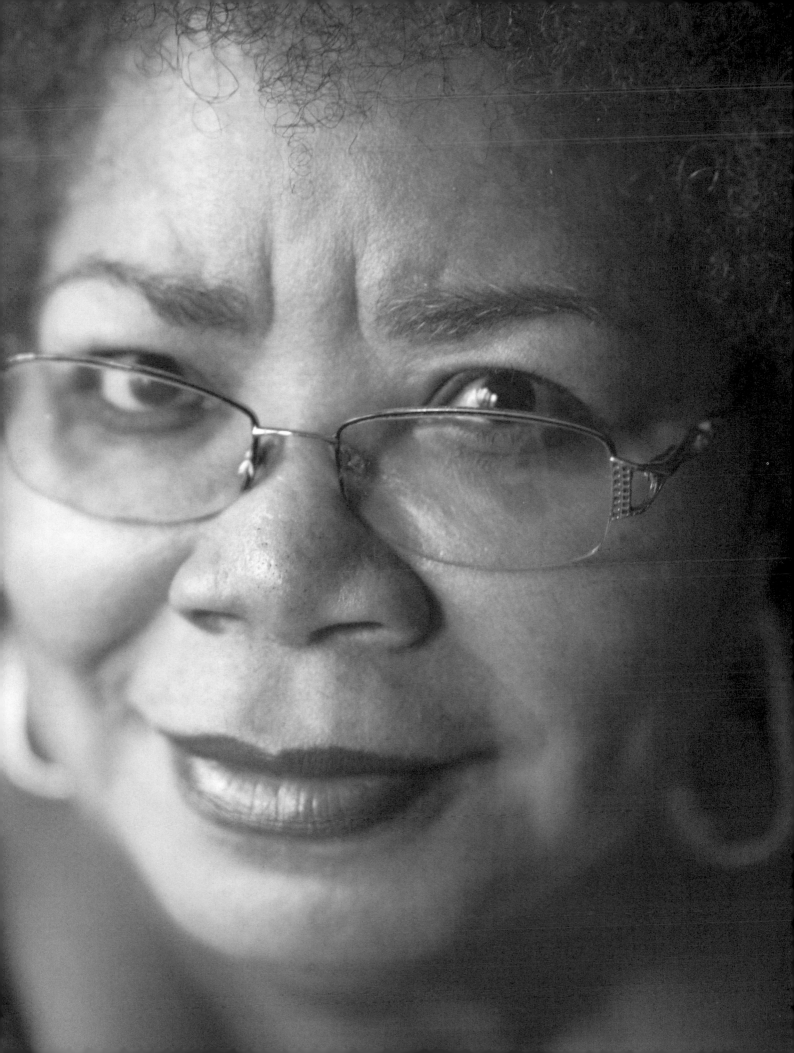

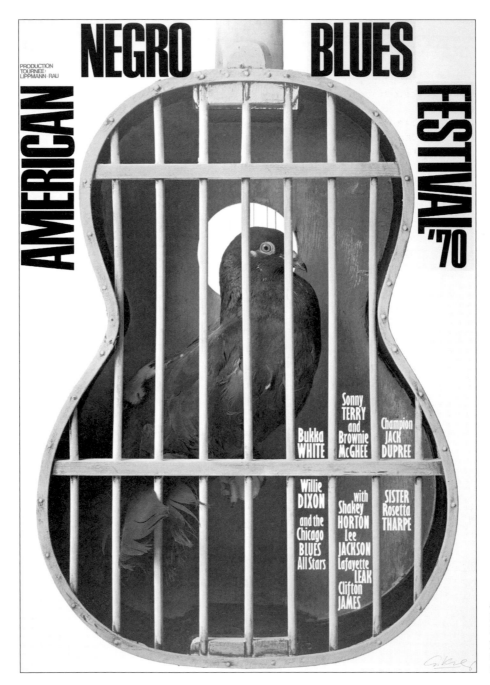

American Negro Blues Festival '70, poster by Gunther Kieser, 1970

Fannie (of Fannie Lou Hamer)

Fannie sang in jailhouse cells
Don't you know her songs
swung the bars
high in the window
back and forth between snot
hard tears and stars.

Fannie Hamer sang about climbing
Jacob's ladder
rung
by
rung
that cottony voice rose
above smoke
and robes and swamps, dust
roads, lynch ropes, and water
hoses, dogs, badges, and mud
weary beaten bones and bullets.

Miz Fannie sang about climbing
Jacob's ladder, wrestling
angels, climbing

swinging rung by rung, from crying
to shining
bringing one by one, from crying
to shining
as far as the heart can
see,
as far as the back can
carry.

Fannie sang in jailhouse cells.
Do you know her songs?

Have you ever seen a Queen Spider dance?
She seems to be kneeling but is not.
She is always getting up.

Have you ever seen a Queen Spider dance?
Some of them have wings.

Major
Jackson

1

Seems like poetry was always with me—how difficult it is to pinpoint exactly what convergences and confluences have shaped me into becoming a poet; more a series of vague memories that intensify to one reality. From my earliest years, I have held a deep love for language, the physical properties of words in the mouth, first heard in the home—Black Tennessean folk up north suddenly urban, signifying on conditions and each other, making sense and alluding to more than what was "officially" seen and heard like the Holy Spirit in the head. Words uttered and possessed, earthbound and heavenbound, too. Hard and soft skins. Church hats and ways of seeing.

2

Langston Hughes. Robert Frost. Selecteds and Collecteds. North Philadelphia. Grandparents' three-floor tenement with stacks of second-hand books crowding the 2nd-floor hallway. So many altars. Temple University. Sonia Sanchez. African-American Literature. Robert Hayden. Yusef Komunyakaa. Toni Morrison. Gwendolyn Brooks. Derek Walcott. Amiri/Leroi/Baraka/Jones. Introduction to Poetry. Garrett Hongo. Philip Levine. Advanced Poetry. Robert Lowell. *Black Scholar. Journal of Black Poetry. Negro Digest. Black Poets. Drama of Nommo.* Broad Street Line. Hoods. Russian hats and gold gazelles. Hip-hop. Ways of seeing. Dark Room Collecteds.

3

I relish the alterable space of a sentence along with words' inherent satellite meanings, shaped and hammered to rhythms in my head. Their force and propulsion feel like lifelines shared with friends. Many poets show the way and what we pray for is a passage into the living: song, prayer, coveted conversations.

4

I wish to make a sound that echoes in the end that says Major Jackson. No more. No less.

Major Jackson is the author of three collections of poetry: Holding Company *(W.W. Norton, 2010),* Hoops *(W.W. Norton, 2006), and* Leaving Saturn *(University of Georgia, 2002), which was awarded the Cave Canem Poetry Prize and was a finalist for the National Book Critics Circle Award in Poetry. He has published poems and essays in* AGNI, American Poetry Review, Callaloo, Harvard Divinity Bulletin, The New Yorker, The New York Times Book Review, Poetry, Tin House, *and other fine literary periodicals. His poetry has been included in* Best American Poetry *(2004, 2011, 2013) and* Best of the Best American Poetry. *He is the editor of the Library of America's* Countee Cullen: Collected Poems. *Major Jackson is a recipient of a Guggenheim Fellowship, a Pushcart Prize, a Whiting Writers' Award, and has been honored by the Pew Fellowship in the Arts and the Witter Bynner Foundation in conjunction with the Library of Congress. He has served as a creative arts fellow at the Radcliffe Institute for Advanced Study at Harvard University and Fine Arts Work Center in Provincetown. Major Jackson is a core faculty member at the Bennington Writing Seminars and the Richard A. Dennis Professor at the University of Vermont. He serves as the Poetry Editor of the* Harvard Review.

Rose Colored City

When Jennifer and I
 near the Ross Island
 Bridge pass the two

young men in matching
 black combat boots
 & white t-shirts

beneath suspenders
 that blaze an X on
 their backs,

I see them first as partners
 taking a late evening walk,
 like us, locked arm

to arm, charmed by park
 lamps & floral pathways,
 then well up with pride,

glorying in the picture
 our generation makes,
 & think what passes

between us, lust
 holier than war
 & lovelooks tinged

with righteousness,
 could fertilize a new
 & supreme race,

but then, one says
 Wassup sister? White Power
 & I snap out

of my reverie
 & remember the sound
 of History & blood,

& look over my shoulder
 & sneer my long, teasing dark
 smile & say, *Right*

 On! Black Power
to which they spill
 out of each other's

arms & stomp Nazi-like,
 cursing, Aryan heads bald
 as trophies in gold

streetlight, & we set off
 to crossing the avenue,
 a soft jog of hand-

holding that breaks
 in a sprint, back
 to our segregated lives.

Tyehimba
Jess

I started being a poet around the age of 16, staring out from my window in Northwest Detroit and writing about my hometown at the beginning of the crack wars and at the end of worldwide American automobile dominance.

Later, I was fortunate to have the poet Dudley Randall as one of the judges for my poem that won second place in a Detroit poetry contest. That prize encouraged me to pursue what I loved. In Chicago, I became a disillusioned English major who turned to Public Policy after being unable to find my brown face reflected in the syllabus. But a stroke of luck struck in the form of poet and professor Sterling Plumpp at the end of my college career. As one of only two male instructors that I had during my entire academic career, he served as a model for rigorous attention to detail, inventiveness, political integrity, and attention to our roots in music and history.

I also learned a lot from Chitown and the poets I ran with on the open mic circuit. On the Green Mill Slam Team I learned to reach deeper into myself and imagine greater possibilities.

Cave Canem, the poetry collective and workshop dedicated to Black poets, was a life-changing event. CC introduced me to an entire community of Black poets who were challenging, industrious, inventive, and showed me up close how to make it in the world as a poet. I still look primarily to this community as a source of inspiration and guidance.

I'm very lucky to be able to string words together and paint stories and images that hopefully move people—and to do it for a living. I'm always mindful that the words we write today are in conversation with the entirety of Black literature and the lustrous, complicated world that has brought the African Diaspora to where it is today. I want to write in a way that challenges myself towards life—that continues to bring the hard questions our literary forebears brought to the nation's consciousness. I am on a quest to be, as the Association for the Advancement of Creative Musicians says, "Ancient to the Future."

Detroit native Tyehimba Jess' first book of poetry, leadbelly, *was a winner of the 2004 National Poetry Series. The* Library Journal *and* Black Issues Book Review *both named it one of the "Best Poetry Books of 2005." Jess, a Cave Canem and NYU Alumni, received a 2004 Literature Fellowship from the National Endowment for the Arts, and was a 2004–2005 Winter Fellow at the Provincetown Fine Arts Work Center. Jess is also a veteran of the 2000 and 2001 Green Mill Poetry Slam Team, and won a 2000–2001 Illinois Arts Council Fellowship in Poetry, the 2001 Chicago Sun-Times Poetry Award, and a 2006 Whiting Fellowship. He exhibited his poetry at the 2011 TedX Nashville Conference. Jess is an assistant professor of English at College of Staten Island.*

I'VE RUN

FROM ONE FIRE

TO ANOTHER.

I'VE GOT A HEAD FULL

OF SONG,

BOILING AWAY.

Infernal

There is a riot I fit into,
a place I fled called the Motor City.
It owns a story old and forsaken
as the furnaces of Packard Plant,
as creased as the palm of my hand
in a summer I was too young to remember—
1967. My father ran into the streets
to claim a small part of my people's anger
in his Kodak, a portrait of the flame
that became our flag long enough
to tell us there was no turning back,
that we'd burned ourselves clean
of all doubt. That's the proof I've witnessed.
I've seen it up close and in headlines, a felony
sentence spelling out the reasons
my mother's house is now worth less
than my sister's Honda, how my father's worthy
rage is worth nothing at all. In the scheme
of it all, though, my kin came out lucky.
We survived, mostly by fleeing
the flames while sealing their heat
in our minds the way a bank holds
a mortgage—the way a father holds his son's hand
while his city burns around him... I almost forgot
to mention: the canary in Detroit's proverbial coal
mine who sang for my parents when they fled
the inferno of the South, its song
sweaty sweet with promise. I'm singing
myself, right now. I'm singing the best way
I know about the way I've run
from one fire to another. I've got a head full
of song, boiling away. I carry a portrait
of my father.

Patricia Spears **Jones**

I grew up in Arkansas, a landlocked state where cotton was still king and where the Black public schools were shut down in the spring and the fall so that students could chop or pick cotton; it was a dying world. My first poem started with a photograph in *Life Magazine* of John F. Kennedy on a beach. I had never seen a beach. Imagination is a powerful thing.

Going to New York with $50 and friends' addresses in 1974 made all the difference for me. Downtown New York was mostly white, but I found writing mentors at the Poetry Project, especially Lewis Warsh and Maureen Owen, and fortunately, remnants of the Umbra Workshop, Steve Cannon, Ishmael Reed, and Lorenzo Thomas were around. With experimental theater, "loft jazz," and cultural feminism in the mix, I found my artistic home.

For a young Black woman, the 1970s were a great time to be a poet in New York, what with Ntozake Shange, June Jordan, Jayne Cortez, and Audre Lorde as role models of art and activism. For me, the high point was co-editing the anthology *Ordinary Women*, which still serves as a model for inclusion and diversity of poets.

I am proud that each of my poetry collections has cover art by a Black artist: Willie Birch for *The Weather That Kills;* Carrie Mae Weems for *Femme du Monde;* Carl E. Hazlewood for *Painkiller;* and Sandra Payne for *A Lucent Fire: New and Selected Poems;* even my first chapbook *Mythologizing Always* has a cover by Rick Powell aka Richard E. Powell, Ph.D., at Duke. *THINK: Poems for Aretha Franklin's Inauguration Day Hat* was a fun project because poets were able to both consider the new Obama Administration while praising a special aspect of Black culture, the church lady hat. If you grow up in Forrest City, Arkansas, you know from church hats.

Patricia Spear Jones' career has included being Program Coordinator at The Poetry Project, running The New Works Program in Massachusetts, serving as Development Director for The New Museum, and obtaining a Goethe Institute grant to travel in Germany. She is the recipient of two NYFA grants, an NEA and awards from The Foundation of Contemporary Arts that funded her first trip to Paris. Her awards include writing residences at Squaw Valley Community of Writers, Virginia Center for the Creative Arts, Millay Colony, and Yaddo.

Saltimbanque

That there is a place of art in the city and society, the space allowed to art, its different guises and its very different publics, its perversions in the courts and its suppression in the streets.

–T. J. Clarke, *The Absolute Bourgeois: Artists and Politics in France 1848–1851*

1
Suppose Daumier had behaved differently? His walks across
Paris uneventful. News banal—barricades, congresses,
the secret societies ineffectual. What would his cartoons reveal?
The fat bellied bourgeois slimmer? The masses
stepping into well made shoes?
Or would he have—as he did in private—made more paintings
of the *saltimbanques*: street performers suppressed,
by order of the State?

Were their songs too political, pornographic?
Had their children not received instruction from the priests?
Were their dancing dogs and wily monkeys better off
burned?

Have we not enough water?
Is there not enough air?

2
Banners dirty and torn, fragmented song singes air.
Why are the revolutions of 1848 present?

Weapons in the hands of peasants, slave rebellions
in the American South, the monarchy in crisis,
plutocrats measure their new-found power in gilt, silk, velocity.

Pamphleteers for the right hand and the left.
Militarists, Marx, and monopoly capitalists,
the modern world embryonic.

3
What a blaze was to be made in less than one hundred years.
Sorting through shadows, airborne war machines
disrupt, destroy with electrical ease.
An eleven year old's voice is suddenly burdened
with dust,
human dust as ovens roar a clinical heat.
(Attendants weep as a passage from Wagner rises
from a well-tended Victrola.)
Displaced, disloved, dissolved almost,
a patch of khaki becomes a small girl's dress,
old shoelaces are ribbons for her hair.
A population of zombies beg for cigarettes and curse.

4

On a Saigon street, in the midday heat
or so it seems in the black and white film

a Buddhist monk in a moment
of amazing rage and pure tenderness
doused his saffron robes.
We do not see this vivid yellow.
We taste dust. Human dust.

Sous les paves, la plage.
Under the pavement, the beach.

5

Sous les paves, la plage
Songs of freedom scorch parched throats.

Workers and students defy enforced alienation.
Rise together, spray police with pamphlets, curses,
on the very paving stones that once were danced upon
by the saltimbanques, their children and trained beasts.
While an ocean away, under an image of the ever defiant Che,
intellectuals, idealists, the disaffected rallied across
a hemisphere. In the mountains of Central America,
poets purged themselves in clear, cold streams,
debated desire, and learned to shoot.
Sous les paves, la plage.

6 On a road to Biafra, in the slums of Manila,
on the back streets of Kingston, inside the chain-linked lawns
of South Los Angeles, people make a song, new song, riot song
as a stockpile of promises collapses the shanty towns,
miners' camps, the migrant workers' busses traveling north
from Florida seats sticky with overripe oranges.

Under the pavement, the beach.
Under a stockpile of rotting promises, human stench
Bodies gunned down in daylight in Manila, Mexico City,
Memphis, Tennessee. Cameras chasing children
grabbing a solid taste of fire.

And earlier that year, Soviet tanks pressed against
the Prague Spring, a winter storm drowning flowers.

7 Martin King sat bleeding in a Birmingham jail. He worked
his mind along the sacred stations of the cross and found,
if not solace, then the tattered cloth called dignity,
as he prayed for the souls of his jailers.

Tracing Alabama dust, his cross just heavy enough to bear,
Word could have been miracle, joy, power.
It was likely to have been song, people, or alone.

He made, in private, a face mimicking the fat, snuff-dipping guards.
Clown face turned towards jail-floor dust.
His tears roll away holy laughter. *Saltimbanque*
in a moment of amazing tenderness and pure rage.

Under the paving stones, the beach.

*Nathalie Schmidt contributed the French phrases created by the Situationists
from the May 1968 Student Protests in Paris.*

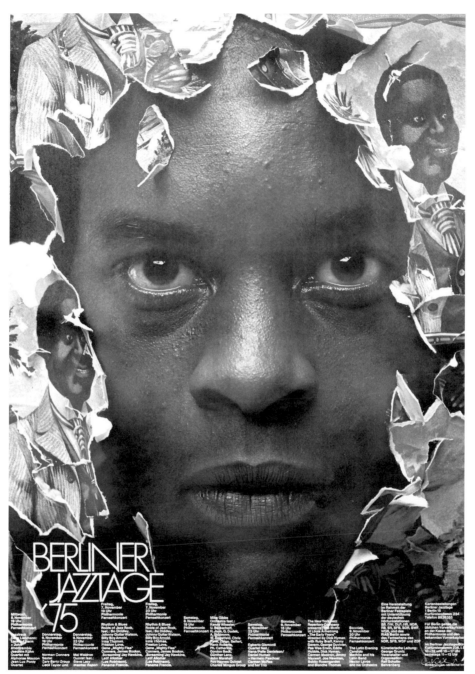

Berliner
Jazz Tage
'75, poster
by Gunther
Kieser, 1975

Douglas Kearney

Mom and Pop's house bumped with talk. Even the fussing was burst with signifyin'. TVs dumped chatter and ruckus all over the carpet. My brother's box boomed. I screwed my ear to all of it. So my head is like that house and when I think of music I hear speech.

Writing is a way, then, to see music. Yet, it also has a way of meaning for me, giving the mouthed tune a mouth and sense. These mouths, like speakers, populate my poetry. I interrogate language and systems with themselves and find myself surrounded. So, I write to read and get read by them.

Getting this reading means poetry to me. Thus, to get this reading means, for me, being a poet. If I get over the getting of this reading, perhaps I'll forget to be a poet, at which point I hope I get sense enough to stop writing poems. This could happen. After all, I forgot to be a short story writer after college when I realized I wanted to bend lingo from javelins to boomerangs. I stopped writing short stories then, which should relieve everyone for a bit.

Remembering, looking back, hooking back like a boomerang winging back into why I do this: The boomerang *wushes* behind Harryette Mullen, Fred Moten, Tracie Morris, swoops by Jaylib, De La Soul, Public Enemy, nearly misses Bob Kaufman, Melvin Tolson, Ishmael Reed, BAM! and banks/bonks off Sterling Brown, T.S. Eliot, Gertrude Stein, and the Futurists before getting back to me.

I bend it again and wing it, hoping it hones in on a signal made static-y by present shock and Altadena's foothills, where my Mom and Pop's house still stands. But my mother is dead, the house has new rooms and strangers sleep where I picked through talk, fussing, signifyin', chatter, ruckus, boom. From here, wherever I am, I screw my ear to it all and read.

Poet/performer/librettist Douglas Kearney's second, full-length collection of poetry, The Black Automaton *(Fence Books, 2009), was Catherine Wagner's selection for the National Poetry Series. Red Hen Press published Kearney's third collection,* Patter, *in 2014. He has received a Whiting Writer's Award and fellowships at Cave Canem, Idyllwild, and the Callaloo Creative Writer's Workshop. His third opera,* Sucktion, *has been produced internationally, and his fourth,* Crescent City, *premiered in Los Angeles in 2012. He teaches at CalArts, where he received his MFA in Writing in 2004.*

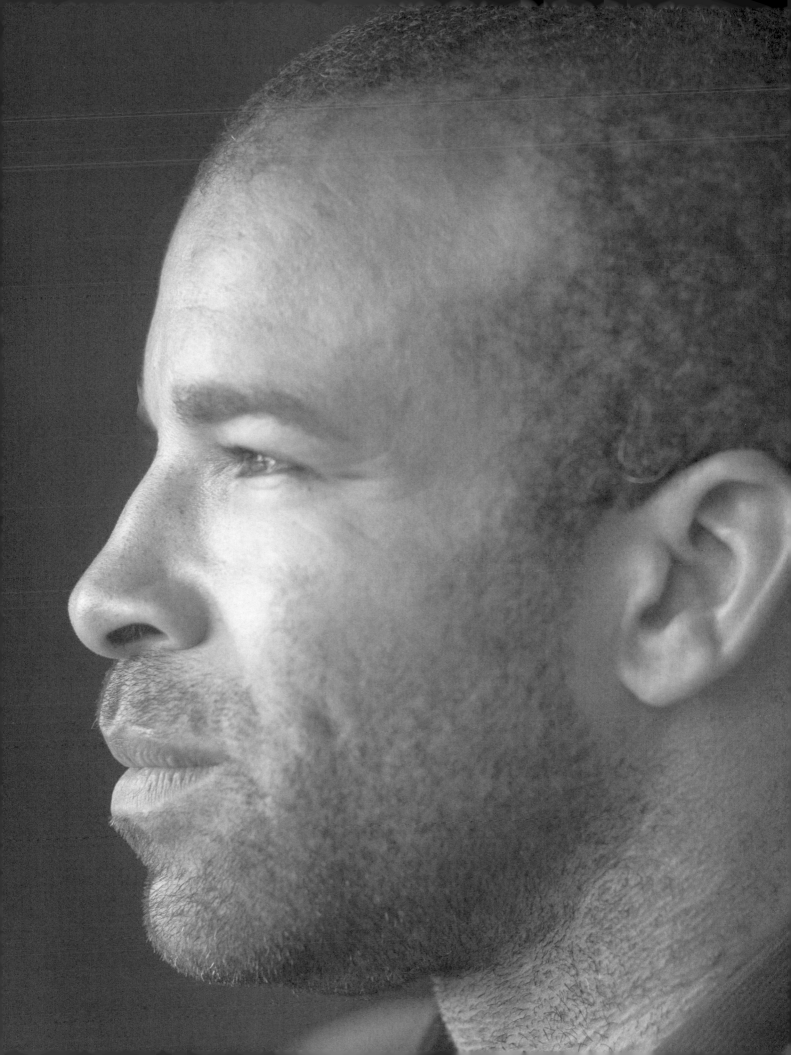

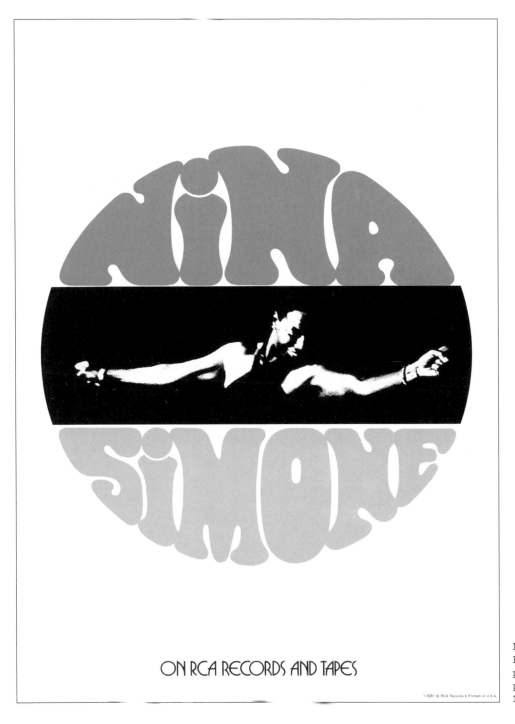

Nina Simone,
RCA Records
promotional
poster, circa
1966

Tallahatchie Lullabye, Baby

—Emmett Till (1941–1955)

cattail cast tattles Till tale,
lowing low along the hollow;
cricket chirrup and ribbit-lick-up.
what's chucked the 'hatchie swallow.

up skimming skin upon pond scum skiff-ish,
going slow along the hollow.
now may mayfly alight brown brow.
what's chucked the 'hatchie swallow.

maybe bye baby bye baby by and by,
lowing low along the hollow.
we will slip the knot not slip will we?
what's chucked the 'hatchie swallow.

who's a bruise to blue hue 'hatchie,
going slow along the hollow?
whose a bruise to bruise hue, 'hatchie?
what's chucked the 'hatchie swallow.

Kodak flash tattles Till tale
going slow among the hollow.
who's a bruise to bruise hue?
swallow what the 'hatchie chucks.

Yusef
Komunyakaa

The deep song of Bogalusa always pulled me to the cusp of something new and genuine, and I loved getting my hands into the loamy soil. Perhaps the true moment that brought me to poetry was the summer when I was 15, when I entered the pine forest with Uncle Ado to cut pulpwood beside him and his son, Ado Junior, pulling a crosscut saw from 5:30 a.m. to dusk. Insects sang in the early morning light, and they seemed to have been calling to the birds to devour them. Also, that summer I began to read aloud the poems of William Butler Yeats to my 14-year-old cousin, Beatrice.

I continued to ingest the poetry of Edgar Allan Poe, James Weldon Johnson, Sterling Brown, Ann Spencer, Walt Whitman, Langston Hughes, and Gwendolyn Brooks. Many turns in the road approached and years passed before I found myself holding a copy of Robert Hayden's *Ballad of Remembrance*. His voice, his sense of craft, his robust knowledge of history—it all demanded my full attention. For the first time, I felt the challenge, the pull of something oceanic and political; there was grace in the power of "Middle Passage," and the spirit of the poem remains lyrical truth incarnate—its authority almost intimidating. For me, this moment pulsated in a caldron of voices and images. The Black Mountain School. The Beat Movement. The Black Arts Movement. An echo of Allen Ginsberg's "Howl" shook the psychedelic air. The voices of Sam Cooke, Odetta, Bob Dylan, Joan Baez, Nina Simone,

Richie Havens—the social and cultural atmosphere edgy, magnanimous. Protest had grown into one, big, needful—and at times, brutal—work of art.

Amiri Baraka, Bob Kaufman, Michael Harper, and Etheridge Knight reset the clock in my psyche, and I journeyed back to the music I had grown up with. I must admit, Galway Kinnell's *The Book of Nightmares* and Philip Levine's *Not This Pig* also rung my bell. Each possesses a tonal spine that still challenges me to write, to attempt creating a language that approximates a seeing-into-things.

For the poet writing in America today, few of us have taken a stance—even rhetorically—against the grandmasters of violence in our neighborhoods scored for MTV. Maybe we know language has also betrayed us, but I wish to write poems that say, No, we'll never let language subvert or diminish the content of our character.

Yusef Komunyakaa's 17 books of poetry include Taboo, Dien Cai Dau, Neon Vernacular *(for which he received the Pulitzer Prize),* Warhorses, The Chameleon Couch, *and* Testimony. *His many honors include the William Faulkner Prize (Universite Rennes, France), the Ruth Lilly Poetry Prize, the Kingsley Tufts Award for Poetry, and the 2011 Wallace Stevens Award. His plays, performance art, and libretti have been performed internationally and include* Saturnalia, Testimony, *and* Gilgamesh: A Verse Play. *He is Global Professor and Distinguished Poet at New York University.*

History Lessons

I

Squinting up at leafy sunlight, I stepped back

& shaded my eyes, but couldn't see what she pointed to.

The courthouse lawn where the lone poplar stood

Was almost flat as a pool table. Twenty-five

Years earlier it had been a stage for half the town:

Cain & poor white trash. A picnic on saint augustine

Grass. No, I couldn't see the piece of blonde rope.

I stepped closer to her, to where we were almost

In each other's arms, & then spotted the flayed

Tassel of wind-whipped hemp knotted around a limb

Like a hank of hair, a weather-whitened bloom

In hungry light. That was where they prodded him

Up into the flatbed of a pickup.

II

We had coffee & chicory with lots of milk,

Hoecakes, bacon, & gooseberry jam. She told me

How a white woman in The Terrace

Said that she shot a man who tried to rape her,

How their car lights crawled sage fields

Midnight to daybreak, how a young black boxer

Was running & punching the air at sunrise,

How they tarred & feathered him & dragged the corpse

Behind a Model T through the Mill Quarters,

How they dumped the prizefighter on his mother's doorstep,

How two days later three boys

Found a white man dead under the trestle

In blackface, the woman's bullet

In his chest, his head on a clump of sedge.

III

When I stepped out on the back porch

The pick-up man from Bogalusa Dry Cleaners

Leaned against his van, with an armload

Of her Sunday dresses, telling her

Emmett Till had begged for it

With his damn wolf whistle.

She was looking at the lye-scoured floor,

White as his face. The hot words

Swarmed out of my mouth like African bees

& my fists were cocked,

Hammers in the air. He popped

The clutch when he turned the corner,

As she pulled me into her arms

& whispered, *Son, you ain't gonna live long*.

Quraysh
Ali Lansana

I consider myself, for the most part, a direct descendant of the Black Arts Movement (BAM), at least contextually. BAM doctrine supported art "for, by, and about Black people." Born in 1964, the youngest of six, I was immersed in Black Power politics and culture well before I learned to read. Bonnie and Charolette, my two oldest sisters, afros like small planets, integrated the Enid High School orchestra, my brother 'Cuda (William) was likely among the first Blacks to play in the school band, Cookie (Sharon) led Black student demonstrations, and Dede (Diana) was the first Black captain of the drill team. I was too young to understand most of this activity but was informed by it, as well as the Nikki Giovanni and Amiri Baraka poems taped to the walls in my eldest sisters' room.

Unlike my siblings, my childhood friends were quite diverse: Native American, Pan-Asian, Black, and Caucasian. My first best friend was Cherokee. We met in kindergarten. We didn't watch Westerns and never played "Cowboys and Indians." I can't say that I fully understood the politics, certainly not at 5 or 6 years of age. But I knew my friend became angry or sad about these things. I believe, even in the most affluent or sheltered of circumstances (of which I am neither), that people of color are introduced to cultural and racial dynamics very early in life. I have always been a political person, but perhaps not consciously until high school. I am also a student of history and believe very strongly in the inter-connectedness of politics, culture, and history. And time.

The writers who most influence how I "see" are Gwendolyn Brooks, Lucille Clifton, James Baldwin, and Etheridge Knight. All of these writers explore this confluence with searing elegance.

I am the sixth-strongest poet in my house. Nile and Onam, my teenage sons, are remarkable writers and outstanding young men. They are my heroes.

Quraysh Ali Lansana is the author of eight poetry books, three textbooks, a children's book, editor of eight anthologies, and coauthor of a book of pedagogy. He is a faculty member of the Creative Writing Program of the School of the Art Institute and the Red Earth MFA Creative Writing Program at Oklahoma City University. He is also a former faculty member of the Drama Division of The Juilliard School. Lansana served as Director of the Gwendolyn Brooks Center for Black Literature and Creative Writing at Chicago State University from 2002–2011, where he was also Associate Professor of English/Creative Writing until 2014. Our Difficult Sunlight: A Guide to Poetry, Literacy & Social Justice in Classroom & Community (with Georgia A. Popoff) was published in March 2011 by Teachers & Writers Collaborative and was a 2012 NAACP Image Award nominee. His most recent books include The BreakBeat Poets: New American Poetry in the Age of Hip Hop *with Kevin Coval and Nate Marshall (Haymarket Books, 2015) and* The Walmart Republic *with Christopher Stewart (Mongrel Empire Press, September 2014).*

statement on the killing
of patrick dorismond

a petty hoodlum (cop) shot/killed suspect
(blackman) after hoodlum (pig) was told

by suspect (haitian) that he (junglebunny)
was not a drug dealer (nigga). the police

commissioner (bounty hunter) referred to suspect
(coon) as a *lowlife* (african) though his (aryan)

comments were later proven false (white lies).
the shooting (genocide) is the third (pattern)

in thirteen months (institution) in which plain-clothes
officers (gestapo) shot/killed an unarmed man

(cheap blood). *i would urge* (doubletalk) *everyone*
(oprah) *not to jump* (dead nigga) *to conclusions* (acquittals),

mayor guiliani (overseer) said, *and allow* (blind faith)
the facts (ethnic cleansing) *to be analyzed* (spin) *and*

investigated (puppets) *without people* (darkies) *trying*
to let their biases (racial profiling), *their prejudices*

(welfare queen), *their emotions* (fuck tha police),
their stereotypes (o.j.) *dictate the results* (status quo).

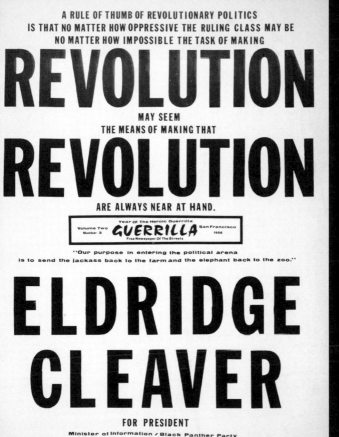

Revolution,
Revolution,
Black Panther
Party poster,
circa 1968

Haki
Madhubuti

In order to identify what prompted me to start writing poetry, I begin with the moment my life was changed by a Black writer. I was 13 years old. My mother sent me to the Detroit Public Library to check out a book for her: *Black Boy* by Richard Wright. I almost didn't get the book because I didn't want to go anywhere asking for anything Black. I found the book, however, sat in a corner of the library, and began to read. For the first time in my life, I was reading ideas that were not insulting to my own personhood. Richard Wright's experiences were mine. When I finished the book, a foundation had been planted.

In addition to Wright, others who were influential in the shaping of my poetic voice were Gwendolyn Brooks, Melvin B. Tolson, Langston Hughes, Margaret Walker, Amiri Baraka, and Sterling Brown. These writers were serious about Black people and our cultural stories. My quest to read turned into a need to write. I came to poetry through struggle and a search for identity. I am a poet in the African griot tradition, a keeper of culture's secrets, history, short and tall tales, a rememberer.

What made or makes me a poet is best answered through my poetry:

It is the poets who run toward fear.
They are what we read,
think, and speak,
fighting for greater possibilities.

It is this greater possibility that keeps me writing and questioning the everyday truths of our existence. I ask myself the same questions that I would ask of any poet:

Can you write a poem not about politics, culture, economic struggle, or the possibilities of drinking unfiltered water? Can you put words of rhythm together that do not comment on the warmth and cold of indigenous teas and corporate coffee or the conflict of words, worlds, and actual life?

My answer: Don't try to be something or someone you are not. Poetry has defined my life. My poetics are rooted in a Black aesthetic that created an art, a movement, and a language of empowerment.

Poems bind people to language, link generations to each other and introduce cultures to cultures...To be touched by living poetry can only make us better people.

The achievements that most distinguish my contributions as a poet are the founding of Third World Press, which has provided a literary home for hundreds of writers; cofounding the Institute of Positive Education and four Chicago schools; serving as a key architect of the Black Arts Movement; activism and intimate participation in national and international Black struggle; spending 42 years as a university professor; serving as the founding director of the first MFA program at a predominantly Black institution; and for 20 years hosting a writers conference that showcased national and international writers of African ancestry. And finally one of my greatest honors was to be the cultural son of Gwendolyn Brooks.

As of 2015, Professor Haki Madhubuti has written and/or edited 34 books, including 14 books of poetry and 12 books of essays.

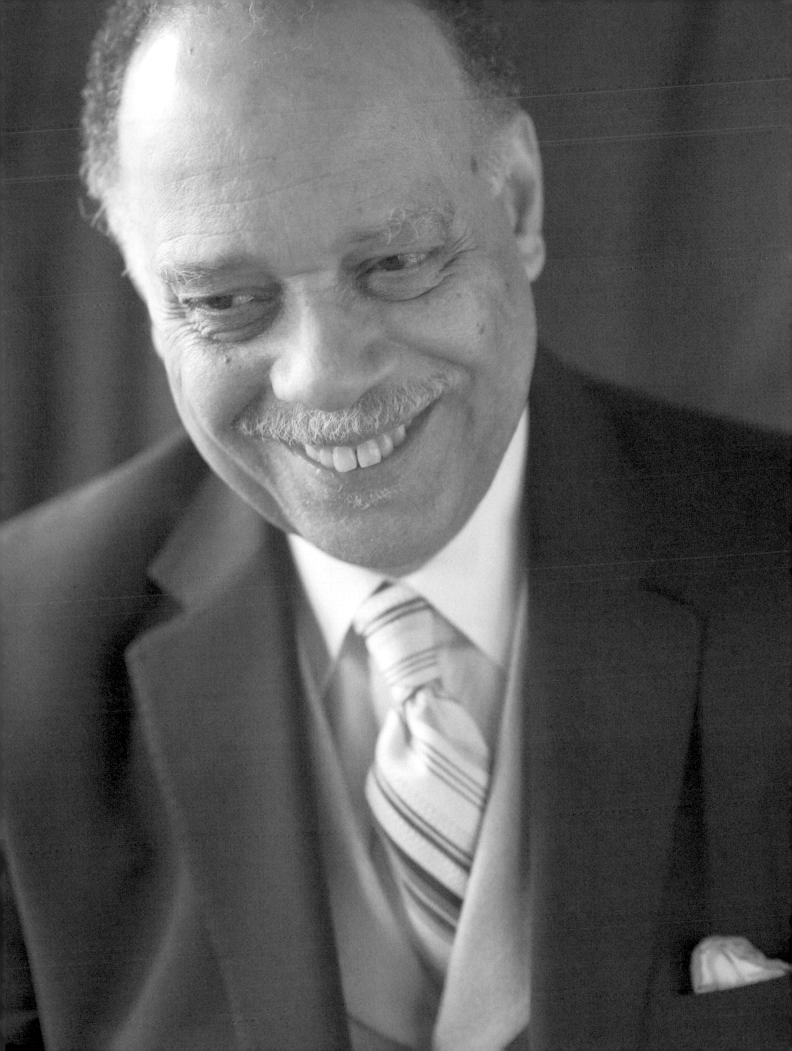

The Great Wait

(it is possible that those persons who feel the need to
act against evil will be told to wait, be calm, have
patience, don't get upset, be realistic, don't rock the
boat, you are not so bad off, etc., etc.)

conscious tire of
waiting on waiters who wait for a living
as movers perfect the reasons why
others must wait.

movers say that waiting is an ancient art form
perfected by negroes waiting on something called *freedom*

that will surely come
if the waiters wait patiently in the kneeling position long
 enough.
long enough is when the waiter's knees shine and
head automatically drops whenever waiters are in the
 presence
of movers that tell them to be grateful
to have something to wait for.

movers say that afrikans can't even clothe themselves,
that the major occupation in central america is the
 maintenance of cemeteries,
that the people of asia need to control their sex drive,
that the only people that *really* understand modern
 technology are the south afrikaners and their brothers
 on pennsylvania avenue and
that the major problem for others is that they do not
 want to wait for their time.

most of the waiters are poor and miseducated.
waiting, like cocaine, is addictive.
people wait on welfare, workfare, healthfare, foodfare
and for businessmen and politicians to be fair.
waiters are line wise having spent a third of their lives
waiting in telephone lines, gas lines, light lines, bus lines,
 train lines and unemployment lines.
waitin, waitin, tush, tush, tush.

waiters wait on presidents and first ladies to tell them
the secret of why waiting is better than
communism, socialism and hinduism,
why waiting is more uplifting than full employment
and is the coming tool to eliminate illiteracy and hunger.
waitin, waitin, tush.

western economists and sociologists have postulated that
waiting is the answer to family separations and ignorance.
that waiting will balance the budget and give waiters
the insight into why others care more about their condition
than they do.

the conscious world
waits on a people who have become
professional waiters.
the waiters' education clearly taught them
to aspire to become either the
waiter, waitee or waited.
for most wasted
waitin, waitin, tush, tush, tush.
popular consensus has it that
waiting builds character, cures dumbness and blindness,
waiting brings one closer to one's creator, waiting is
 intelligent work,
waiting is the fat person's answer to exercise
waiting will be featured on the johnny carson show this week
 disguised as
black urban professionals pushing the latest
form of waiting, "constructive engagement."
waitin, waitin, tush, tush, tush.
It is documented that
waiting will save the great whale population,
waiting will feed the children of the sudan,
waiting will stop acid rain,
waiting will save the great amazon forest,
waiting will guarantee disarmament and peace.

the major activity of waiters is watching television, sleeping,
eating junk foods and having frequent bowel movements.
waitin waitin tush tush tush tush

consciousness decays from
waitin on people with plastic bags
on their heads waitin
waitin on negroes that live for pleasure and money only waitin
waitin on a people that confuse freedom with handouts waitin
waitin on sam to straighten his spine and care for his children,
waiting on six child sue to say no,
waiting on $300 a day junkies,
waiting on a people whose heroes are mostly dead,
waitin on boldness from all this education we got,
waiting on the brother,
waiting on the sister.
waiting on waiters who wait for a living
as movers perfect the reasons why
others must wait.
waiting benefits non-waiters and their bankers.
most people are taught that
waiting is the misunderstood form of action,
is the act that is closest to sex and bar-b-q consumption.
waiting. waiting. waiting. waiting. waiting. waiting.
a truly universal art is practiced
by billions of people worldwide
who have been confirmed by their leaders
to be happy, satisfied and brain dead.

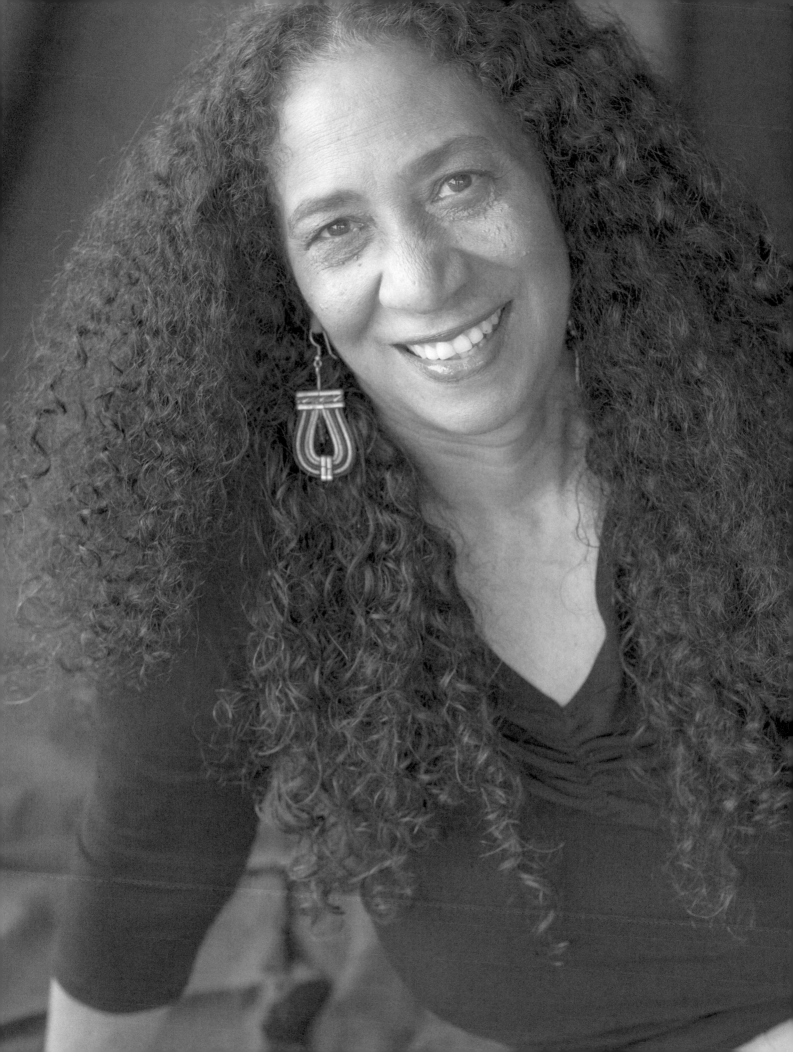

devorah major

I was always surrounded by books, which filled two walls of our home. Arna Bontemps' *Sad Faced Boy* was there, along with Baldwin's *Go Tell It on The Mountain.* Hughes' *Simple Stories* and Richard Wright's *The Outsider,* along with *The Story of Man in Pictures,* the *Sweet Flypaper of Life,* the *Rise and Fall of the Third Reich,* and a slew of Henry Miller. Walter Benton's *This Is My Beloved,* and Dylan Thomas' *Under Milkwood* along with e.e. cummings and Gwendolyn Brooks, Sonia Sanchez, Lucille Clifton, Henry Dumas, and (then) LeRoi Jones all started me on my young adult poetry road.

My influences were all the people on my path, some more than others, not because of their status or education, but because of their grace and the gifts of their knowledge and experience and wit.

I studied dance and groomed myself as an actress performing with San Francisco Bay Area companies and writing in life's margins. Somewhere along the line as my life became entwined with the Black liberation movement and I became a part of those struggling for a solution, I found a way to join my love of movement and performance and my need for activism to the written word. As for why I write, it is a way to love, to understand, to remember and reframe history, and to heal spirit and planet.

devorah major, San Francisco's 3rd Poet Laureate, is the poet in residence at San Francisco's Fine Arts Museums, a senior adjunct professor at California College of the Arts, author of four books of poetry, travelling women *(with Opal Palmer Adisa),* street smarts *(which won the PEN West Josephine Miles Award for Literary Excellence),* with more than tongue, where river meets ocean, *two novels,* An Open Weave *(which won the BCALA First Novel Award) and* Brown Glass Windows, *and two biographies for youth,* Rosa Parks: Freedom Fighter, *and* Frederick Douglass: A Hero for All Times. *She tours nationally and internationally performing her poetry with and without musicians. She is also featured on several CDs and has written the text for* Trade Routes, *a symphony composed by Guillermo Gallindo and commissioned by the Oakland Symphony.*

Raised by a father who loved words and a mother who loved colors and textures, I was surrounded from the womb by the arts. A 1950s early childhood found me in North Beach near the artists and writers where my father worked and wrote and my mother worked and painted. That was where I met Bob Kaufman when I was a toddler, but never really knew him until I found his book *Garden Sardines* on one of the many shelves that made up the small library in our home.

I was brought up in a home of activism, raised to know that the quality of people rested in the way they treated other people, the way they treated themselves, and that allowing anything less than freedom and dignity for everyone was accepting the underside of what was human but not humane.

Mumia
Abu Jamal,
poster, artist
unknown,
circa 1977

on continuing to struggle

for Mumia Abu Jamal

i don't want to write *a memorial poem*
in commemoration of the fact
that another knot was tied in
our tongues

i don't want to write the *we gave more blood*
to water their poison crops poem
the *on reviewing the execution*
of another black man poem

a man who could see through cells without windows
who could speak though bound and gagged
who could lead under chain behind bars
from isolated chambers
while penned in a land where
as a matter of policy
family is forbidden to touch
except through glass

who of us could hold their heart intact
who of us could keep the vision so strong
that others become bright in its glow

i do not want to write
the *we tried but the ain't it a shame* poem
the *what a god damn crime* poem
the *we did all we could, but still* poem
the *they won this round*
we'll have to get them the next time poem
the *lost more than ground this time* poem
the *they killed him anyway* poem
the we *didn't stop them* poem

i'm not going to carry banners of defeat
and wear shackles of resignation
i say i want to sing praises in celebration
not through mourning
say i want to give thanks for community
that is birthing new freedoms
not burying fresh kill

i'm going to work on *the road is long but we still truckin'* poem
going to work on the *keep scaling that mountain* poem
going to work on the *making sure there are better days ahead* poem
working on the free *mumia* poem
working *on freeing mumia*
working on seeing mumia free

E. Ethelbert Miller

I define myself as a literary activist. I don't separate my writing from the work I do every day. Issues pertaining to politics, art, and culture have shaped my career since the early 1970s. I became a poet on the campus of Howard University. I was one of the first students to major in African American Studies. My work was influenced by leading members of the Black Arts Movement (BAM), including Amiri Baraka, Haki Madhubuti, Sonia Sanchez, Nikki Giovanni, Carolyn Rodgers, and Norman Jordan.

How a poem could "sound" became evident when I was introduced to Sterling Brown. I attended a reading he gave on Howard's campus in 1969 and poems like "Strong Men" and "Old Lem" took me down the Southern road. As an undergraduate I was introduced to blues and African American folklore by Brown as well as my mentor Stephen Henderson. Henderson had just edited *Understanding the New Black Poetry*. I enrolled in two classes he taught: "Blues, Soul and Black Identity" and "The Black Aesthetic." This was the beginning of my baptism into blackness.

One of my key reasons for writing has been to move ideas into action. I continue to be interested in the role culture plays in social movements. How does language transform the individual as well as the community? Is it possible to create work that brings one closer to the beloved community? This is what I think about even before the poems come. It's why I remain a poet—seeking and reaching for what one cannot touch, this looking beyond the silence and the mysterious, this upholding of faith and the belief in the evidence of things unseen.

I haven't spent much time thinking about poetics. There are things I know a poem won't do. I'm aware of the tradition I've inherited and how life often begs for forgiveness and embraces its own nakedness. I think of Charlie Parker hearing a new music but not yet reaching the point where he could play it.

E. Ethelbert Miller received an honorary degree from Emory and Henry College. His poetry has been placed on permanent display outside two metro stations in Washington, D.C. He has published two memoirs, including Fathering Words: The Making of an African American Writer *(2000) and established his personal archives at George Washington University's Gelman Library. He hopes that his archives will assist scholars in the future doing research into African American culture as well as the literary history of our nation's capital.*

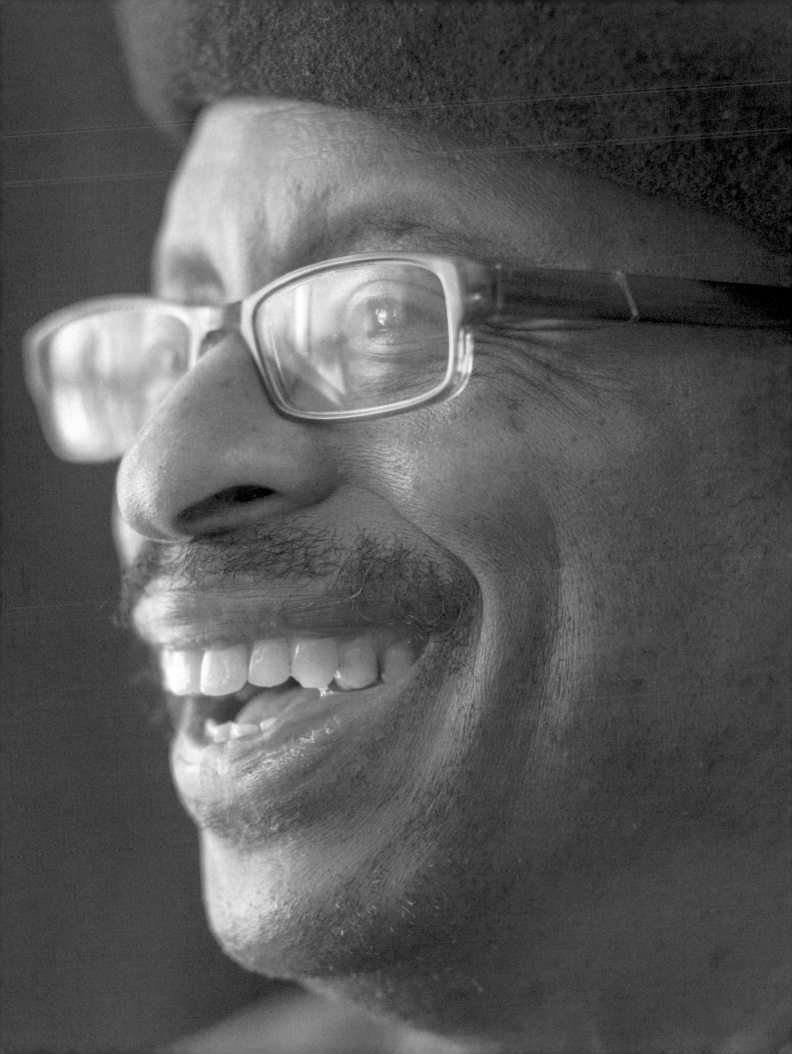

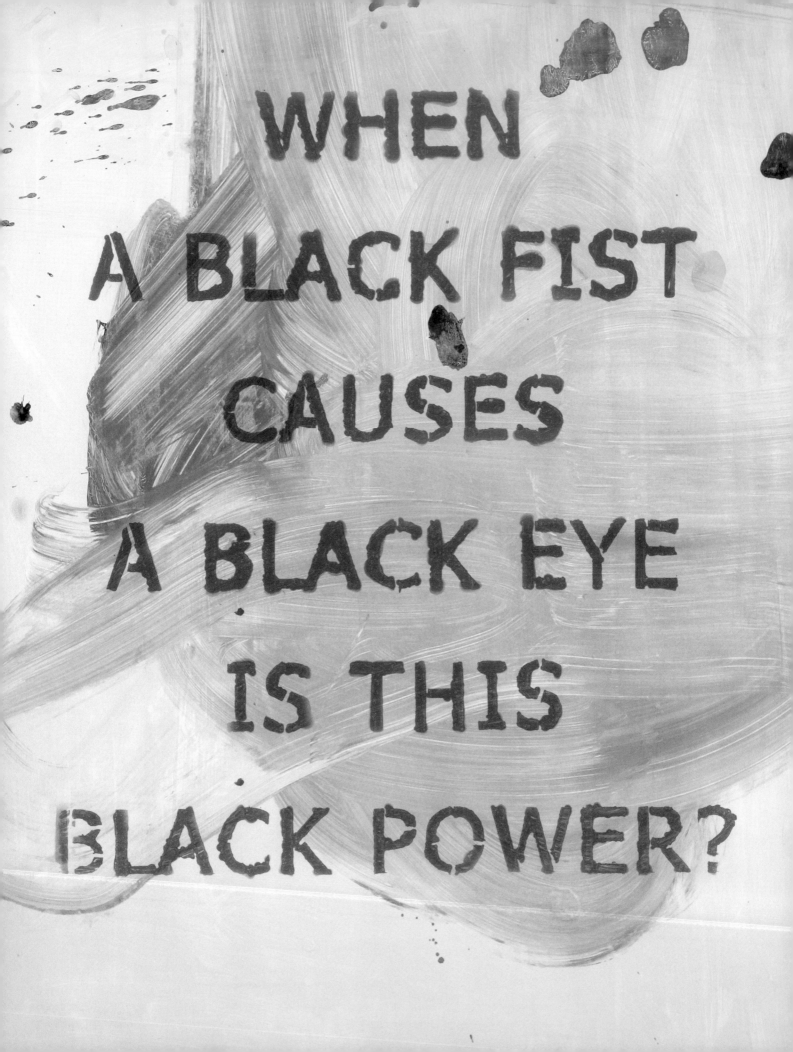

The 10 Race Koans
as presented to Charles Johnson
on the morning of July 13, 2008

Race Koan 1 — Why is the cotton white
and the hands black?

Race Koan 2 — How come our ears are always open
but we can't hear the sound of freedom?

Race Koan 3 — What's the difference between
the Colorline and the starting line?

Race Koan 4 — I have a dream
and you have a dream.
Do we share the same dream?

Race Koan 5 — Is sitting in the dark
the best way to celebrate
Blackness?

Race Koan 6 — A blind black man
boards a bus.
What do you notice first
his blindness or blackness?

Race Koan 7 — Do you ever wonder
what Stevie Wonder
sees?

Race Koan 8 — When DuBois called Garvey
"a Negro with a hat"
what was he wearing?

Race Koan 9 — When a black fist
causes a black eye
is this Black Power?

Race Koan 10 — Red, white, and blue.
Red, black and green.
What do colors mean?

Harryette **Mullen**

Not long ago, when my mother was going through old storage boxes, she showed me proof that I could write my name and a few words when I was 2 years old. My mother is a retired teacher now, who occasionally still volunteers to tutor a neighbor's child. When she was a girl, she played teacher with her friends, and before she actually worked as a teacher, she practiced on us, my sister and me. The bedroom we shared included shelves of books, a desk, a chalkboard with white and colored chalk, an easel with brushes and paint, and a cardboard puppet theater. I don't remember learning how to read or write, any more than I can recall learning to walk or talk.

As far back as I can remember a pencil in my hand felt as natural as a spoon or fork; reading and writing, as natural as talking with a friend. Reading and writing are such deeply ingrained habits that my life would be unrecognizable without these ways of relating what's in my head to what's out there in the world around me. It's not that my mother made me a poet. She was hoping I'd become a pediatrician. Still, she made a space for my sister and me to value our intelligence and creativity. In that space it was safe for us to dream and imagine, to play with words as we played with paint and chalk. In that safe space, it was not unthinkable to love words so much that I could become a poet. It's the closest I can get to magical powers: the way words can conjure images; the way the rhythm of a poem can alter the breath.

Like music and the other arts, and even like a spiritual practice, poetry is what reminds me that I am human. A dog doesn't need to be reminded that it's a dog, but I think occasionally we human beings need to be reminded that we are human.

Harryette Mullen is the author of several poetry collections, including Recyclopedia, *winner of a PEN Beyond Margins Award, and* Sleeping with the Dictionary, *a finalist for a National Book Award, National Book Critics Circle Award, and* Los Angeles Times *Book Prize. Her poems have been translated into Spanish, Portuguese, French, Italian, Polish, German, Swedish, Danish, Finnish, Turkish, Bulgarian, and Kyrgyz.* The Cracks Between, *a collection of her essays and interviews, was published by University of Alabama Press in 2012. Her book of poems,* Urban Tumbleweed: Notes from a Tanka Diary *(Graywolf Press), was a "top pick" for fall 2013 by the* Los Angeles Times. *She teaches American poetry, African American literature, and creative writing at UCLA.*

We Are Not Responsible

We are not responsible for your lost or stolen relatives.
We cannot guarantee your safety if you disobey our instructions.
We do not endorse the causes or claims of people begging for handouts.
We reserve the right to refuse service to anyone.

Your ticket does not guarantee that we will honor your reservations.
In order to facilitate our procedures, please limit your carrying on.
Before taking off, please extinguish all smoldering resentments.

If you cannot understand English, you will be moved out of the way.
In the event of a loss, you'd better look out for yourself.
Your insurance was cancelled because we can no longer handle
your frightful claims. Our handlers lost your luggage and we
are unable to find the key to your legal case.

You were detained for interrogation because you fit the profile.
You are not presumed to be innocent if the police
have reason to suspect you are carrying a concealed wallet.
It's not our fault you were born wearing a gang color.
It is not our obligation to inform you of your rights.

Step aside, please, while our officer inspects your bad attitude.
You have no rights that we are bound to respect.
Please remain calm, or we can't be held responsible
for what happens to you.

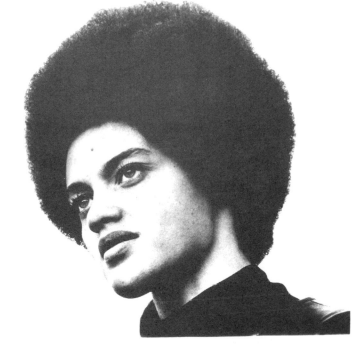

ALL POWER TO THE PEOPLE
BLACK POWER TO BLACK PEOPLE

KATHLEEN CLEAVER

Communications Secretary, Black Panther Party

WRITE-IN CANDIDATE
18th ASSEMBLY DISTRICT
PEACE & FREEDOM PARTY

Kathleen Cleaver,
Black Panther Party
poster, circa 1968

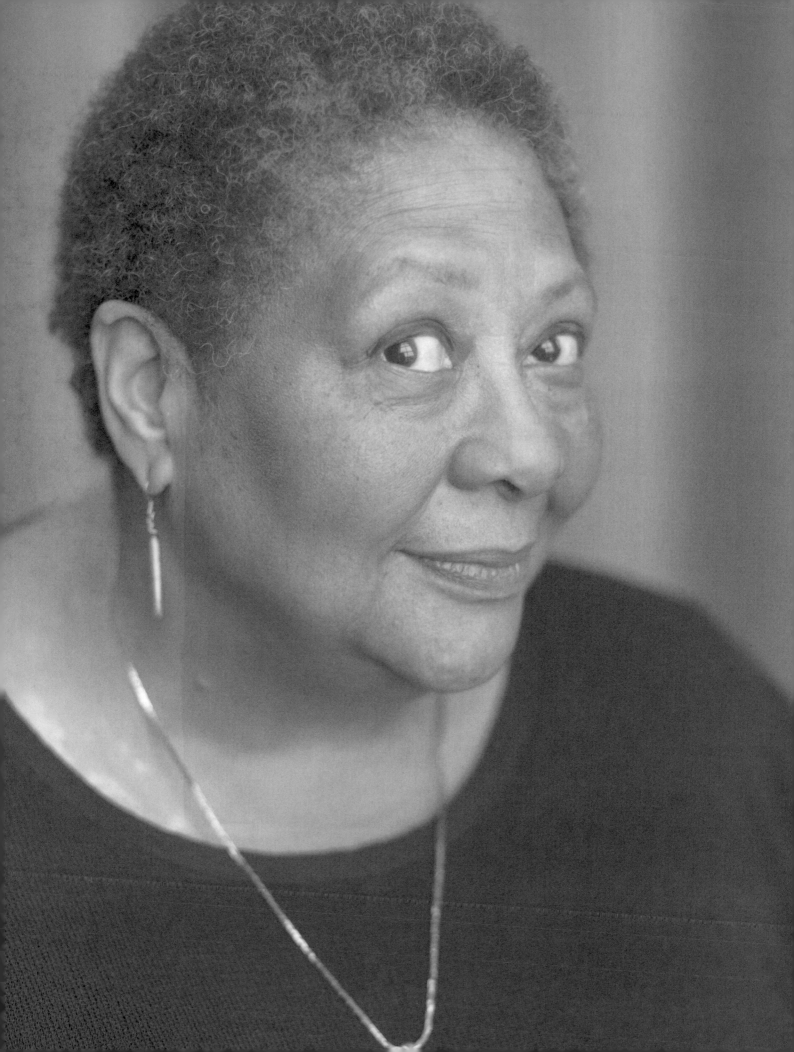

Marilyn **Nelson**

I've thought of myself as a poet for most of my life, ever since my mother explained to her friends that the reason I teared up over a sunset or a flower or the moon or a beautiful word was that "Marilyn is very sensitive: she's our poet."

I don't remember when I started trying to write poems. I do remember loving poems in the pages of the first volumes of the Childcraft: The How and Why Library set of books, and later, in a textbook poetry anthology kept from my father's college days, which moved with us from Air Force base to Air Force base. And I remember that, on the last day of school when I was in 6th grade in Kittery Point, Maine, our teacher predicted what we would be when we grew up. She said I would become a poet, best known for writing for young people.

I suppose one could call me a cis-poet: I've just followed the direction I seemed to be pointed toward. In 7th grade in Ft. Worth, Texas, my English teacher loaned me her collection of books by African American poets. In high school in Sacramento, California, my mother invited home a "real" poet, Eugene Redmond, a Black poet then teaching at Sacramento State University (now Cal State, Sacramento), just so I could meet and talk to him. In the airport in Hartford, Connecticut, on the way to my first reading after the publication of my first book, I passed a couple of Hare Krishna solicitors. One of them said to the other, "Do you feel that vibe? There's a poet in the airport somewhere." Yes, this really happened.

I've loved poets from many traditions, cultures, and languages. One of my regrets is that my parents and I didn't know earlier the value of being able to use other languages. Like most American (and African American) poets, I am fluent in no second language. But I count as influences several poets who wrote in French, Spanish, and German. Some of the greatest joy I've had as a writer has come from losing myself in the egoless service of translation.

I'm partial to the order that form imposes on the chaos of existence. My definition of poetry has always been "shaped language"—a definition at odds with the contemporary poetry of discord. To my ear, rhythm, repetition, sound, and rhyme are primary sources of poetic pleasure.

Marilyn Nelson's books include Carver: A Life In Poems, Fortune's Bones, The Freedom Business, *and* A Wreath For Emmett Till. *Her honors include two creative writing fellowships from the N.E.A., a Guggenheim fellowship, three National Book Award Finalist medals, the Poets' Prize, the Boston Globe/Hornbook Award, a Newbery Honor medal, two Coretta Scott King Honor medals, the Flora Stieglitz Straus Award, the Lion and Unicorn Award for Excellence in Poetry for Young Adults, the American Scandinavian Foundation Translation Award, and the Robert Frost Medal. Nelson is the former Poet Laureate of Connecticut, and was for 10 years the founder/director of Soul Mountain Retreat.*

Cells and Windows
after work by neogeo painter Peter Halley

Black men in their prime
working years, especially
those without a high school
diploma, are much more likely
to be in jail than white men are.
(a) true (b) true

Blondes (a) have more fun
(b) are beautiful but dumb

While institutionalization rates
rose for both blacks and whites
from 1980 to 2000, the rise was
especially sharp among the less
educated black men—from 10%
in 1980 for those ages 20 to 24
to 30% in 2000. In 2010, the
institutionalization rate for this
group dropped to 26%, but, as
was the case in 2000, they were
more likely to be institutionalized
than they were to be employed
(19% employment rate in 2010).
Institutionalization and employment
trends were similar, if not more
dramatic, for black men with no
high school diploma ages 25 to 29.

Our forefathers
(a) wore wigs
(b) were whipped

In 2010, all black men were six times as likely
as all white men to be incarcerated in federal,
state and local jails, according to a 2013 study
which also found that black-white gaps in median
household income and wealth had widened
in recent decades, while gaps in high school
completion and life expectancy had narrowed.

Stare hard for a few
seconds into an empty
prison colored cell.
Close your eyes, then
open them to stare at
a blank white wall.
You will see an after
image. Who is he?

Walk through a gallery
of Peter Halley's work.
In day-glow acrylic
and Roll-a-Tex, in acid
azures, fluorescent
oranges, in terrified
screams greens, intense
hot squares and stripes
are barred windows,
a high-wire head-trip
through circuitry, into
our forefathers' rabbit
holes, past the machines
that do a day's work
without complaint or pay,
all the way down
to the bottom of deep,
psychedelic loneliness.

Yeah,
Baby.
I miss
you to.

Sterling Plumpp

I write because when I learned the meaning and power of literacy there was no way for me to make sense of reality as I perceived it without my pursuit and mastering of a personal literacy. There was no way for me to know the margins I exist in and any possibility for my self-realization without my learning to write. I also write because the conditions in which I came to know and live in this country had so rigged narratives of the truth that it was impossible for me to accept them. Therefore, the only acceptable option for me was to begin the quest of journeying to construct literary texts of my own.

I love and accept the challenge of producing literary texts. It is a labor of love. When I entered college in 1960, I discovered Greek literature and mythology. *The Odyssey, Prometheus Bound* and *Oedipus Rex* completely flabbergasted me, shattering my Southern upbringing and Catholic education's worldview. Nothing could quell the thirst in my being and the need to articulate this quest. The years one must apprentice him or her self to literary texts in order to learn craft is lifelong.

I discovered James Baldwin, Richard Wright, and Ralph Ellison around the age of 20. I had spent all my years in the South and was now at a mostly white college in Kansas. I read everything I could get my hands on regarding Black history and the Black experience.

Then I marched to Cicero, Illinois in 1968 in a protest by Chicago CORE, and

the reception I received from its inhabit-
ants led me to write a poem, "Black Hands."
It was published in *Negro Digest* in 1968. I
was hooked as a poet.

Baldwin, Wright, and Ellison baptized
me. They introduced me to Black vernacu-
lar and Black music. However, it was the
music in the inspired images, rhythms,
and allusions from "Preface to a Twenty
Volume Suicide Note" and "Dead Lecturer"
by Amiri Baraka (LeRoi Jones) that got me
to thinking about poetic texts.

I am an American poet of African
descent who privileges the diasporic cul-
tures of African ancestors. I am particularly
amazed by the humanity of and articulate
brilliance of its musical traditions. There-
fore, Negro spirituals, gospel, blues, jazz,
and Black vernacular are the models I
use to construct my poetic imagination.
I hold dear the narratives of my history
buttressed by facts. I dread narratives built
on the uncertain foundation of myth.

I am proudest of my efforts to produce
literary texts inspired by African Ameri-
can history, culture, and music. *The Mojo
Hands Call, I Must Go, Blues the Story
Always Untold, Hornman, Ornate with
Smoke, Blues Narratives, Velvet BeBop
Kente Cloth,* and *Home/Bass* are all texts
in that tradition.

*Sterling D. Plumpp is Professor
Emeritus of African American Studies
and English at University of Illinois at
Chicago. He has one daughter, Harriet, a
son-in-law, Brett, and two grandchildren,
Duncan and Mali.*

I Hear the Shuffle of the People's Feet

i am a name clanging
against circles

i go round
in what's been said and done
the old puts leashes
on my eyes
i go round
in tribal wisdom

men walking from the sea
as if it is dry land
enter my circle
put me in a straight line
from profit to death
i turn from now
back to the past
they fold my future
in their bank accounts

they take me from hands
to memory
i move from knowledge
to obedience
i plant tobacco
i train sugarcane
i yessir masters
i go straight from sunrises
to death
when i remember
i chant shango
i sing ogun
i dance obatala
i hum orishas

i am folded in work
i get up
i obey
i rebel
i runaway
they beat production
from my bones
and track up my mind
with their language

after one generation
i go round in silence
while my children work
without ever knowing tribal hands
they echo my songs
until whips dull their voices

i survive dungeons
by singing songs shaped by brutality:
i sing new necessities
in a strange band
my songs carry
rhythmic cries of my journey
and when i dance
yes, when i dance
i revive tribal possessions
the elders' hands
twist my eyes on right
and let my body go

true believer, the whip
tells my mind
what to dream
i feel the blood of africa
dripping down my back

though my pride rises
in what i do
to destroy the masters' blade
sinning against my skin
true believer, i survive
yes, i survive, i keep going
though they take everything away
i survive america

my name is written
in blood-wrapped days
untold centuries of cruelty
but i survive
come into the union
through a crack
my fist made
i had experienced
breaking freedom holes
by laying underground railroads
by plotting at night
by striking blows

they closed equality's door
before i could enter
they sent me bluesing towns
facing hostility
with open-eyed moans
i get my woman
from the master's bed
but lose her to his kitchen
learn every road
from all my searching
and not one of them end at opportunity
they send me bluesing towns

when I get the vote
terror drives me into fear
the tar, ropes, and evil men
scar my name with blood

they puke their fright and weaknesses
on me
instead of on those who own our bones
though they slaughter
still they cannot stop my efforts
i survive
following rivers to cities
putting my story on brass and winds

i live tyranny down
by swinging with jazz
but the white man's word
places hinges on my sky
from the shadows
i hear plantations talk
the civil war
sets me free from legal whippings
but not from lashes

when booker t prayed conformity
at backseat rites
i could hear lynches scream
i could hear frightened men cry
i walked with DuBois
at Niagara
they jailed my reputation
in smelly epithets
yet i survive their onslaught
distance between freedom and chains
is measured by steps from backseats
to defiance

i move by going
where there ain't no fields
going where bondage is to production
to the factory's commands
in detroit
chicago
cleveland and milwaukee
away from hot suns
away from boll weevils
away from droughts
to a new world

my music affirms demons
barking resistance in my veins
and i sing ragtime gospels
hi-de-hi-hos hoochie coochies
my girls and temptation walks
in leaving the land
my legacy is transformed
in citified jive sayings

they take me to the work line
but leave my freedom at the station
listening to rails retell the places
i have not arrived at yet
i am still motherless
yet a hip-cat-rhinehart-zoot-suiting
malcolming wolf-waters shoeshine stone
i am a bigger bad trigger greedy
no-name boy prowling chitown
they put ethel in my waters
and she emerges lady day
pestering orchards of my soul
she-goddess of this strangeness
lady instrumentalized voice
tingling new sounds in new times

what the whip and lynchings
didn't get on the land
hard work, high prices, and the hawk
took away on these streets
they send me bluesing towns
"i ain't got nobody/got nobody
just me and my telephone"
i burn from exploitation
i empty my soul on fads
powdery substances Messiahs stand on

i mau-mau stampedes
against racist stalls
bellowing "for your precious love
means more to me
than any love can ever be"
the work songs rise
to become freedom anthems

the Supreme Court hears my lyrics
and its laws change beats
"separate but equal"
becomes "equality for all"
malcolm speaks/speaks so sweet
i hear the shuffle of the peoples' feet
we move in montgomery
we move in little rock
we move
we move at sit-in counters
we move on freedom rides
we move
we move in birmingham
we move on registration drives
we move
malcolm speaks/speaks so sweet.

doin the riot/i fall from new bags
with a world fighting back
in viet nam
in angola
in mozambique
in the panther walks
poppa got a rebellion thing
momma wears a freedom ring
freedom rings
from every alley and hole
brother, come here quick
take this struggle stick
freedom rings
the get black
burning too
take all the streets
do the boogaloo
freedom rings
feel so good
black out loud
dancing in the streets
with the fighting crowd

doin the riot
the burning too
throwing molotov cocktails
making black power new

we move
malcolm speaks/speaks so sweet.
i hear the shuffle of the peoples' feet

Keep the Faith Baby,
poster by
David Nordahl,
circa 1967

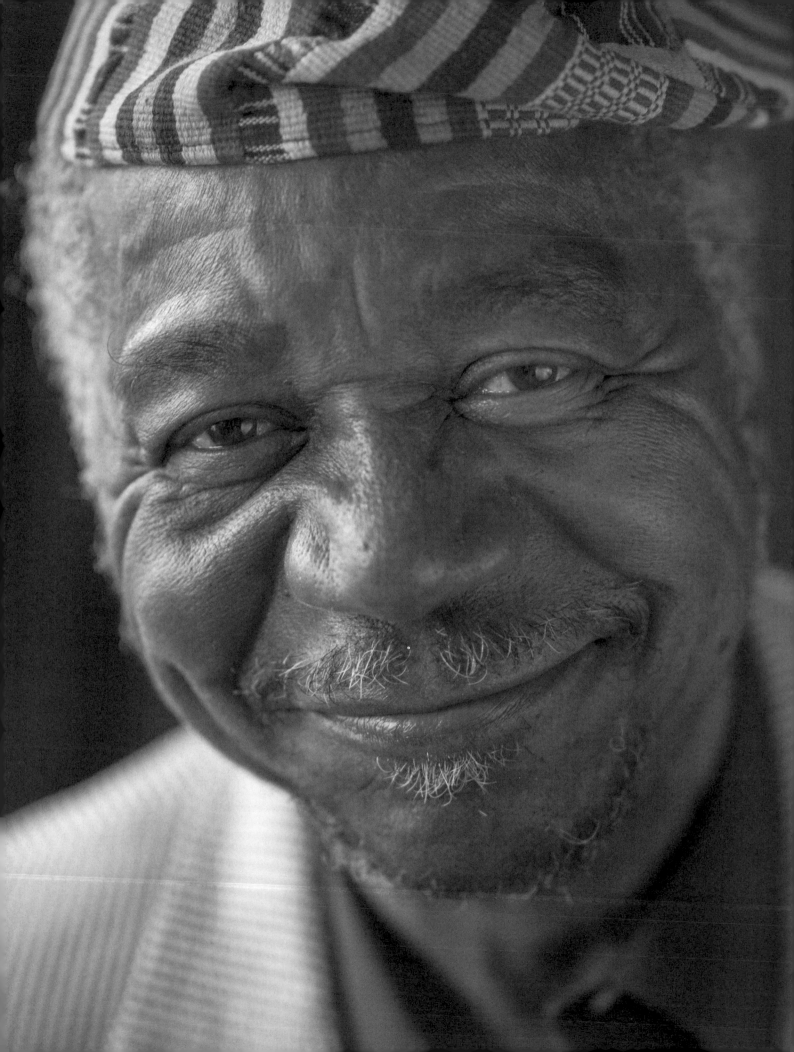

Eugene B. Redmond

The informing and forming of my poetics and the context in which I began to "make" poems has been a sight-, sound-, and soul-filled whirl-world of word-sniffing, word-shifting, and word-riffing. With Whitman (gray Walt & black Albery), I've been "endlessly rocking." Initially sailing the Soular System in a vessel that I call "Arkansippi," I became fervently immersed in the verbal works-womanship of my mother, Emma, and my father, John Henry. She referred to him as "Mister Redmond." His mantra was "the blues ain't nothing but a good man feeling bad."

Growing up in East St. Louis, Illinois ("East Boogie"), life was full of funky-intellectual-songified verisimilitudes, simultaneities, corollaries, and cultural/racial/poetic chain reactions. Blues, jazz, R&B, gospel, oratory, verbal gymnastics, buckets of blood & guts, high-styling do's & don'ts. A 24-7 infusion-transfusion-suffusion of ecstasies, hurts, sleights & heights, of traditions culminating on Saturday nights and Sunday mornings when each Black neighborhood was one giant sound system of radios, juke boxes, diddly-daddy do-woppers & hi-fidelity record players.

Within this framework, I framed words, inspired by neighborhood schools named after poets & other word-peeps like—Dunbar, Longfellow, James Weldon Johnson (whose voice—"lifted" anthem we all knew by heart), Washington Irving—and church/school assignments for plays, recitals, talent shows, & pep rallies. Within this framework, I memorized Bible verses & hymns, Dunbar & Hughes, Kilmer ("If") and Poe ("Annabel Lee," "The Raven"), Longfellow ("Hiawatha") & the naughty narratives of eight-page bibles, "The Signifying Monkey," Moms Mabley & Red Foxx. Within this frame-wording, 32-year-old Gwendolyn Brooks won the Pulitzer Prize for poetry.

It was 1950. I was a 13-year-old student at Hughes-Quinn Jr. High School & Brooks' feat was noted in classrooms and—& on current events boards—as a major "first" for Negroes. (It was later that I'd read, meet, & be hugely influenced by her. However, I'll always believe there was a photosynthetic effect on the 13-year old poet aborning.) Years later at grad school (Washington U. in Saint Lou), while aiming to master the "modernist" movement in poetry, I was advised by a mentor to "stop reading T.S. Eliot!" When I asked "for how long?" he shot back, "Preferably forever, but at least 10 years!"

Eugene B. Redmond, author/editor of several dozen plays, volumes of poetry & critical studies, journals, & anthologies, was named Poet Laureate of East St. Louis in 1976, the year Doubleday Publishing Co. released his "critical history," Drumvoices: The Mission of Afro-American Poetry. *Earlier (late 1960s), he served as teacher-counselor & poet-in-residence at Southern Illinois University's Experiment in Higher Education, where he taught with Henry Dumas & Katherine Dunham, and as writer-in-residence at Oberlin College. In 2006 he coordinated the International Memorial Celebration for Dunham in East St. Louis. A string of professorships, residencies, awards (NEA, ALA, Pushcart, an honorary doctorate from SIUE), and books followed (including a 700-page issue of* Drumvoices Revue *[2008] &* Arkansippi Memwars: Poetry, Prose & Chants 1962–2012 *[Third World Press, 2013]). He is a professor emeritus of English at SIUE.*

Poetic Reflections Enroute to, and During, the Funeral and Burial of Henry Dumas, Poet, May 29, 1968

Forty-Five Minutes to the Cemetery

Rain,
Earlier in East St. Louis and now in New York.
The skies continue to mourn for the fallen poet and warrior,
Mojo-handler and prophet.

Four passengers in the fourth car,
Divided by a generation of intellect,
But feeling a common pain,
A mutual bewilderment:
Four gritting faces of the oppressed.

The dead poet rode in the first car
But was present in the whole train—
Smiling in approval at our candid talk.
Dumas was like that. "Man, let's just tell it," he used to say.
Yes, and he had given direction to the
Pen of the younger poet earlier that morning
Several stories up, adrift in a big bird of steel.

Our talk was shop:
"Henry and I finished Commerce High School together,"
The driver intimated.
A middle age friend of the poet's mother said:
"They're killing off all our good men...I tell ya, a black man
Today speaks his piece at the risk of losing his life."

New Yorkers talk differently than East St. Louisians,
The younger poet observed to himself.

The cars of the procession,
Standing out with bright eyes against the dim day,
Sped cautiously toward Farmingdale National Cemetery
Where white marble headstones stood mute and macabre:
Quite geometrically arranged in a sprawling well kept
ocean of green.

Again talk: "They're slaughtering our boys in Vietnam,"
the middle age lady
Quipped. "The graveyard will be filled up soon"
A bus carrying the Army Honor Guard joined us at the
entrance to the cemetery.

The guard gave a trifling, sloppy salute to the fallen poet
Who had served his country.
More talk as we departed the graveside:
"Young David walks just like his daddy,"
The driver informed us about Dumas' eldest son.

"Neither of the boys understand what's going on,"
The driver's mother added.
"Who does?" the poet asked himself.

A confession from the middle age lady: "Cain't cry no more.
Just won't no more tears come out—all dried up."

Her aging, inquisitive eyes looked like rubies
Polished to worn perfection
By having seen many things
Including the dead poet's "good looking" remains.
The driver echoed her: "Henry was beautiful; he looked
Just like he was sleep."
The driver was a spirit lifter, also an interior observer:
"Henry thought too deep for the average person."

Upon leaving the cemetery
The procession broke up.
Cars bearing license plates from various places sped on or
turned off,
Went their way and our way.
The skies lifted their hung heads.
Mrs. Dumas smiled finally and played with her sons,
David and Michael.
The boys, cast in the same physical mold as their father,
Were impeccably dressed.

Ishmael Reed

I write this as I am on my way to Hunan, China, where my play, "Mother Hubbard" will be performed. This is my second trip to China within the last two years.

Earlier this year I threw a party for Haitian, American, and African expats in the Paris apartment of saxophonist and composer David Murray. From there, I flew to Mulhouse, France, to be honored for promoting "Multi-Culturalism." Scholars from China, England, and the Czech Republic study my work. My daughter and I traveled to Basel, Switzerland to perform with students of the Basel Jazz School. That performance was reviewed in China.

How did I become a world-class writer? One reason was my study of Japanese, at the age of 50, which led to trips to Japan and China. There had been a backlash against my work by those who impose "blueprints" on Black writers. "Blue Prints" that demand "positive" treatment of writers they deem wonderful and flawless. I decided that never again would my work be judged by the whims of any group dictating the Black experience.

Black writers, especially men, might be marginalized by the elite members of one of England's overseas cultural colonies, but to the world they are regarded as the authentic interpreters and carriers of the American experience. The cultural elite always rewards those who see the world as they do—right now it's "post-race." Post race? Tell that to the families mourning the victims of increasingly routine police shootings. Black readers always support my writing. How else would my play, "The Final Version," which was ignored by the New York media, still do well at the box office? It was Black radio, especially the efforts of Daa'iya El Sanusi of WHCR and word of mouth through the Black neighborhoods of Brooklyn that made it a success.

In recent years, I have been cited in *The New Yorker*, *The New York Times*, *The New Republic*, *Vanity Fair*, *The Rolling Stone*, and *The Nation*, mostly as a journeyman, a boxing term, against which the editors test up-and-coming tokens. Rarely do these publications review my novels. My last three nonfiction books were published in Montreal. I have published books since 1974. Based on my 1999 trip to Nigeria, I published two anthologies of Nigerian writers, including *Short Stories by Sixteen Nigerian Women,* selling both collections to the Egyptian Center of Translation, which is translating them into Arabic. My career shows young writers that they no longer have to audition to be a token. They have access to the big world. With the ever-expanding reach of smart digital devices, that world is becoming even bigger.

Ishmael Reed is the author of 20+ titles, including the acclaimed novel Mumbo Jumbo, *as well as essays, plays, and poetry. His awards include the MacArthur Fellowship ("Genius Grant"), the Robert Kirsch Award for Lifetime Achievement, and the Lila Wallace-Reader's Digest Award. He is Professor Emeritus at the University of California Berkeley and founder of the Before Columbus Foundation. His book* The Complete Muhammad Ali *was completed in 2015.*

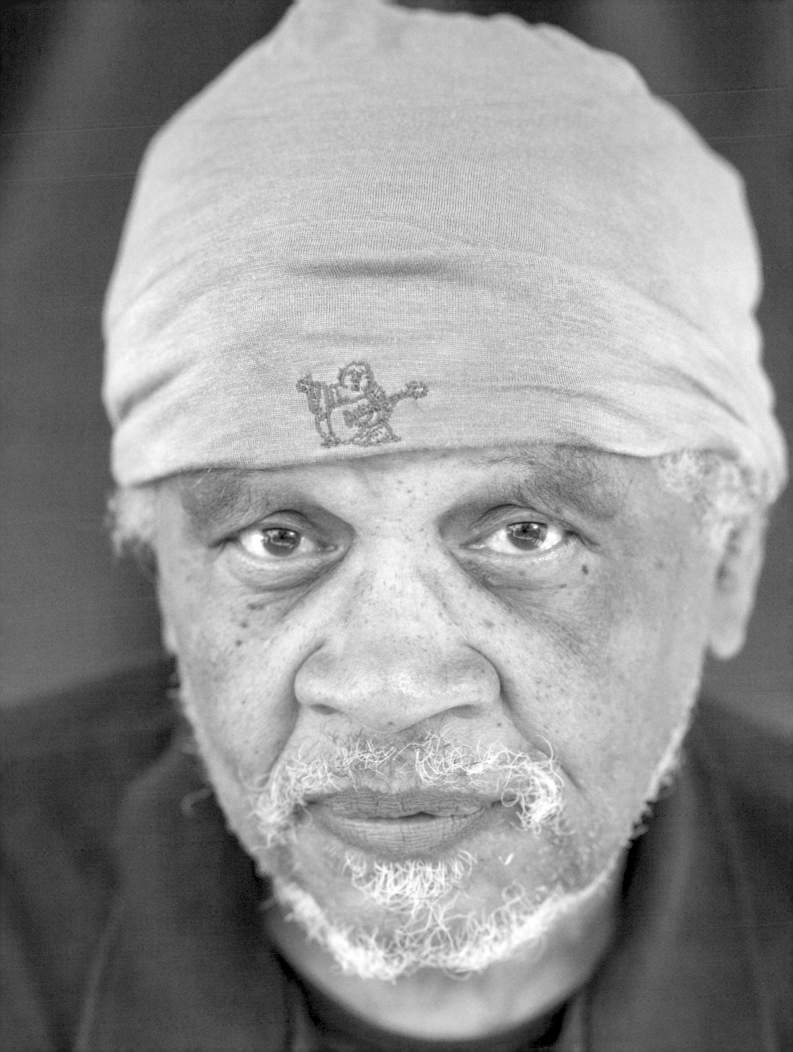

Sweet Pea

On Dec. 2nd, 1938
at Pittsburgh's Stanley Theater
a one time vaudeville hall
the movie palace version of Versailles
whose interior displayed a
4,700 pound chandelier
12 feet wide, 18 feet high mirrors
a place where Dick Powell
crooned soft ballads
and Cab Calloway did his
Hep Cat dance
and whose 1927 opening night
was attended by Adolph Zuker
of Paramount Pictures
Billy Strayhorn, nicknamed
"Sweet Pea," was introduced
to Duke Ellington

Thus began a collaboration that
lasted until May 31, 1967

Those who witnessed the birth
of this creative partnership
were Harry Carney, baritone saxophonist
Johnny Hodges, alto saxophonist
and Ivie Anderson, vocalist

Duke said to Billy, 23 years
old at the time
"Sit down at the piano,
and let me hear what you can do."
He said "Sit down at the piano
and let me hear what you can do"

Never one to hide his proclivities
He got through high school
thinking of himself as a "Lonesome Flower"
a "Passion Flower"
Don't real men think of themselves as steel
with arms full of power
who put their shoulders to the wheel
As "towers of strength" who won't read a book
Not one could cook for the cast of
Otto Preminger's *Anatomy of a Murder*
Duke said "He became the official cook,
because we had a great big kitchen with lots
of pots and pans. He would not allow anyone
else to enter the kitchen, and he used to cook
some great dishes. He even got himself a
Chef's hat."

That was Billy Strayhorn
whose songs were about the haunted
those who spend their days in daydream
in reverie
who see bridges that can't be found
whose feet don't seem to touch the
ground
missing in action from every day
life
journeying through life without a
spouse
they prefer the café rounds at night

Billy Strayhorn
Your music could be as subtle as
a chilled martini glass of gin
with a light spray of vermouth
the drink they called "Billy's Drink"
at Café Society
You knew all about wines
your music could be fantastical
ethereal
Shakespearean
But then it could come at you like
the fist of "The Brown Bomber"
like the score you wrote based
simply on the Duke's instruction
to you about how to get to his
house, 409 Edgecombe Ave.
Harlem

The Sugar Hill of Fats Waller
of W.E.B. DuBois, Walter White,
Roy Wilkins, Rev. Adam Clayton Powell, Sr.
Of Langston Hughes, Ralph Ellison, Zora Neale Hurston,
Paul Robeson, Cab Calloway, Thurgood Marshall
George S. Schuyler, Sonny Rollins
Joe Louis once ran a bar here
Fletcher Henderson
The architect of Swing
He was looking over your
shoulder when you
wrote "Take The A Train"
And there it was
on the Hit Parade
1952

THAT WAS

BILLY STRAYHORN

WHOSE SONGS

WERE ABOUT

THE HAUNTED

THOSE WHO SPEND

THEIR DAYS IN DAYDREAM

IN REVERIE

Duke is doing some fancy things
with his right hand
 Ivie Anderson is jitterbugging in
the aisle
the quickest way to get
to Harlem
"where negro poets and negro numbers
bankers mingled with downtown poets
and seat-on-the-stock exchange racketeers"
The Harlem of
Malcolm X and Flo Mills
Of mansions and cheap thrills
A place where people raised hell
Bessie Smith bailed Ma Rainey
out of jail

Of Garvey's "Knight Commanders of the
Distinguished Order"
his Black Cross nurses
marching
of the Cotton Club, and Connie's
Jumping at the Savoy
Bert Williams had supper
every night at
a club on 136th Street called
"The Oriental"
Countee Cullen wrote of
Harlem's "blithe ecstatic hips"
moving under Sterling Brown's
"motherly moon"
"Take The A Train"
Introduced in the key of
C major with 4 bars including
those famous triplets
then switching to F major
at the bridge
'Hurry get on now it's coming'
Billy Strayhorn
Aren't we lucky that you didn't
take a cab

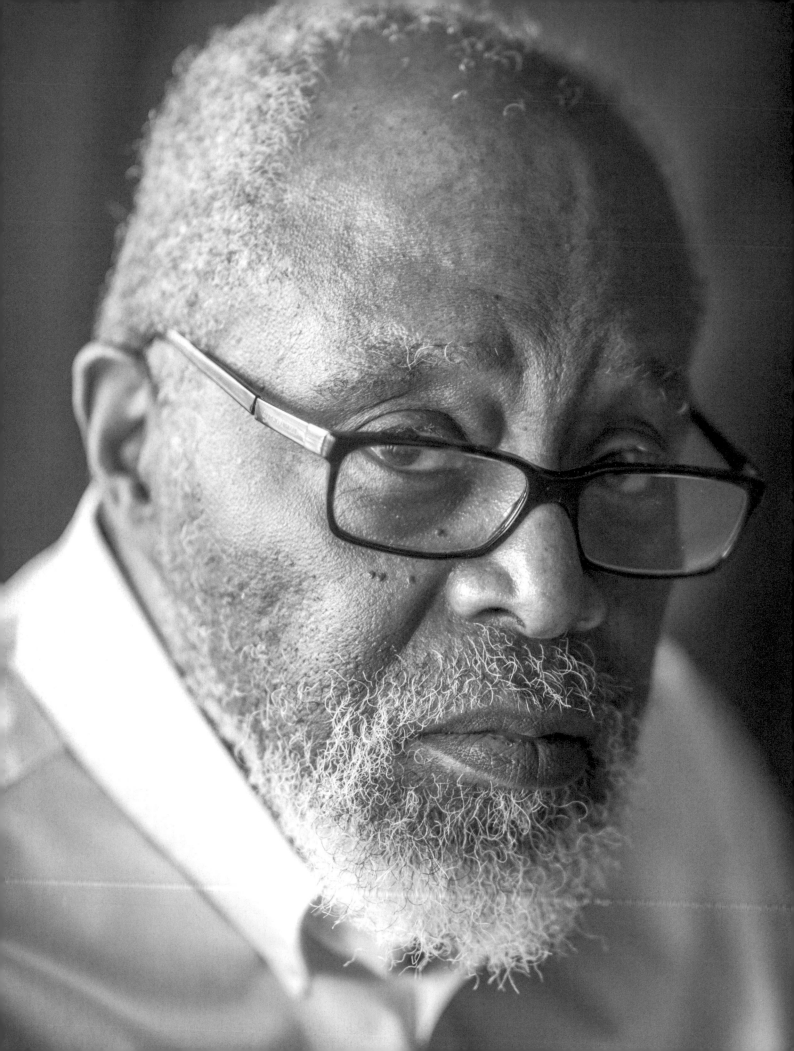

Ed
Roberson

I nitially, my artistic means of expression was drawing and painting. My father taught me to draw, and I spent Saturday mornings in art classes at Pittsburgh's Carnegie Museum of Art. There is still a strong visual element in my work. One of my 10th grade teachers declared that nothing written in the 20th century was worth reading, so she refused to teach the last half of our literature textbook. I was the kind of kid who if you told me not to do something I investigated why. I discovered T.S. Eliot, Walt Whitman, Robinson Jeffers, e.e. cummings, and Wallace Stevens on my own, in that seemingly disobediently investigative reading.

I liked poetry, but I never thought of it as something to do until college. I learned to write poetry in that same transgressive way. A favorite college professor lamented the sad fact that sonnets were not much favored by contemporary poets. I read and saw how intricate and complex sonnets were and set out to see if I could write one. I discovered the craftwork that goes into literary art through taking apart the sonnets of Donne and others. It took off from there.

I entered college as a science major and had a work-study job as an undergraduate lab assistant. My professor took me along on field expeditions. On one, we drove from Pittsburgh, across Canada and up the Al-Can Highway to Alaska, the Kenai Peninsula, and flew to the Kodiak and Afognak Islands. I witnessed rock and mountain climbers, as we drove through the Canadian Rockies and later joined the Explorers Club of Pittsburgh to learn those skills. I went on climbing expeditions to the South American Andes. In Peru, I climbed Simon Bolivar (18,000 ft) in the Huascaran massif and, in Ecuador, the north peak of Illiniza (16,000 ft), and I made two attempts to reach the volcano Sangay (19,000 ft.) in the Ecuadorian Amazon.

My love of travel has taken me across the U.S. and back on a motorcycle, a drive down to Mexico City, and trips to Jamaica and Nigeria. These experiences have made it into my poetry, framed in the experience of a young Black American. I read about the March on Washington in a hotel in Quito having just returned from Ecuador's upper Amazon. I saw/recognized my mode of protest, at the time, as going my own way even while exploring and working on the ideas of more organized movements and persons in the struggle. Beyond the profound effect of the Black Arts Movement, I'd name Nathaniel Mackey, Amiri Baraka, Derek Walcott, Bob Kaufman, Carolyn Rodgers, Stephen Henderson, Gary Snyder, Jack Spicer, and Ishmael Reed, among my most appreciated and enduring influences as a writer.

Ed Roberson is author of 10 books of poetry. His literary awards include the Iowa Poetry Prize, the National Poetry Series, Lila Wallace—Reader's Digest Writers' Award, and the Poetry Society of America's Shelley Memorial Award. He lives in Chicago and retired in 2015 while serving as artist-in-residence at Northwestern University in the English Department, Creative Writing Program.

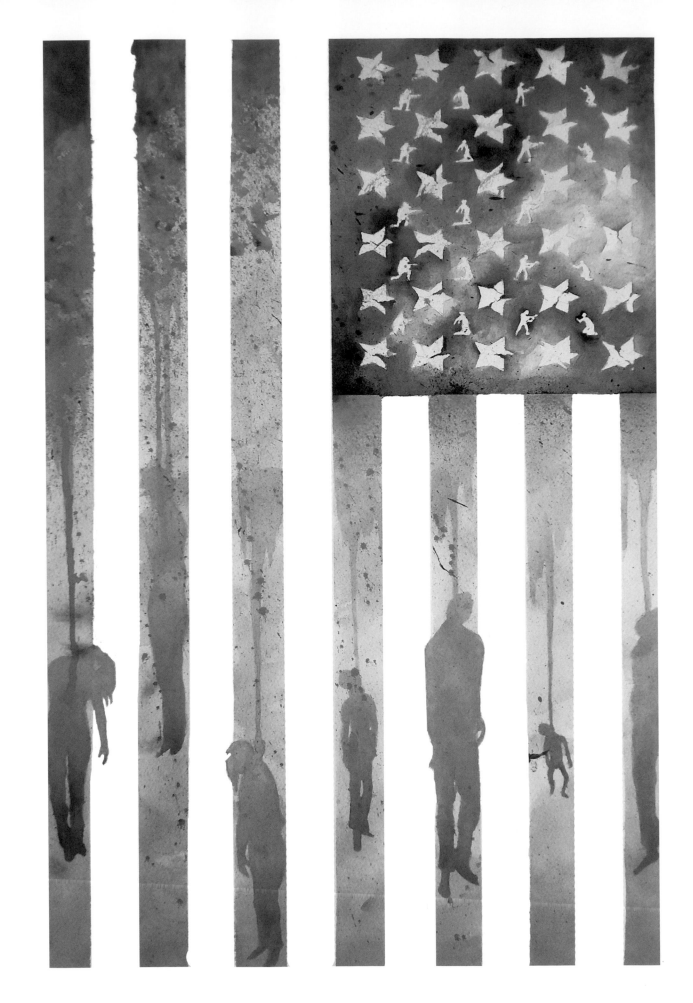

Not Brought Up

Just as a matter of scope it felt
 like that
 was the numbers of people
we wanted justice
 brought down upon –
 that many gone along
keeping silent kept in office for –
 Just the sweep of the complicit terror
against us –

The lynchings each of the thousands of
 times it happened
 the whole white town
come down
 to a smoky picnic – each black
 blackened by the family there is in soot
must have felt that
 magnitude against them stacked
 high come down out of the hills

must have felt that
 register force the running
 or the blank walk away
up Broadway or Greenwich
 coated in the white no longer
 simple ash ghosts like a range of that
not brought up

The New Age
of Slavery,
original art
by Patrick
Campbell, 2014

Sonia Sanchez

When I started to write, I wanted to tell how I had become/became this woman with razor blades between her teeth. What made me rise up to tell my story? I guess it must have been something underneath our skirts—women/sisters from Africa, the Caribbean, America, Asia, Latin America, South America, the Middle East, and Europe. Something accented/unaccented in our talk/walk.

My love for writing began at 6 years old after my grandmother died. I, child stutterer, who ran with the boys, tasted the wind in my eyes and mouth and swallowed it whole. I wrote privately and secretly for years. This private self became the public self when I discovered that all of the pain and rage inside me had a herstory/history.

I was born in B'ham, Ala.—or Bombingham as some people called it—where many of the Black women were housewives, maids, and teachers. The men were mostly workers—a few were businessmen, clergymen, and teachers in black schools—but most were laborers like my grandfather, who worked at the American Cast Iron Company.

My grandmother was a domestic. Housewife. Mother. Deaconess in the AME Zion Church. We lived in the shadow of segregation. Overt racism. In the shadow of Black Folk at the mercy of everyone. School. Police. Courts. Government. All of our experiences were shaped by these various forces.

One of my missions as a Writer, Educator, and Activist has been to eradicate/ erase the aura of the educated class while cherishing the creative power of learning a task for the truly creative person. I wanted to celebrate the nodding men and women. The church-going sisters and brothers. The red/black/gums, corncob smoking, staring, loving people who were never considered poetic. We gave them life. Form. Beauty. Herstory and History.

Carlos Fuentes wrote: "We only hurt others when we're incapable of imagining them." Cruelty is caused by a failure of the imagination. The inability to assign the same feelings and values to another person that you harbor in yourself. So I help people to imagine me, Black women, men, and children, in all of our beautiful and terrible selves.

Amiri Baraka's words also resonate with me: "I believe you have to be true to people. You have to be writing something that people understand but at the same time something that's profound enough to have meaning post say, the 6 o'clock news." Amen. Amen. Amen. Awoman. Awoman. Awoman.

Sonia Sanchez is writer. Mother. Professor. Cultural worker. Human rights activist. Author and editor of 21 books, including Wounded in the House of a Friend, Does Your House Have Lions?, Shake Loose My Skin, *and* Morning Haiku. *She is co-editor of* S.O.S. Calling All Black People: A Black Arts Movement Reader, *the first book on the Black Arts Movement since* Black Fire. *Her many awards include The American Book Award, The Langston Hughes Award (from City College of New York), The Peace and Freedom Award from WIILPF, a Pew Fellowship in the Arts, The Harper Lee Award, The Pennsylvania Governor's Award for the Humanities, The Alabama Governor Arts Award, The Robert Creeley Award, and the Robert Frost Medal for Poetry in 2001. She was inducted into the Alabama Writer's Hall of Fame in June 2015.*

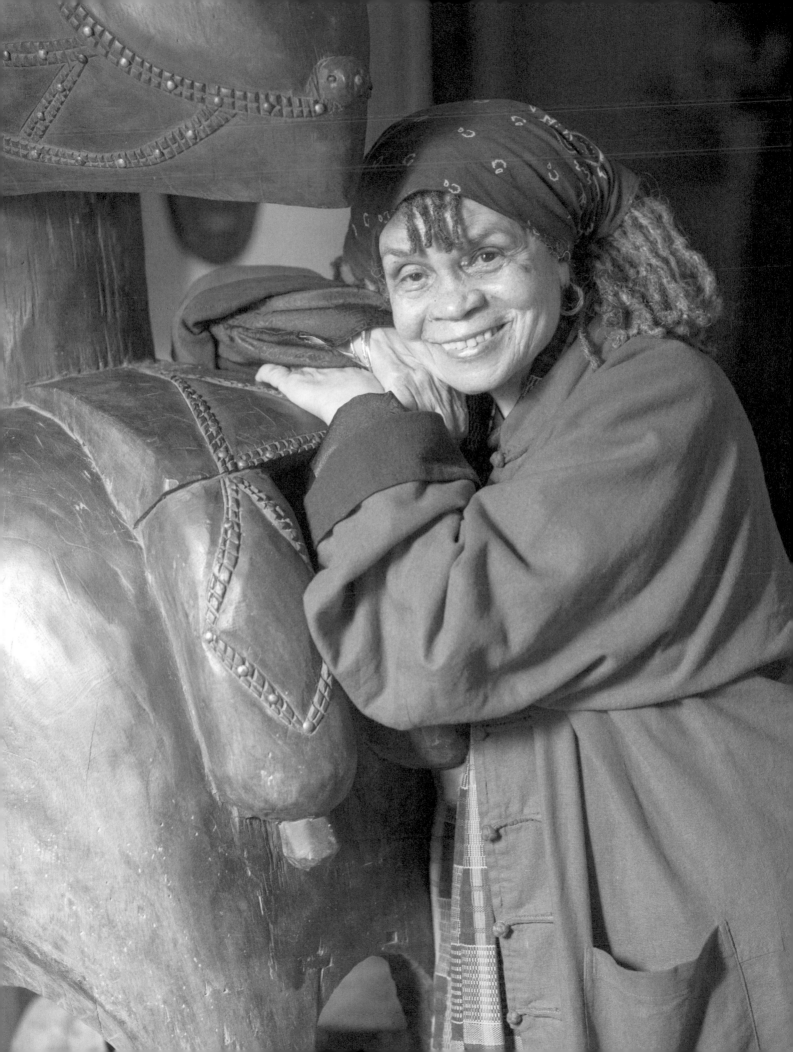

Elegy (for MOVE and Philadelphia)

1 philadelphia
 a disguised southern city
 squatting in the eastern pass of
 colleges cathedrals and cowboys.
 philadelphia. a phalanx of parsons
 and auctioneers
 modern gladiators
 erasing the delirium of death from their shields
 while houses burn out of control.

2 c'mon girl hurry on down to osage ave
 they're roasting in the fire
 smell the dreadlocks and blk/skins
 roasting in the fire.

 c'mon newsmen and tvmen
 hurryondown to osage ave and
 when you have chloroformed the city
 and after you have stitched up your words
 hurry on downtown for sanctuary
 in taverns and corporations

 and the blood is not yet dry.

3 how does one scream in thunder?

4 they are combing the morning for shadows
 and screams tongue-tied without faces
 look. over there. one eye
 escaping from its skin
 and our heartbeats slowdown to a drawl
 and the kingfisher calls out from his downtown capital
 And the pinstriped general reenlists
 his tongue for combat
 and the police come like twin seasons of drought and flood.
 they're combing the city for lifeliberty and
 the pursuit of happiness.

5 how does one city scream in thunder?

6 hide us O lord
deliver us from our nakedness.
exile us from our laughter
give us this day our rest from seduction
peeling us down to our veins.

and the tower was like no other. amen.
and the streets escaped under the
cover of darkness amen.
and the voices called out from
their wounds amen.
and the fire circumcised the city amen.

7 who anointeth this city with napalm? (i say)
who giveth this city in holy infanticide?

8 beyond the mornings and afternoons
and death detonating the city.
beyond the tourist roadhouses
trading in lobotomies
there is a glimpse of earth
this prodigal earth.
beyond edicts and commandments
commissioned by puritans
there are people
navigating the breath of hurricanes.
beyond concerts and football
and mummers strutting their
sequined processionals.
there is this earth. this country. this city.
this people.
collecting skeletons from waiting rooms
lying in wait. for honor and peace.
one day.

Evie
Shockley

I grew up writing stories more than poems. I burned through pads of paper, filled notebooks with "once upon a time" and rhyming quatrains intended as song lyrics rather than poems. My first "publications" came early, when I was in 5th and 6th grade. I wrote (and illustrated!) a short science-fiction story that my teacher, Mrs. Glenn, had spiral-bound in enough copies for my whole class, and my Black History Month poem about Martin Luther King, Jr. was printed in the school newspaper. These early affirmations meant that I never doubted that I could be a writer—though whether I would be a good writer remained a question for me for many years.

I write for the same reason I read: I like to visit other worlds. This motivation may seem less obvious with regard to poetry than prose fiction, but it holds true. Whether narrative or lyrical, poems create an alternative reality through language, sometimes wildly different from the world in which we live and sometimes eerily similar. Either way, the goal of the poem is, in one sense, to address some void, some unfulfilled need in our world, felt deeply by the writer and—perhaps vaguely, perhaps hungrily—by the reader. In both senses, the poem makes up for it as it identifies and adds the missing ingredients, or envisions the space where we might hope to live more freely and creates the map we might follow to get there.

My influences are much broader than I could ever manage to identify. Because what are my "influences" but the panoply of people, works of art, and ways of being that have taught me what it is possible for my poetry to do? I could name my literal teachers: Alan Shapiro and Reginald Gibbons, among the earliest; Lucille Clifton and George Elliott Clarke, the most sustained; and Sonia Sanchez, Sharon Olds, Yusef Komunyakaa, Kimiko Hahn, Brenda Hillman, and Timothy Liu, in brief but meaningful encounters. I could also name poets who have taught me primarily through their poems and prose: Gwendolyn Brooks, Harryette Mullen, Amiri Baraka, Ed Roberson, Emily Dickinson, Langston Hughes, and Shakespeare, to just name a few.

I've learned from elders and peers in organizations like the Carolina African American Writers Collective and Cave Canem, as well as less formal organizations of writers I've been blessed to work among. I've learned from musicians and visual artists, from neighbors and people on the train. Have we met? I've probably learned something about poetry from you.

Evie Shockley is the author of The New Black *(winner of the 2012 Hurston/Wright Legacy Award in Poetry),* a half-red sea, *and two chapbooks. She has also published a critical study,* Renegade Poetics: Black Aesthetics and Formal Innovation in African American Poetry. *Her honors include the 2012 Holmes National Poetry Prize and fellowships from the American Council of Learned Societies (ACLS) and the Schomburg Center for Research in Black Culture. She is associate professor of English at Rutgers University in New Brunswick, New Jersey.*

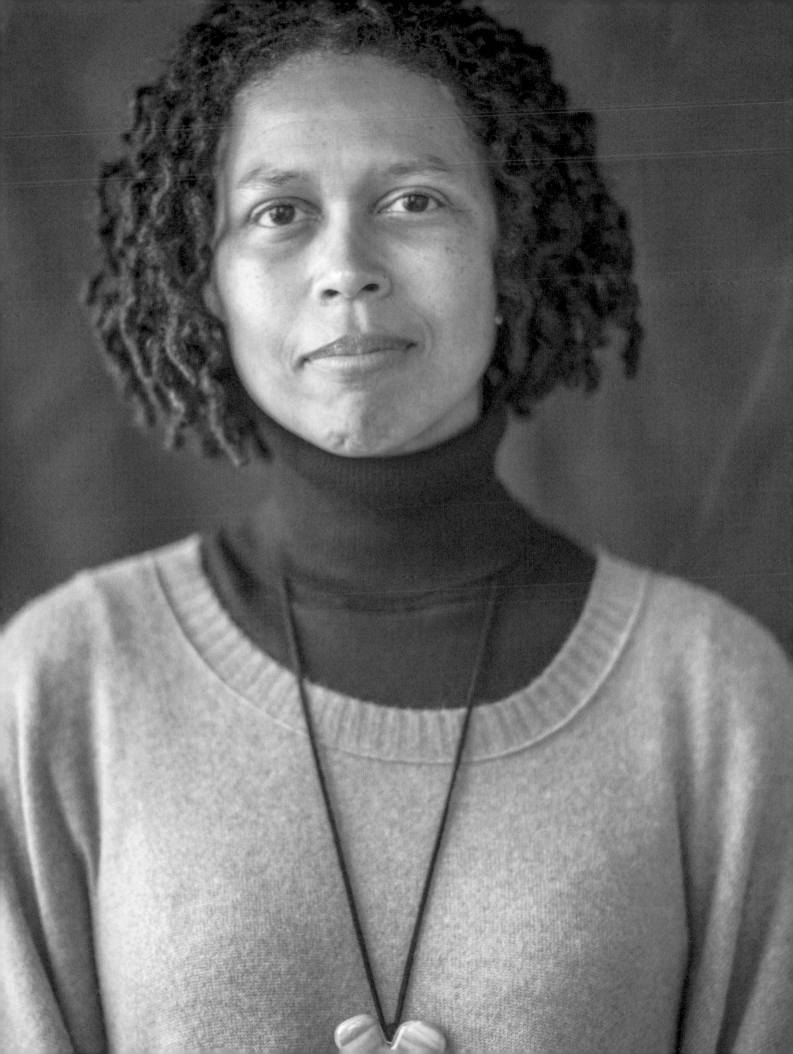

BERLINER JAZZTAGE

Berliner
Jazz Tage
'73, poster
by Gunther
Kieser, 1973

x marks the spot

affable african

 amiable american

affirmative african

 amazing american

 affectless african

 ambulant american

 affronted african

 amorous american

 affordable african

 ambidextrous american

 afflicted african

 amusing american

 affixed african

 amended american

 affirmative ambulance

 amazing affront

 affordable amusement

 ambidextrous affirmation

 affectless amateur

 amiable affliction

 affluent ambivalence

 ameliorative affability

 affected american

 amenable african

 african amendment

american afterglow

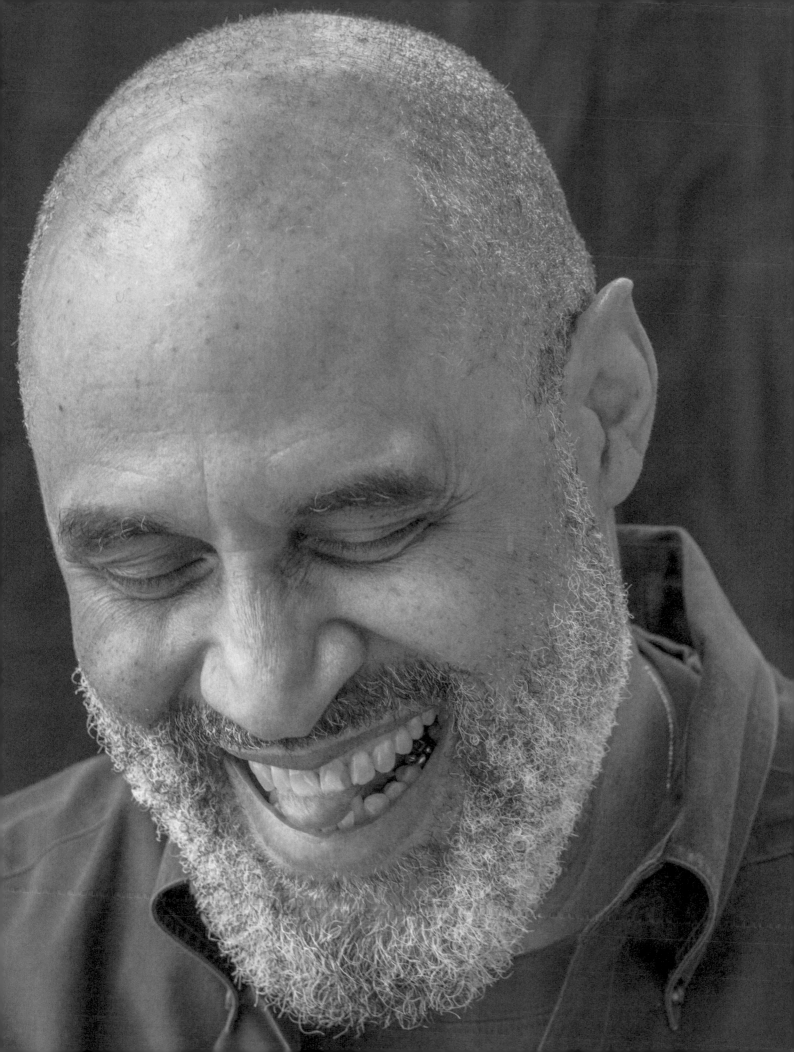

Tim Seibles

My first encounters with poetry began with my mother, an English teacher who loved to read aloud. Initially, there were the basic kid stories: *The Three Little Pigs, Little Black Sambo, The Billy Goats Gruff*, etc., but at some point, she began reading *A Child's Garden of Verses* to me and my brother. I loved those poems and stories as much for my mother's renditions of them as for their content. Subconsciously, I absorbed her sense of the livingness of language and literature. This is how the seeds of my own love of writing were planted. My sense of a reading as a concert also began with her.

The shape of what mattered to me was forged in the crucible of 1960s Philadelphia. In my teens, I found myself among gang members, "conscious brothers," hardcore athletes, and dedicated musicians—even a small underground network of neighborhood brothers who listened to rock music: The Who, The Rolling Stones, Ten Years After, Grand Funk, Jimi Hendrix. I was a Motown disciple but a rock-hound too, and definitely a *Hendrix freak*.

I already liked writing, figured I could be a novelist (and maybe play pro football). My mother made sure I knew of the Harlem Renaissance writers, and I was tuned into The Last Poets, Nikki Giovanni's "Ego Trippin," and Gil Scott Heron's fearless words, and I wrote the occasional love poem when I was smitten by some *stone-cold fox* in one of my classes.

I began writing poetry regularly in college, having stumbled into Michael Ryan's and Jack Myers' "creative writing workshops" as a sophomore. Ryan was a member of Students for a Democratic Society and Myers had his own *outsider* edge. We read Ai, Jon Anderson, Norman Dubie, Lucille Clifton, Gary Gildner, Michael Harper, Russell Edson, Linda Gregg, Thomas Lux, Rita Dove, Charles Simic—so much poetry I'd never known about. These voices prompted me to think of my own writing as a way to talk back to life, to say what might otherwise be silenced.

Engaging in public poetry with my friends furthered my belief in poems as part of our social discourse, poems as a way to kid with, shake up, or soothe my fellow citizens. I still see poems as public documents, meeting places for thirsty souls—people dissatisfied with the given terms of our lives, who want something more daring, more true.

Tim Seibles has written five full-length collections of poetry, including Hurdy-Gurdy, Hammerlock, *and* Buffalo Head Solos. *His first book,* Body Moves, *was recently re-released and his last,* Fast Animal, *was a finalist for the 2012 National Book Award in poetry. His two chapbooks are entitled* Kerosene *and* Ten Miles an Hour. *He spent a semester as writer-in-residence at Bucknell University and has been awarded fellowships by both the Provincetown Fine Arts Work Center and the National Endowment for the Arts. In December 2013, he was awarded an Honorary Doctorate of Humane Letters for his literary accomplishments.*

At 59

after Randall Jarrell

Roving from Nike to New Balance,
Prince to Puma, I pick up a pair
of size 13s, some shorts and blue sweats,
still feeling the sneakered beast scuff
his muzzle against my skull.

Two tall, hard-shouldered young brothaz
fondle *Air Jordans*, talkin' a little shit:
If I getchu down on the block
wit **deez** *muhfuckas'll be callin' you* **Betty**

"A drowning man," Mooji wrote, "is not
interested in air" and as the constellation
that pardoned my life goes dark, I recognize
this snag in my chest, this cut breath, this

lonely, late mid-life knowing: the inescapable
all around me, desperation all around—my own

stumbly efforts at love, my own
trying to say *say something*,
while the duck-speaking dickheads
salute their zombie platoons.

Always big, bad Death posting me up,
backing me down, the ball's trick bounce
racking my heart: I know He's smooth
with either hand, but still mean
to snuff his shot.

 In my college days,
when my parents were well
and the bulk of worry sat elsewhere,
I strolled around with *my boys* and mostly,
we wanted the same things:

to play sports, "make big bucks," and have
the fine babes find the come-hither in our faces.

What I miss is that damn sure *hellyeah!*
we carried like crisp cash. JC, his wit,
that manic laugh—Eric's slick grin
and Doc, so thin only his head
cast shadow: that loud halo
of hair. "Don't touch the 'fro," he'd say.

I miss my boys and *The Ohio Players*
funkin' us up against the Earth's black hips—

> *...you a bad, bad missez*
> *with those skin-tight britches*
> *runnin' folks into ditches, yeah...*

We couldn't help ourselves.

There's a girl: a young woman, I guess
in her mid-20s, testing the exercise machines—
a serious athlete wearing sneaks that mean
speed, her righteous gluteus maximus rippling
each lift and pull. What I wish, now that I'm
older, is that she see through the three decades
between us and work *my* back, but these days

I'm a *sir* a gray beard to be addressed
with deference, someone whose wisdom could
maybe be vaguely revered.

O Sex, song book of our better angels, how I craved
and savored your generous pages—chapter
and verse and verse: kissing for hours, daylight lost
to the liquid velvet of the tongue, the body:
delicious synagogue, cello hungry to be bowed.

I don't believe the longing ever ends. I can't believe
I'll ever understand what I need to understand,

but in college I told Doc, "Prob'ly by the time
I'm forty things won't get to me as much."

As I look at my life, I'm afraid and earlier today,
in the mirror, I saw my mother's face
shocked at how old I am. *My goodness! How old
are you?*
 And when I tell her, she's sure
I'm lying—and to be honest, I just
don't know if I'm the age I am. Each year
part of a conversation I almost had
with someone I meant to call.

You think maybe all you do adds up
to a definable sum: the eulogy,
a small fire that lets survivors
warm their chilly hands, but really
nobody knows
what turned inside you or why
evolution has guaranteed that
none of us stick around. Last night,

a friend shrugged, "Might as well be positive,"
and I want to believe in people because I'm a person:

I think about kindness, how it flickers
in a darkened place

and lynching—how some people loved it—
and Malcolm X, his soul sweetened after Mecca,

dying with buckshot scalding his chest,
but who ever mentions Yuri Kochiyama

holding his head in her lap. I believe
in the last light of her hand on his cheek.

Across the street, beneath a sky-blue sky, trees
black-barked and bare. I'm in a café now, surrounded
by clattery laughs and scrambled chatter, a mad jazz
that would scatter birds. What is it
with this world? Awhile back,

one of my boys died. I heard about it long after—
the funeral, somewhere in Georgia—so in my mind's eye,
Dewey's still *doin' the bump*, party-whistle gleaming
in his mouth, "Jungle Boogie" forever *rockin' the house*.

I used to think my lucky days made me
different somehow— "some angel
payin' my way"—like my mom said,
but this poem

could just as easily be Dewey, almost
remembering me at the same party,

under the same groove: my fantastic history
filed down to a few finger-pops and some *Kool*

and The Gang. It's hard to breathe
without the delusion that magnified my life.

I sat across from him in class. We both
wrote poetry. Does everyone secretly

believe they're indispensable? I sit
inside this self amazed by my face

which is brown and unremarkable.

Patricia
Smith

I

t began with my daddy.

Smelling like burnt tobacco and cheap blaring cologne, flasher of a marquee gold tooth, Otis Douglas Smith was Arkansas squirming in sudden city clothes. Part of the Great Migration of Blacks from the South to Northern cities in the early 1950s, he found himself not in the urban Mecca he'd imagined, but in a roach-and-vermin-riddled tenement on Washington St., Chicago's West Side. There he worked alongside the bag boys, day laborers, housekeepers, and cooks who dreamed the city's wide, unreachable dream.

Many of those urban refugees struggled to fit, but my father never really adopted the no-nonsense-now rhythm of his new home. There was too much of the storyteller in him, too much unleashed Southern song still scrambling for open air. My place was on his lap, exploring his stubbled cheek with a tiny hand and listening to his growled narrative, conspiratorial whispers and head-thrown-back laughter. He turned people we knew into characters. The butcher shop clerk, slogging all day in sawdust, his apron splattered with dark blood. Ms. Mamie, powdered girth spilling out of her dress, pressing hair on Saturday in her tiny kitchen. The blustering, scarlet-cheeked white man daddy called boss. There was always a new twist to be added to stories we knew by heart. People failed,

triumphed, deceived, and died. The boundaries of our tiny part of Chicago moved farther and farther apart. Magic abounded. There were tales everywhere, and my own personal griot knew just how to infuse them with an unbridled life.

Because of him, I grew to think of the world in terms of the stories it could tell. From my father's moonlit tales of steaming Delta magic to the sweet slow songs of Smokey Robinson, I became addicted to unfolding drama, winding narrative threads, the lyricism of simple words. I believed that we all lived amidst an ongoing adventure that begged for voice. In my quest for that voice, I found poetry.

Poetry is the undercurrent of every story I hear and read. I can think of no better way to communicate, stripping away pretense, leaving only what is beautiful and vital. Or leaving what is desolate, truth like a backhand slap. Like my father, I am addicted to both the light and shadow of the story. I am addicted to the story.

Patricia Smith is the author of Shoulda Been Jimi Savannah, *winner of the 2013 Lenore Marshall Prize from the Academy of American Poets;* Blood Dazzler, *a finalist for the National Book Award, and* Teahouse of the Almighty, *a National Poetry Series selection. Her work has appeared in* Poetry, The Paris Review, *and in* Best American Poetry, Best American Essays *and* Best American Mystery Stories. *She is a 2014 Guggenheim Fellow, a 2012 Fellow at MacDowell and Yaddo, a 2-time Pushcart Prize winner, recipient of a Lannan fellowship and a 4-time individual champion of the National Poetry Slam. She teaches at the College of Staten Island and Sierra Nevada College.*

NO WOUND OF EXIT

How would it end...ain't got a friend
My only sin...is in my skin
What did I do...to be so black and blue

> –What Did I Do (To Be So Black and Blue), recording by Louis Armstrong, 1929

The body is secured in a blue body bag with Medical examiner seal 0000517.

The boy structure of skin and stick was surrounded by dripped brick, night shriek,
vermin and hiss. He was never not secured, but was never secure. Since he had
not been apprised of the questions inherent in moving forward, his walk was
conjured of side-eye, a rapper's lisp and rain. The grit of neon sugar ate away at
his closed mouth. The body is secured in a blue body bag. The body is secured in
a blues body bag. The body absorbs the blues.

The body is viewed unclothed. The body is that of a normally developed black
male appearing the stated age of 17 years with a body length of 71 inches and body
weight of 158 pounds. The body presents a medium build with average nutrition,
normal hydration and good preservation.

Pause for the definition of a normally developed black man.
Pause for the definition of a
normally developed—
Pause

Rigor mortis is complete, and lividity is well developed and fixed on the posterior
surfaces of the body. The body is cold to the touch post refrigeration. Short black
hair covers the scalp. The face is unremarkable.

Correction: The black face is suppressed fireworks. It so easily turns your
given name to knives. It gobbles slimy Tabasco-ed chicken wings and spits
out watermelon seeds. It has deep antebellum folds. It is never dark enough
for newspapers. Its favorite dance is the perp walk, its favorite place is above the
fold. It squints in the probing bellow of flashlights and slowly repeats its name.
It speaks in rebellion reverb. It speaks in stereotypical. It's done up all wrong for
a job interview. It pants and glows indigo in the bushes behind your duplex. It
was born to reverse your wife. Well. Look. See the sway drip from the doors in his
face. He can no longer harm you. How unremarkable. This particular mug is no
longer google-eye, buck muscle, this face no longer fits around your throat.
The tree-lined suburb in your chest is safe for now.

There is average body hair of adult-male-pattern distribution. The eyes are closed
and have clear bulbar and palpebral conjunctivae. There are no cataracts or arcus
present. The pupils are equal at 5 millimeters. The orbits appear normal. The nasal
cavities are unremarkable with intact septum. The oral cavity presents natural
teeth with fair oral hygiene. The ears are unremarkable with no hemorrhage in the
external auditory canals. The neck is rigid due to postmortem changes, and there
are no palpable masses. The chest is symmetrical. The abdomen is scaphoid.

The upper and lower extremities are equal and symmetrical and present cyanotic nail beds without clubbing or edema. There are no fractures, deformities or amputations. The external genitalia present descended testicles and an unremarkable penis. The back reveals dependent lividity with contact pallor. The buttocks are atraumatic, and the anus is intact.

Ah, the wide tragedy of living and dying before your cock has made a name for itself. Once, let us remember, a buyer would handle the penis of a potential purchase, looking for—what? For heft, for hints of tree trunk, for a steel foreskin. For its ability and willingness to spit seed.

Dead cancels commerce.

Anus intact? *Sigh.* The ass of the dead boy was rigorously examined after closing hours. One of the thousands of things gingerly removed from its depths was the steamy, jack-booted foot of Florida.

Penetrating gunshot wound of the chest.

The entrance wound is located on the left chest, 17 1/2 inches below the top of the head, 1 inch to the left of the anterior midline, and 1/2 inch below the nipple. It consists of a 3/4 inch-diameter round entrance defect with soot, ring abrasion and a 2 x w inch of stippling. This wound is consistent with a wound of entrance of intermediate range.

Further examination demonstrates the wound track passes directly from front to back and enters the pleural cavity with perforations of the left anterior fifth intercostal space, pericardial sac, right ventricle of the heart, and the right lower lobe of the lung. There is no wound of exit.

A black boy can fold his body around a bullet. The cartridge is a pinpoint of craving, a sort of little love, some slugs are warmer than mothers. The bullet wants the whole of the boy, his snot and insomnia, his crammed pockets and waning current. The bullet strains to romance the blooded boy structure in a way that blazes first and final, it swoons through his map then comes to rest and the boy simply dies around it. It does not matter if he has a mother. It does not matter if he has a gold mouth.

The injuries associated with the wound: The entrance wound; perforations of left anterior fifth intercostal space, pericardial sac, right ventricle of the heart, right lower lobe of the lung with approximately 1300 milliliters of blood in the right pleural cavity and 1000 in the left pleural cavity; the collapse of both lungs.

A black boy's lungs collapsing. A mother picking up a phone. The same sound.

Tracy K. Smith

the end of my life to become a writer. This was the early 1990s, when I was an undergraduate at Harvard. Exhilarated by the poetry going on around me, I enrolled in poetry workshops led by poets Lucie Brock-Broido, Seamus Heaney, and Henri Cole, who helped me develop a vocabulary for what poems do, how they leap and sing and question—and, most importantly, how they deepen and clarify our relationship with the world around us.

Through one or two strokes of luck, I became involved with the Dark Room Collective, a group of young Black writers who hosted a reading series for emerging and established writers of color. As an intern at the Collective, I met poets such as Rita Dove, Elizabeth Alexander, Michael S. Harper, and Toi Derricotte.

I remember retrieving Yusef Komunyakaa from Logan Airport near the end of my senior year and going to lunch with him in Back Bay Boston. It was a painfully awestruck few hours, during which I racked my brain for anything interesting enough to say to this great man whose books (particularly *Magic City*, *I Apologize for the Eyes in My Head*, *Copacetic* and *Dien Cai Dau*) had changed my life. He had changed my relationship to language, awakened in me the desire to write poems that were formally wrought, genuinely personal and yet relevant to a broader public history.

After I graduated from Harvard, I returned home to Fairfield, California, where my mother, Kathryn, was battling cancer. Amid the sorrow and upheaval of saying goodbye to a parent, I realized that poetry was helping me process and articulate my sense of loss and grief—indeed, that poetry was what would help me navigate and comprehend my life.

T here was a time when the only poets I knew were dead. That changed as I immersed myself in the Boston and Cambridge poetry scene.

I was suddenly struck by the realization that poetry was written by living writers—by real people whooo voices and anecdotes rendered their work, and the world of poetry in general, more accessible. I knew I did not have to wait until

Tracy K. Smith is professor of Creative Writing at Princeton University. Her books include Life on Mars, *which won the 2012 Pulitzer Prize in Poetry;* Duende, *winner of the 2006 James Laughlin Award;* The Body's Question, *which was awarded the 2002 Cave Canem Poetry Prize; and a forthcoming memoir,* Ordinary Light.

Duende

1

The earth is dry and they live wanting.
Each with a small reservoir
Of furious music heavy in the throat.
They drag it out and with nails in their feet
Coax the night into being. Brief believing.
A skirt shimmering with sequins and lies.
And in this night that is not night,
Each word is a wish, each phrase
A shape their bodies ache to fill—

>*I'm going to braid my hair*
>*Braid many colors into my hair*
>>*I'll put a long braid in my hair*
>*And write your name there*

They defy gravity to feel tugged back.
The clatter, the mad slap of landing.

2

And not just them. Not just
The ramshackle family, the tios,
Primitos, not just the *bailaor*
Whose heels have notched
And hammered time
So the hours flow in place
Like a tin river, marking
Only what once was.
Not just the voices scraping
Against the river, nor the hands
nudging them farther, fingers
like blind birds, palms empty,
echoing. Not just the women
with sober faces and flowers
in their hair, the ones who dance

as though they're burying
memory—one last time—
beneath them.
 And I hate to do it here.
To set myself heavily beside them.
Not now that they've proven
The body a myth, parable
For what not even language
Moves quickly enough to name.
If I call it pain, and try to touch it
With my hands, my own life,
It lies still and the music thins,
A pulse felt for through garments.
If I lean into the desire it starts from—
If I lean unbuttoned into the blow
Of loss after loss, love tossed
Into the ecstatic void—
It carries me with it farther,
To chords that stretch and bend
Like light through colored glass.
But it races on, toward shadows
Where the world I know
And the world I fear
Threaten to meet.

 There is always a road,
The sea, dark hair, *dolor*.

Always a question
Bigger than itself—

 They say you're leaving Monday
 Why can't you leave on Tuesday?

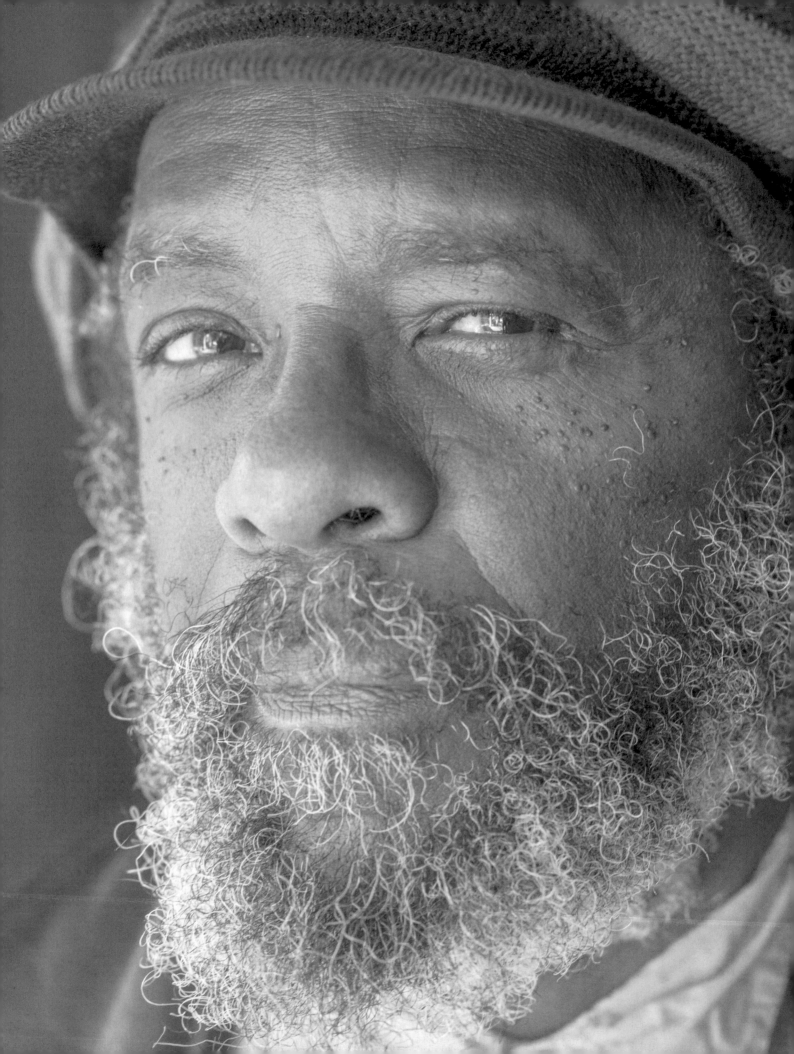

Lamont B. Steptoe

I was born a poet.

It is my belief that poets are born, not made. Early indications of the born poet are a penchant for books, intuitive insight and precocious innate knowledge of things beyond a child's experience. A love of stories, especially stories told by adults about their lives. The ability to remember what others have forgotten or don't want to remember. A sense of mission. I write to overcome injustice and invisibility. I write because I love creating thoughts with words to move, excite, enrage and engage humanity. I write to change the world.

It was during the magical moments of my childhood when I witnessed everything with a sense of wonder that I began to feel "strange." Unlike others. I was a "watcher." Memory became essential to my being.

When you realize you are in the world to create, to be in love with Truth and Beauty, then only death becomes the thing that stops you. I am befuddled at all the beings that pass through life with no desire or passion to leave a record of what it is they experienced. That has always mystified me. It is what keeps me fighting against oblivion. It is what keeps me writing.

My poetic influences were Walt Whitman, Emily Dickinson, James Weldon Johnson, Edna St. Vincent Millay, Edgar Lee Masters, Edgar Allan Poe, Elinor Wylie. Later, Paul Laurence Dunbar, Langston Hughes, James Baldwin, Amiri Baraka, Richard Wright, Gwendolyn Brooks, Samuel Allen, Dennis Brutus, Ted Joans, Mari Evans, Nikki Giovanni, Margaret Walker Alexander, Ishmael Reed, Sonia Sanchez, Helene Johnson, Dudley Randall, Etheridge Knight....

I don't see my poet life as a "career"; that implies academia. I am a poet/ priest/shaman! I like to think of myself as an "enfant terrible" who can always be counted on to shock, enrage, and outrage whoever is listening!

Lamont B. Steptoe is a poet and photographer born and raised in Pittsburgh, Pennsylvania. He is a recipient of The American Book Award, is a Pew Fellow in the Arts, and has a degree from Temple University's School of Communications and Theater. Steptoe taught himself photography at the age of 14 and has exhibited his work at the Painted Bride Art Center, Art Around Gallery, Bacchanal, Dirty Franks, Robins Bookstore, Giovanni's Room, and elsewhere. He is widely published and his poems have appeared in Big Hammer, African American Review, *and other literary journals. His subject matter often features poets, jazz musicians, street scenes, family, and American landscapes of his train trips across the country.*

THE MARCHING FEET

OF SOLDIERS

AND PROTESTORS

EBBING AND FLOWING

ON THE BEACHES

OF TIME

IN THIS AMERICAN LAND

Such a Boat of Land

Against a backdrop of Pennsylvania hills
Woodsy, farmed and framed
In Amtrak window, Amish men
Black-suited like Lincolns just off
The assembly line
Silver beards tangled with mists and crows
Buggy toward the horizon
Such a boat of land moved by sails of sky
Cornfields talk at night
Tally the body counts of Pittsburgh and Philadelphia
City dwellers know this land
But only come robed in the stuff of dreams
This other country
Barned, hexed
So much space in this different place
How to explain the closets of cities
The subterranean rivers of blood
Coursing beneath the land
How to explain the cardboard Hoovervilles
Rogue weeds of human despair
How to explain niggervilles, gookvilles, spicvilles...
How to explain the awful silence
After the shouting, the shooting, the burning,
Such a Boat of Land con...

The marching feet of soldiers and protestors
Ebbing and flowing on the beaches of time
In this American land

Natasha **Trethewey**

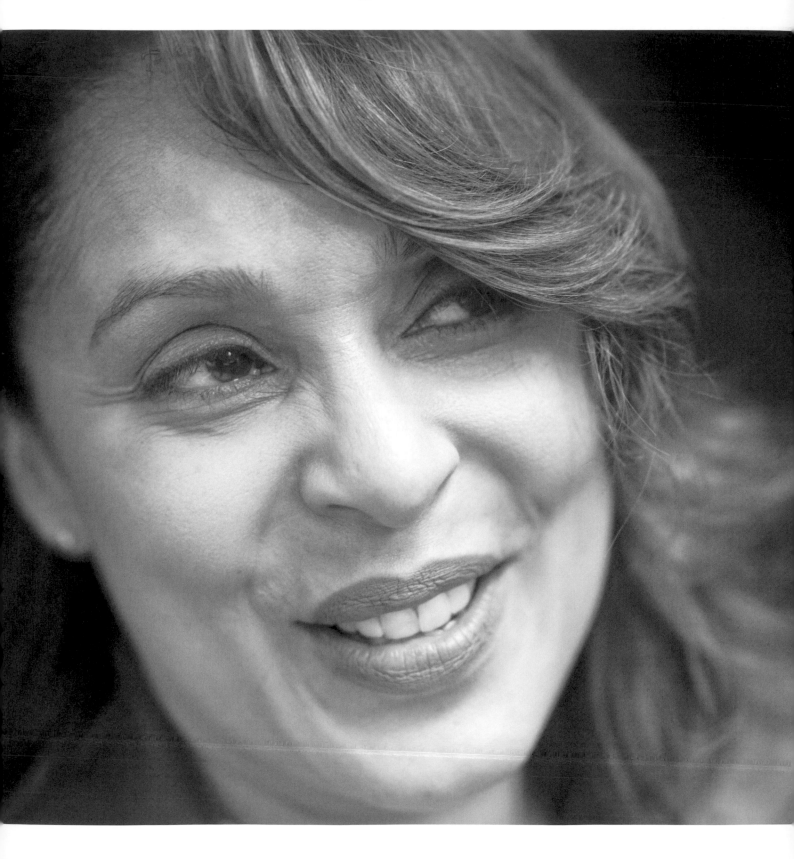

All writers must eventually answer, as Orwell did in his 1946 essay, "Why I write." The first time I had to do this I was trying to get into a graduate creative writing program and needed a statement of purpose. My father, a poet and professor of English, suggested that I read Orwell's essay.

Orwell's words spoke directly to me, emboldening me, providing a scaffolding of ideas that justified my evolving attraction to words. These sentences stood out to me: *I cannot say with certainty which of my motives are the strongest, but I know which of them deserve to be followed*; and, *Looking back through my work, I see that it is invariably where I lacked a political purpose that I wrote lifeless books....* Armed with Orwell's words, I composed my essay, and barely got into that graduate program. A famous poet on the admissions committee rejected my application by writing on a slip of paper that I was "too concerned with my message to write *real* poetry."

When I learned of this I pondered the definition of message: *a significant point or central theme, especially one that has political, social, or moral importance*. Didn't the poems I loved stir in me a moral vision, a sense of empathy, of social, ethical engagement? The poems of Yeats and Whitman, Auden and Bishop, Williams and Hayden, Brooks, Ahkmatova and Hughes: and did I not attend as much to their music, their sound, as to their meaning, the messages I took away from them?

As a small child, I had felt, as Orwell had, "the joy of mere words" in their juxtapositions—in the rhymes and near-nonsense phrases my mother sang to amuse me—long before I was conscious of their political power. When I read—in the 5th grade—*The Diary of Anne Frank*, the words planted deep in me empathy for the suffering of people living in very different circumstances than my own.

I was born in the land of King Cotton, land of a brutal history of slavery, racism and injustice, land of violence, of lynching and murders, one of the poorest states in the nation—but it is also a place of fertile Delta soil; birthplace of the blues, home to a tradition of writers like William Faulkner, Eudora Welty, Richard Wright, Margaret Walker Alexander, and Tennessee Williams. I have inherited from this geography both great cultural richness and great suffering:

I write because I cannot stand by and say nothing, because I strive to make sense of the world I've been given, because the soul sings for justice and the song is poetry.

Natasha Trethewey is the 19th Poet Laureate of the United States and the author of Domestic Work *(2000);* Bellocq's Ophelia *(2002);* Native Guard *(2006), for which she was awarded the Pulitzer Prize;* Beyond Katrina: a Meditation on the Mississippi Gulf Coast *(2010); and* Thrall *(2012). She is Emory University Robert W. Woodruff Professor of English and Creative Writing.*

(Excerpted from Natasha Trethewey's lecture "Why I Write: Poetry, History, and Social Justice")

American
Folk Blues
Festival '69,
poster by
Gunther Kieser
1969

Liturgy

To the security guard staring at the Gulf
thinking of bodies washed away from the coast,
 plugging her ears
against the bells and sirens—sound of alarm—
 the gaming floor
on the coast;

To Billy Scarpetta, waiting tables on the coast,
 staring at the Gulf
thinking of water rising, thinking of New Orleans,
 thinking of cleansing
the coast;

To the woman dreaming of returning to the coast,
 thinking of water rising,
her daughter's grave, my mother's grave—underwater—
 on the coast;

To Miss Mary, somewhere;

To the displaced, living in trailers along the coast,
 beside the highway,
in vacant lots and open fields; to everyone who stayed
 on the coast,
who came back—or cannot—to the coast;

To those who died on the coast.

This is a memory of the coast: to each his own
recollections, her reclamations, their
restorations, the return of the coast.

This is a time capsule for the coast: words of the people
—*don't forget us*—
the sound of wind, waves, the silence of graves,
the muffled voice of history, bulldozed and buried
under sand poured on the eroding coast,
the concrete slabs of rebuilding the coast.

This is a love letter to the Gulf Coast, a praise song, a dirge,
invocation and benediction, a requiem for the Gulf Coast.

This cannot rebuild the coast; it is an indictment,
 a complaint,
my *logos*—argument and discourse—with the coast.

This is my *nostos*—my pilgrimage to the coast, my memory,
 my reckoning—

native daughter: I am the Gulf Coast.

Quincy Troupe

I started writing poetry after I injured my knee playing basketball on a US Army basketball team in the early 1960s in France. Growing up in St. Louis, Missouri, where I was born and raised, I always read books because my mother had them all over the house, and I was a member of my local library's Bookworms Club. So when I was injured in France, I started writing what I have called an "awesomely bad" novel about a young African-American basketball player—me—making sexual conquests of women all over Europe. I realized after reading my book that it was bad, so I sought help from my French girlfriend who then turned me on to a writer friend of her family, Jean-Paul Sartre. Though I didn't know who he was at the time, Sartre advised me to write poetry, even though he admitted that he hated poets, as a way to improve my writing skills. So I began trying to write poetry. I fell in love with poetry and I still love it today. I am engaged with the possibilities of exploring my imagination, whether through poetry or prose. But I finally describe myself as a poet because I love the craft of creating poems, of exploring metaphors, constructing a musical, rhythmic language rooted in my African-American experience.

I also love creating neologisms in the American language, exploring new forms. I have created two new forms, the tercetina, and seven-elevens, which I hope expand the American contribution to the history of poetic form. This possibility intrigues me and keeps me getting up every morning to write. My poetic influences are: Pablo Neruda, Aimé Césaire, Jean-Joseph Rabearivelo, Walt Whitman, Langston Hughes, Jean Toomer, Robert Hayden, Amiri Baraka, and Derek Walcott. Others are: Gabriel García Márquez, and Miles Davis, John Coltrane, and Jimi Hendrix and painters. I leave it to others to describe my poetics, which are always evolving.

Quincy Troupe, born in St. Louis, Missouri, is the author of 20 books and 10 volumes of poetry. His book of poems, The Architecture of Language *(Coffee House Press, 2006), received the 2007 Paterson Award for Sustained Literary Achievement. In 2003 Troupe received the Milt Kessler Poetry Award for* Transcircularities: New and Selected Poems *(Coffee House Press, 2002), selected by* Publishers Weekly *as one of the 10 best books of poetry published in 2002. His memoir,* Miles and Me *(University of California Press, 2006), is an account of his friendship with Miles Davis. His most recent books include* Errançities *(Coffee House Press, 2012), and* Earl the Pearl *(Rodale), an autobiography co-written with basketball legend, Earl Monroe, published in 2013. He is Professor Emeritus at the University of California, San Diego and was the first official Poet Laureate of the State of California. Troupe has been awarded three American Book Awards:* Snake-Back Solos, Selected Poems *(1980);* Miles: The Autobiography, Miles Davis with Quincy Troupe *(1990); and a 2010 Lifetime Achievement Award for Sustained Literary Excellence. In 2015 he completed two new volumes of poetry:* Ghost Voices *and* Seductions.

Poem for My Father

father, it was an honor to be there, in the dugout
with you, the glory of great black men swinging their lives
as bats, at tiny white balls
burning in at unbelievable speeds, riding up & in & out
a curve breaking down wicked, like a ball falling off a table
moving away, snaking down, screwing its stitched magic
into chitlin circuit air, its comma seams spinning
toward breakdown, dipping, like a hipster
bebopping a knee-dip stride, in the charlie parker forties
wrist curling, like a swan's neck
behind a slick black back
cupping an invisible ball of dreams

& you there, father, regal, as an african, obeah man
sculpted out of wood, from a sacred tree, of no name, no place, origin
thick branches branching down, into cherokee & someplace else lost
way back in africa, the sap running dry
crossing from north carolina into georgia, inside grandmother mary's
womb, where your mother had you in the violence of that red soil
ink blotter news, gone now, into blood graves
of american blues, sponging rococo
truth long gone as dinosaurs
the agent-oranged landscape of former names
absent of african polysyllables, dry husk, consonants there
now, in their place, names, flat, as polluted rivers
& that guitar string smile always snaking across
some virulent, american, redneck's face
scorching, like atomic heat, mushrooming over nagasaki
& hiroshima, the fever blistered shadows of it all

inked, as etchings, into sizzled concrete
but you, there, father, through it all, a yardbird solo
riffing on bat & ball glory, breaking down the fabricated myths
of white major league legends, of who was better than who
beating them at their own crap
game, with killer bats, as bud powell swung his silence into beauty
of a josh gibson home run, skittering across piano keys of bleachers
shattering all manufactured legends up there in lights
struck out white knights, on the risky edge of amazement
awe, the miraculous truth sluicing through
steeped & disguised in the blues
confluencing, like the point at the cross
when a fastball hides itself up in a slider, curve
breaking down & away in a wicked, sly grin
curved & posed as an ass-scratching uncle tom, who
like old sachel paige delivering his famed hesitation pitch
before coming back with a hard, high, fast one, is slicker
sliding, & quicker than a professional hitman—
the deadliness of it all, the sudden strike
like that of the "brown bomber's" crossing right
of sugar ray robinson's, lightning, cobra bite

& you, there, father, through it all, catching rhythms
of chono pozo balls, drumming, like conga beats into your catcher's mitt
hard & fast as "cool papa" bell jumping into bed
before the lights went out

of the old, negro baseball league, a promise, you were
father, a harbinger, of shock waves, soon come

As a kid I had thousands of questions, and books had answers. Books activated my imagination, and were a way to escape the limitations of being part of a large poor family raised by a young single mother in government housing without a television. There was no public transportation and we didn't own a car so we walked everywhere, experiencing the world at a more deliberate pace, which fed my curiosity and desire to know not just the names of things, but also the origins of the names. This need to understand the power of naming was perhaps the best preparatory academy for a future wordsmith.

By the time I reached high school, my English teachers were encouraging my own critical and creative writing while indoctrinating me with American literary classics (amazingly devoid of writers of color.) It wasn't until I stumbled upon Paul Lawrence Dunbar's vernacular-driven gems that I recognized that poetry's music was alive in my own house. I started listening even closer to musicians like James Brown and Marvin Gaye, paying attention to the social commentary behind their lyrics. Later the mini-series *Roots* awakened what would become my early political consciousness. The final cornerstone in my development occurred when I saw *The Wiz* with Stephanie Mills as Dorothy. I walked around stunned for days, trying to process the power of what I had witnessed and more importantly trying to understand why I was moved to tears by art.

I write because I accept my responsibility as a witness, and because I believe in the transformational power of art. I recognized that *West Side Story* was *Romeo and Juliet* and that *The Wiz* was still *The Wizard of Oz;* that when the Alvin Ailey dancers animated their bodies to the power of *Wade In the Water,* I recognized the joy of growing up in a Pentecostal church. When I wrote "We Real Crunk", Gwendolyn Brooks' "We Real Cool" was ringing in my ears. The need to pay tribute to ancestors and artists who continue to influence us even shows up when rappers sample "old school" beats in hip-hop. This constant call-and-response linking musicians, muralists, ministers and movements, with films, dance and real life beg to be rounded up, given a voice, and translated to the page.

Frank X Walker is the editor of two anthologies and the author of six collections of poetry, including the recent Turn Me Loose: The Unghosting of Medgar Evers, Buffalo Dance: The Journey of York *(which won the Lillian Smith Book Award),* When Winter Come: The Ascension of York *(which won a Chautauqua Institution Literary Circle Award), and* Affrilachia. *He is a founding member of the Affrilachian Poets and the founder and editor of* PLUCK! The Journal of Affrilachian Arts and Culture. *A recipient of numerous awards, including a Lannan Literary Fellowship for Poetry and several honorary doctorates, Walker is the youngest and first African American Poet Laureate of Kentucky. He is a Full Professor of English and Creative Writing at the University of Kentucky.*

Frank X
Walker

Li'l Kings

what if
the good reveren doctah
mlk jr
was just marty
or li'l king
not a pastor
but a little faster
from the streets
quoting gangsta rap
not Gandhi

was not dr. king
but king doctah
or ice-k
his peace sign on a gold tooth
or gleaming 14 karat like
from around his neck

what if somebody
screaming 'nigger'
hit 'im in the head
with a brick
and he pulled out a nine
and squeezed off
one or two rounds
not tears

praying
only that he
not miss
sported mlk
on phat brass knuckles
and a left-handed
diamond pinky ring
walked the streets
with his home boyz
spray painting
let freedom ring
and I had a dream
on bus stops
and stop signs

got arrested for
conspiring to incite riots
disturbing the peace
and resisting arrest

didn't preach from
no pulpit
but on a microphone
behind turntables
mixin' and scratchin'
listenin' to dr. dre
wu tang
and the notorious b.i.g.

pants down to his hightops
hat on backwards
eyes on a prized new voice
not no bel
no peace
of nothin'
that just rings
when it's hit
a voice that
hits back

could he still
be king?

Afaa M.
Weaver

W riting came easier for me than most things, except math and physics. That changed in 1969, when I was 17 years old in my second semester of engineering at the University of Maryland. It was Calculus I. We were doing limits and functions, while in the Engineering Mechanics class we were doing vector analysis. I had started writing poetry during the winter break, when I met a young lady in my neighborhood and fell in love. I left the university in good standing at the end of my sophomore year.

Vector analysis and f (x)—the limit of x as it approached infinity—gave way to poetry in the vector of love. Cartesian logic gave way to a poet's passion. My parents were disappointed, and my father was most disappointed. He was so proud to know I was in the same dormitory as the son of his supervisor at the Bethlehem Steel company. When I left the university for a job in that same steel mill—and later Procter & Gamble—I married that woman I loved. My parents were deeply disappointed. My father had been raised as a sharecropper and became a steelworker. I was to continue the ascendancy.

During my 15 years of factory work from 1970–85, I wrote poetry. I read poetry. In 1985 I signed a contract for my first book, *Water Song*, and received a National Endowment for the Arts fellowship in poetry, my manumission from factory life.

At times poetry took me through life-threatening trials. My early work was heavily influenced by The Black Arts Movement. While still a warehouseman in 1980, I wrote the first draft of "To Malcolm X on His Second Coming" inside the back cover of my copy of the first selected edition of Amiri Baraka's poetry. "To Malcolm X on His Second Coming" has been my private credo. I drafted and revised it for 18 years.

If working class is a sensibility, it lives in the marrow. It lives in my marrow.

Afaa Michael Weaver (born Michael Schan Weaver, 1951) is a poet, playwright, short fiction writer, translator, editor, and journalist. The author of 14 collections of poetry, Afaa was born in Baltimore, Maryland. In 2014, he received the Kingsley Tufts Award for The Government of Nature *(U Pitt 2013), the second book in his Plum Flower Trilogy, which began with* The Plum Flower Dance *(U Pitt 2007) and concludes with* City of Eternal Spring *(U Pitt 2014), winner of the Phillis Wheatley Award. As a playwright, he has had two plays produced professionally and won the PDI award in playwriting from the ETA Creative Arts Foundation in Chicago. He received his B.A. (1986) from the University of the State of New York and his M.A. (1987) from Brown University. He teaches at Simmons College and in Drew University's MFA program in poetry and translation. In 1998 Afaa was named Cave Canem's first Elder.*

To Malcolm X on His Second Coming

Malcolm X, alias El Hajj Malik El Shabazz,
alias Malcolm Little, alias Detroit Red—
 Deceased!

The coffin breaks, fingers wriggle through clay,
touch the light. A chiseled face comes full with flesh,
eyes roaming the landscape of his own prophecy.
Negroes in their Infiniti's, Benzs, and BMWs,
chains of gold around their necks, fifty tons of gold
for teeth, sneakers handmade in the glass pavilions
or murderers. Hiphop stirring the empty souls.
Up from this tomb in our lost hopes, he stands
and prays into Allah's outstretched hands for mercy.

 This is why he came back:
 on a plantation porch, Lil Missy
 plays with Liza, offering her lemonade.
 "Liza, tell me again about them runaways
 you turned in, them bad bucks daddy
 hanged and cut up, lovely little Liza Mae,
 brown eyez, brown eyez."

At five o'clock in the morning in Baltimore,
in Philadelphia, in New York, in Newark, in Chicago,
the fresh morning water of showers falls, and
the followers of Elijah utter their morning prayers.
Allah the Beneficent, Allah the Merciful,
All praises to Allah, and the Nation of Islam,
Hope of the resurrection of the so-called negro,
comes to life, the life before the death of the Master.

 "Liza, where your mind, chile?
 me and the other boys had plans
 for bein free and comin back for y'all.
 my mama raised you from a little nothin,
 and you turned us in. Now we rottin
 in some place with no name, cut up
 like dog meat. Liza, where your mind?"

Malcolm walks in Harlem along the broken streets,
gathering mystified eyes. In Sylvia's he pokes his head in
and asks what food there is for the soul. Some woman
says, "You look just like Malcolm X. You shoulda been
in that movie that boy Spike Lee made." And she goes on
cutting up custard pies and singing a gospel song she wrote.
Malcolm goes over to St. Nicholas Avenue, looks down
on the city. Afternoon shadows begin to fall like
the difficult questions of his father. Malcolm mourns
his mother, the abyss she fell into and could not escape,
the abyss of his genius. In a glimmer an angel settles
on his shoulder, as small as a pin but with a voice like
a choir singing. "No more grief, blessed son, no more grief."
Malcolm falls to the pavement, sobbing for Elijah.

Lil Missy sits in her bedroom chair,
sewing eyes on her doll, singing.
Liza listens to night sounds, afraid
of darkening the door to tomorrow.
Lil Missy says, "Liza, come round here
and rub my feet befo you go to
my daddy's room."

In the Audubon ballroom the night he was killed,
Malcolm X saw his assassins rise amid a host of spirits
battling for his life. Demons and angels filled the space,
battling for his soft head, as his eyes took Allah's kiss.
His murder was a rupture in the world of the spirit,
the demons rushing desperately to name their position
in the African heart, where the angels fought to defend
God's voice uttering His own holy name, Allah.
Malcolm's head hit the stage like a giant stone
from Zimbabwe landing on Earth. His mind
took on its silence while his spirit was filled with song.
"Oh, blessed son, come unto me. Oh, blessed son."

In front of the Schomburg, Malcolm rises
above the city, his mind covering all of Harlem,
while he issues the manifesto:

On self-defense:
strike me, and I will strike you back
On freedom:
freedom is a fire waiting to come
On the future:
no profit will come from destruction
On the Nation of Islam:
the saved are still saving

Caravans form in the streets, unloading
the unconscious souls. The open eyes of the living dead
stare from windows and shops at this voice
that is in every doorway, this body that is the landscape,
as if the city is now flesh. In one moment he is there,
and then he is gone, letting their bodies go softly
back into time. Negroes wonder what has been
among them and is now gone. Malcolm sits on steps
on Convent Avenue, again just another man.
An old woman pulling a cart comes to him, touches
his head, and both of them vanish into Allah's wish.

The wise among us chant the filling of our life with life,
take this fragment of a gift from heaven and anoint
the heads of the young, who are our promise to live—

Teach, Master, teach. Teach, Master, teach
Teach, Master, teach. Wa Alaikum Salaam.

Ronaldo V. Wilson

In our sewing room, which doubled as a library, I lounged with books on the mattress, thick, jungle print, that served as the floor, encountering medical texts and encyclopedias, world almanacs. The body drawn and charted. What connected what to what, who was who and when, how to splint a broken bone, and where to stop the flow of blood at the closest major artery. I became a poet in a world of many rooms, some flush with old white television men (Ed McMahon, Vick Tayback) or men in showers at military base pools, fantasies of lying in bed with them, or *The Six Million Dollar Man,* or the old, fat hairy neighbor whose curtains I peeked through at night.

Out of books, I stared at water, the brown slick of the Mississippi River, then the wide beaches in Guam. Overlooking cliffs, I lived near the Mariana Trench, Navy brat, playing on playgrounds made of land bound Navy ships, a submarine buried in a field, the sleek surface of a copper plaque that marks memory.

What keeps me a poet arises when I swim, today, in the resort pool, stretching, my back loose, fingers curled then opening, hands cutting below, my arms dart forward and release. This movement twins my backhands, yesterday, my left hand pulling back the racket's throat like a bow and arrow before I make contact, the arms wing out, my chest opens. How I strike the water is how I hit the ball—almost unconsciously—I enter the poem through its motion, time and space.

I've studied with many poets: June Jordan, Ishmael Reed, Yusef Komunyakaa, Sharon Olds, Galway Kinnell, David Rivard, Cornelius Eady, Toi Derricotte, Allen Ginsberg, Gwendolyn Brooks, Myung Mi Kim; and critics Barbara Christian, Alfred Arteaga, Michele Wallace, and those who've helped me to work between poetry and criticism, Eve Sedgwick, Meena Alexander, and Wayne Koestenbaum. I've also been influenced by peers and mentors: Dawn Lundy Martin, Duriel E. Harris, Khary Polk, Wesley Yu, Iyko Day, Torkwase Dyson, M. NourbeSe Philip, John Keene, giovanni singleton, Tisa Bryant, Erica Hunt, and others whose work, through conversations and collaborations, has fueled my engagement with poetry, language, and art.

Ronaldo V. Wilson is the author of Narrative of the Life of the Brown Boy and the White Man *(University of Pittsburgh, 2008), winner of the 2007 Cave Canem Poetry Prize, and* Poems of the Black Object *(Futurepoem Books, 2009), winner of the Thom Gunn Award and the Asian American Literary Award in Poetry in 2010. He is an assistant professor of Poetry, Fiction and Literature in the Literature Department of the University of California, Santa Cruz. His latest books:* Farther Traveler: Poetry, Prose, Other, *is forthcoming from Counterpath Press, and* Lucy 72 *will be released by 1913 Press. As an Artist in Residence at the Headlands Center for the Arts in 2013, he worked on a dance/video project, playing with elements from his sound album* Off the Dome: Rants, Raps, and Meditations.

OPEN UP.
IN YOUR PALM,
COME EAT
AT MY TABLE.
WHAT YOU SEE
IS HOW YOU
BURN.

For the Sky, In Which
You Will One Day, Belong

You had it coming surely,
 Surely,
 Surely,
You had it coming surely.

 "Ballad of Pearl May Lee," Gwendolyn Brooks

In this poem, a body is "gotten tomorrow,"
snatched, caught up—in these streets,
a chimp, firing screams,
ripping off a mouth.

Where did you get caught,
where you got caught?
In the face, you thought you had it all.
What will come is a door.

Open up. In your palm,
come eat at my table. What you see
is how you burn. Sometimes you
have to make up your own map.

Sometimes the body has to be told,
angle after angle, you are not wanted
to recall that when they sit around the tables,
your wings, they start to molt.

You realize, those birds are dead in the nest.
Those birds are dead in their fields.
The dark in your corner is in your corner.
Say, Convince, Cut.

Al Young

Growing up in Ocean Springs, Mississippi and Detroit, Michigan, the contrasts between North and South, the city and country, strongly contributed to my curiosity about the world and the mystery of what I could not see. My family walked down to the Gulf of Mexico nearly every day to get shrimp and crabs, and I was intrigued by the ocean, that there was a *beyond*.

To bridge the distances, I listened to music, old radio shows, and stories told by my family on the front porch. When I was a little older I lived across the Detroit River from Windsor, Ontario. I tuned in to the Canadian Broadcasting Company, which aired jazz, pop, live symphonies, plays, documentaries, and poets like Dylan Thomas reading their work. Listening to those poets I heard all the energy, nuance, and secret meanings that the voice transmits. Poetry came alive. I began, systematically, to go through the poetry shelves of the Detroit Public Library.

I entered the University of Michigan at Ann Arbor with the intention of being a literature major. I was immediately discouraged by the "New Criticism" that dominated English departments at the time. I considered becoming a lawyer because of my "gift of gab." What saved me was a Cervantes seminar that integrated the whole of Western culture and history into the study of *Don Quixote*, and I thought, "This is it!" By the end of my senior year, restless again, I decided I did not need a degree to be a writer, and that traveling and supporting myself with odd jobs would be more edifying.

I worked as a radio deejay, medical photographer, warehouseman, yard clerk for the Southern Pacific Railroad, lab aide, industrial films narrator, singer and guitarist. I performed blues tunes, traditional folk fare with an injection of jazz voicing and contemporary idioms. Then I quit music and returned to school, received a degree in Spanish at UC Berkeley, with the plan of teaching Spanish while writing on the side. I wanted to avoid teaching literature and creative writing at all costs.

Ironically, I was hired as a writing instructor immediately upon graduation, and over the years I have taught creative writing at the University of California campuses of Santa Cruz and Berkeley, the University of Michigan, and the University of Washington. I have been a Jones Lecturer at Stanford and a Mellon Distinguished Professor of Humanities at Rice University. To this day, I've never conducted a single class in Spanish.

Al Young's many honors include Wallace Stegner, Guggenheim, Fulbright, National Endowment for the Arts fellowships, the PEN-Library of Congress Award for Short Fiction, two American Book Awards, two Pushcart Prizes, two New York Times *Notable Book of the Year citations, and the Richard Wright Award for Excellence in Literature. Whittier College conferred on him its highest honor: the Doctor of Humane Letters. In 2005, Governor Arnold Schwarzenegger appointed him Poet Laureate of California. Al Young's most recent books are* Something About the Blues; An Unlikely Collection of Poetry *(Sourcebooks-Fusion, 2008) and* Jazz Idiom: The Jazz Photography of Charles L. Johnson *(Heydey, 2009).*

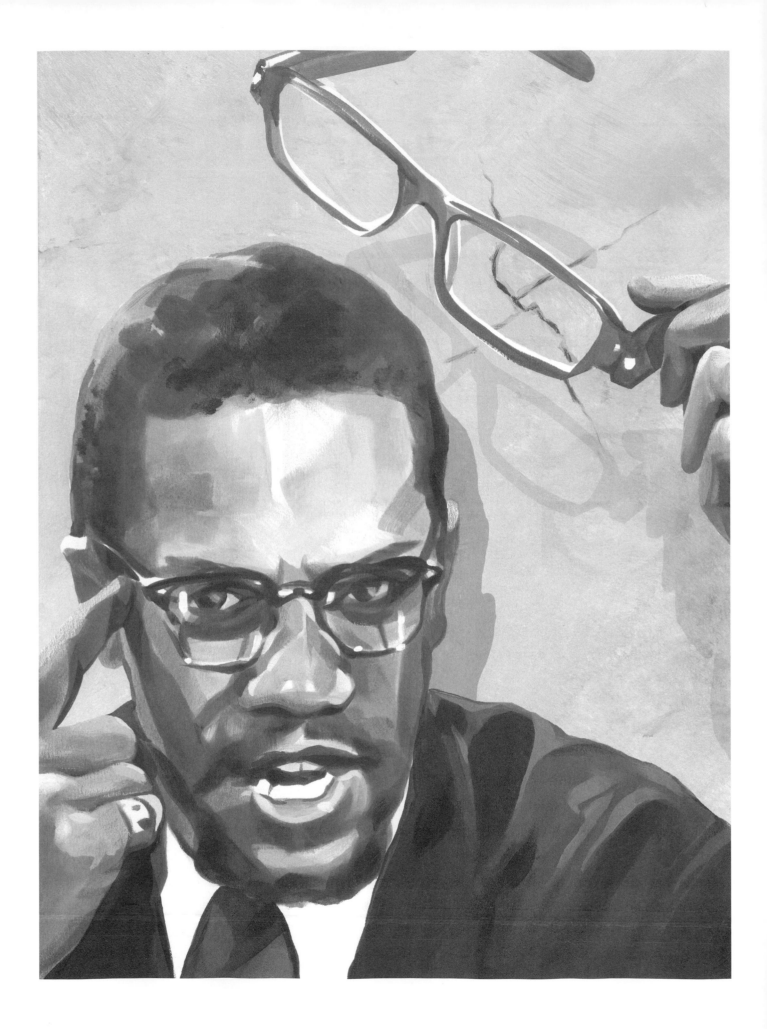

Blues for Malcolm X

When I decided to go hear you speak
that week, it was Oakland, it was way out
west, it was long before Blue Tooth tech,
it was youth, way back before the truth
got put on commission. I was older
than the early Sixties, younger than rain.

It was when a café colleague declined
my invitation for her to join me to catch you
that I got it right. She was white.
She declined. She declared: "No, you go.
I don't think he'll like me very much."
My political black friends—none of them
had the time, either. I took the bus.

To bust the chops of integrationists—
your mission exactly. You carried it out
with charisma and charm. For dignity
and equality you spoke. "I love all black,
brown, red and yellow people," you said
at the close of your spellbinding talk.
Then you blew us kisses. This is memory.

Now the very government that shot you
down for dead has made you postage,
stampable, sendable, official at last.
Does this surprise you? Official history
—a snake that hisses, a snake that hushes—
smoothes you out, burnishes. I still prefer
the kids who called you Malcolm Ten.

They didn't know where to hide you, so
they put you on a stamp. With Booker T.,
who wouldn't sit with Woodrow Wilson
and the First Lady at his White House Dinner,
you wanted us to separate and split.
And that was it: You, Malcolm X, would fix
the system with the ballot or the bullet.
May these blues clarify your red position.

Malcolm X,
original art
by Olivia Wise,
2013

Epilogue
Statement by The Reverend
Dr. William Barber II

I believe that deep within our being as a nation there is a longing for a moral movement that plows deep into our souls—a movement that recognizes that we can't be, as the scriptures say, "at ease in Zion"—a longing that recognizes that the attacks we face today on fundamental civil rights, including attacks on the great hallmark of equal protection under the law and the promise to establish justice, which are supposed to be at the heart of who we are as a nation, are not a sign of our weakness but rather the sign of a worrisome fear by those who hold extremist views and do not welcome a truly united society.

It is this longing that explains why today, despite the attacks, we are seeing a merging of the tributaries that run toward the great stream of justice: people regardless of race, creed, color, gender, sexuality, or class—whether in the Hands Up, Don't Shoot, I Can't Breathe, and Black Lives Matter movements; the fast food workers' Raise Up minimum wage movement; the voting rights and People Over Money movements; the women's rights and end rape culture movements; the LGBT equality movement; the immigrant rights movement; the Not One More! movement; or the state-based anti-racism, anti-poverty, pro-justice, fusion Moral Monday movement—we are flowing together.

We are flowing together because we recognize that the intersection of all of these movements is our opportunity to fundamentally redirect America. And I believe, if we do not become at ease in Zion, and if we continue pushing forward together, this will be the birth of what will be a Third Reconstruction movement in America, a movement that will push us toward our truest hope of a "more perfect union" where peace is established through justice, not fear, and in the prescient words of the great poet Langston Hughes, "Opportunity is real, and life is free," and "Equality is in the air we breathe."

The Reverend Dr. William Barber II is president of the North Carolina Chapter of the NAACP and the Architect of the Moral Mondays movement.

Reverend Barber II leading a march, photo by Tom Wolf, 2015

Martin Luther King, Jr., original art by Olivia Wise, 2013

Acknowledgments

Phil Cushway, the conceptual and philanthropic force behind *Of Poetry & Protest: From Emmett Till to Trayvon Martin,* uses a phone as if it were a lasso, concentrating on what he wants to catch, extending his reach, and pulling in potential collaborators. After reading the groundbreaking anthology *Black Nature: Four Centuries of African-American Nature Poetry,* edited by Camille T. Dungy, Phil called her and asked if she would serve as editor on what at the time was still titled *There Came A Thunder—Of Poetry & Protest.* She sent him to me.

I was on a poetry tour and consulting on cultural competency at the University of Mississippi when the call came. It was February 2013. "Ole Miss" was seriously and systematically responding to hate language that had been spewed by a few students demonstrating against the reelection of President Barack Obama three months earlier. This was happening soon after the university had recognized the 50th anniversary of the violence that had erupted in response to the enrollment of the school's first black student, James Meredith. The call coincided with the one-year memorial of the murder of Trayvon Martin. Police, security guards, and vigilantes killed at least 136 unarmed African Americans that same year, according to a report from the Malcolm X Grassroots Movement. All of this was an inescapable reminder that the bloody thread running through American history had not been broken. #BlackLivesMatters had also been created a year earlier—resistance was alive and well.

It was in this context of injustice and the ongoing struggle for justice that I received Phil Cushway's vision of a series of books that would combine poetry, original photographic portraits and biographical statements of the poets, essays, and archival materials—it was brilliant, enticing, and relevant.

With a sense of urgency we met the day after my return home to San Francisco from Mississippi. A week later we met with rock photographer Victoria Smith, and considered options for photographing poets scattered across the country. As I drove home from the meeting it dawned on me that the annual Associated Writers & Writing Programs (AWP) conference was being held in Boston two days later. When I arrived home I conducted a quick survey of how many African American poets would be in Boston for the conference and proposed that we attend, set up a makeshift studio at the convention center, and photograph as many African American poets as possible. Within two days we were in Boston.

I arrived at the John B. Hynes Veterans Memorial Convention Center early on opening day to track down someone in charge. I found Christian Teresi, Director of Conferences. Within minutes of my sharing an early dummy of the book and giving a pitch on the project, he gave us full access

to the conference center and connected me to the staff who would provide the furniture and materials we needed to "build" our studio. Over the next two-and-a-half days I would track down and persuade more than 50 poets to visit our 3rd-floor studio, where they were feted, soothed with music, and photographed by Victoria. The enthusiastic engagement at AWP in our project, which everyone was hearing about for the first time, was the beginning of an outpouring of support that would continue throughout the process.

I knew many of the poets walking the exhibition floor, participating in the panels and parties at AWP. For those I did not know I received introductions from my poets-in-arms—whom I knew from my poetry-centric days in Chicago when we were forging what I liked to call a poetry movement—including Patricia Smith, Tyehimba Jess, and Quraysh Ali Lansana, who also shared knowledge and know-how based on his vast publishing experience. Other poets/editors from my Chicago circle, who answered when I asked, included Mary Hawley, Lew Rosenbaum, and Hugh Steinberg and my own publisher and old friend/ex-roommate/collaborator Luis Rodriguez. Third World Press (TWP) opened its doors to us not only for a photo shoot that included poets from around the Chicagoland area and East St. Louis, but also a group interview with Professors Haki Madhubuti, Sterling Plumpp, Eugene B. Redmond, and Useni Eugene Perkins. None of this would have happened without TWP staff members Gwendolyn Mitchell and Rose Perkins.

Alison Meyers was an invaluable thought partner and advisor in the early stages of this project, and gave us access to the Cave Canem offices for photo shoots of poets on the East Coast. Lee Briccetti and the crew at Poets House allowed us to take advantage of a program featuring the Dark Room Collective and to commandeer space for our last photo shoot after a week in NYC. Bob Holman's advice on the right time of night to reach Amiri Baraka by phone proved invaluable. I had many midnight arguments over edits to the essay Amiri wrote for *Of Poetry & Protest*.

This book would not exist without the remarkably talented, skilled, and patient people on the creative/production side of this project. I am indebted to art director and book designer extraordinaire Bob Ciano, graphic designers Beth Brann and Olivia Wise, and contributing writer/assistant editor Tamara Ginn, who especially in the final stages of this project contributed whatever was needed to get this idea closer to an actual book that we would finally hold in our hands. Finally, I have to thank my wife Patricia Zamora who again put up with stacks and stacks of poets' books scattered in our dining room, living room, and bathroom, in addition to my obsessive behavior during another literary project. Birthing *Of Poetry & Protest: From Emmett Till to Trayvon Martin* conjured up an entirely new level of creative obsession. I am grateful to everyone who had a hand in bringing this idea to sweet fruition.

—*Michael Warr, Poetry Editor, July 16, 2015*

Closing Quotes

"The Emmett Till 'incident' was horrible [but] commonplace in the
State of Mississippi. Every time, the officials would drag the Pearl River they would come
up with bodies of black men and black women."
Rev. Ralph Abernathy (Blackside Interview, 1985)

"We declare our right on this earth to be a human being, to be respected as a
human being, to be given the rights of a human being in this society, on this earth, in this
day, which we intend to bring into existence by any means necessary."
Malcolm X (By Any Means Necessary, 1970)

"After the acquittal of George Zimmerman in July 2013, my close friend
Alicia Garza and I were on Facebook together and she wrote the phrase "Black Lives
Matter" and I made it a hashtag...#BlackLivesMatter is about Black Pride and
Black Power and standing up against a world that tries to annihilate us."
Patrisse Cullors (Essence.com January 5th, 2015)

"Rather, we are saying that Black bodies do matter. And our work must
be to continue taking to the streets and standing together against the routine actions
of police and the DA's who collude with them; and continue saying, "No Justice, No
Peace, No Racist Police," until there is real change on the agenda for us."
Angela Davis (Essence.com January 5th, 2015)

"They stare down police outfitted like soldiers. They refuse to accept second-class
citizenship. They demand justice. They hand-letter the signs that express the anger, rage,
disappointment... And the signs read 'Black Lives Matter.'"
Melissa Harris-Perry (Essence.com January 5th, 2015)

"Hip Hop is not the problem. Our reality is the problem of the situation."
(Billboard, 2015) "the real problem [is] the senseless act of killing these young boys.
I think for the most part it's avoiding the truth. This is reality, this is my world."
Kendrick Lamar (XXL JUL 2ND, '15)

"You know, there's a lot of activism that doesn't deal with empowerment,
and you have to empower yourself in order to be relevant to any type of struggle."
Talib Kweli (askmen.com, 2007)

"So that the gap between have and have-nots is getting wider and wider.
Let me just finish this point because I do want to scare them a little bit: It's going to be
a problem that no amount of police can solve, because, you know, once you have
that sort of oppression, you know, and that gap is widening, it's inevitable
that something is going to happen."
Jay Z (Bill Maher Show, 2013)

Credits

POETRY

Elizabeth Alexander: "Narrative, Ali" from *Antebellum Dream Book*. Copyright © 2001 by Elizabeth Alexander. Reprinted by permission of Graywolf Press, Minneapolis, Minnesota, www.graywolfpress.org

Amiri Baraka: "Wise 5" and "Protest Poetry." Copyright © 1999, 2013 by Amiri Baraka. Permission of Chris Calhoun Agency.

Wanda Coleman: "Emmett Till" from *African Sleeping Sickness: Stories & Poems*. Copyright © 1990 by Wanda Coleman. Reprinted by permission of Wanda Coleman.

Kwame Dawes: "New Day" from *Wheels*. Copyright © 2011 by Kwame Dawes (Peepal Tree Press, 2011). Reprinted by permission of Peepal Tree Press.

Toi Derricotte: "A Note On My Son's Face," from *Captivity*. Copyright © 1989 by Toi Derricotte. Reprinted by permission of Pittsburgh Press.

Rita Dove: "The Enactment" from *On The Bus with Rosa Parks*. Copyright © 1999 by Rita Dove. Reprinted by permission of Rita Dove.

Camille T. Dungy: "Conspiracy" from *American Poetry Review* Vol. 42 No. 2. March/April 2013. Copyright © 2013 by Camille T. Dungy. Reprinted by permission of Camille T. Dungy.

Cornelius Eady: "Emmett Till's Glass-Top Casket" by Cornelius Eady. Copyright © 2010 by Cornelius Eady. Reprinted by permission of Cornelius Eady.

Kelly Norman Ellis: "Superhero" from *Offerings of Desire*. Copyright © 2012 by Kelly Norman Ellis. Willow Books (2013). Reprinted by permission of Aquarius Press.

Thomas Sayers Ellis: "The Identity Repairman" from *Skin, Ink*. Copyright © 2010 by Thomas Sayers Ellis. Reprinted by permission of Graywolf Press, Minneapolis, Minnesota, www.graywolfpress.org

Nikky Finney: "Left" from *Head Off & Split*. Copyright © 2011 by Nikky Finney. Published 2011 by TriQuarterly Books/Northwestern University Press. All rights reserved. Reprinted by permission of Northwestern University Press.

C.S. Giscombe: "Dayton, OH, the '50s and '60s" from *Here*. Copyright © 1994 by C.S. Giscombe (Dalkey Archive Press, 1994). Reprinted by permission of Dalkey Archive Press.

Duriel E. Harris: "Voice of America" from *Drag* (Elixir Press, 2003). Originally appeared in *African American Review* 36:2 (Summer 2002). Copyright © 2001 by Duriel E. Harris. Reprinted by permission of Duriel E. Harris.

Reginald Harris: "New Rules" from *Autobiography*. Copyright © 2013 by Reginald Harris. Published 2013 by Northwestern University Press. All rights reserved. Reprinted by permission of Northwestern University Press.

Terrance Hayes: "Some Luminous Distress (for Betty Shabazz)" from *Muscular Music*. Copyright © 1999 by Terrance Hayes. Reprinted by permission of Terrance Hayes.

Angela Jackson: "Fannie (of Fannie Lou Hamer)" from *Dark Legs and Silk Kisses*. Copyright © 1993 by Angela Jackson. Published 1993 by TriQuarterly Books/Northwestern University Press. All rights reserved. Reprinted by permission of Northwestern University Press.

Major Jackson: "Rose Colored City" from *Northwest Review* (Volume 47, No. 2). Copyright © 2008 by Major Jackson. Reprinted by permission of Major Jackson.

Tyehimba Jess: "Infernal" from *Used Furniture Review*. Copyright © 2013 by Tyehimba Jess. Reprinted by permission of Tyehimba Jess.

Patricia Spears Jones: "Saltimbanque" from *Callaloo*, Vol. 19, No. 4, ed. by Charles Rowell, et al., Fall 1996, and *Femme du Monde*, Tia Chucha Press. Copyright © 2006 by Patricia Spear Jones. Reprinted by permission of Tia Chucha Press.

Douglas Kearney: "Tallahatchie Lullabye Baby" from *The Black Automaton* (Fence Books, Albany, New York, 2009). Copyright © 2009 by Douglas Kearney. Reprinted by permission of Douglas Kearney.

Yusef Komunyakaa: "History Lessons" from *Pleasure Dome*. Copyright © 2001 by Yusef Komunyakaa. Reprinted by permission of Wesleyan University Press, www.weslayan.edu/wespress

Quraysh Ali Lansana: "statement on the killing of patrick dorismond" from *Role Call: A Generational Anthology of Social and Political Black Literature and Art* (ed. w/Tony Medina & Samiya Bashir) (Third World Press, 2002) and *The Walmart Republic* w/Christopher Stewart (Mongrel Empire Press, September 2014). Copyright © 2002, 2014 by Quraysh Ali Lansana. Reprinted by permission of Quraysh Ali Lansana.

Haki Madhubuti: "The Great Wait" from *Killing Memory, Seeking Ancestor*. Copyright © 1987 by Haki Madhubuti. Reprinted by permission of the author. (Published by Lotus Press in 1987 and reissued by Third World Press in 1997.) Reprinted by permission of Third World Press.

devorah major: "On Continuing to Struggle for Mumbia Abu Jamal" from *Where River Meets Ocean*. Copyright © 2003 by devorah major (City Lights Publishing, 2003). Reprinted by permission of devorah major.

E. Ethelbert Miller: "The 10 Race Koans As Presented to Charles Johnson on the morning of July 13, 2008." Published online in *The Ear Is An Organ Made For Love.* Copyright © 2010 by E. Ethelbert Miller. Reprinted by permission of E. Ethelbert Miller.

Harryette Mullen: "We Are Not Responsible" from *"Sleeping With The Dictionary."* Copyright © 2002 by the Regents of the University of California. Reprinted by permission of UCPress.

Marilyn Nelson: "Cells and Windows." Copyright © 2015 by Marilyn Nelson. Reprinted by permission of Marilyn Nelson.

Sterling Plumpp: "I Hear The Shuffle" from *The Obsidian.* Copyright © 1982 by Sterling Plumpp. Reprinted by permission of Sterling Plumpp.

Eugene B. Redmond: "Poetic Reflection" from *River of Bones and Flesh and Blood Poems.* Copyright © 1971 by Eugene B. Redmond (Published by Black River Winters, 1971). Reprinted by permission of Eugene B. Redmond.

Ishmael Reed: "Sweet Pea." Copyright © 2011 from [in French translation] l'art du jazz, Paris, France: Éditions du Félin. Copyright © 2011 by Ishmael Reed. Permission granted by Lowenstein Associates, Inc.

Ed Roberson: "Not Brought Up" from *City Eclogue.* Copyright © 2006 by Ed Roberson (Published by Atelos, 2006). Reprinted by permission of Ed Roberson.

Sonia Sanchez: "Elegy" from *Under a Soprano Sky.* Copyright © 1987 by Africa World Press & The Red Sea Press, Inc. Reprinted by permission of Africa World Press.

Tim Seibles: "At 59." Copyright © 2015 by Tim Seibles. Reprinted by permission of Tim Seibles.

Evie Shockley: "x marks the spot" from *The New Black.* Copyright © 2011 by Evie Shockley. Reprinted by permission of Wesleyan University Press. www.wesleyan.edu/wespress

Patricia Smith: "NO WOUND OF EXIT." Copyright © 2013 by Patricia Smith. Reprinted by permission of Patricia Smith.

Tracy K. Smith: "Duende" from *Duende: Poems.* Copyright © 2007 by Tracy K. Smith. Reprinted by permission of Graywolf Press, 2007. www.graywolfpress.org

Lamont B. Steptoe: "Such A Boat of Land" from *Unsettling America: An Anthology of Contemporary Multicultural Poetry.* Copyright © 1994 by Lamont B. Steptoe. Reprinted by permission of Lamont B. Steptoe.

Natasha Trethewey: "Liturgy" from *Beyond Katrina.* Copyright © 2007 by Natasha Trethewey. Published by University of Georgia Press. Reprinted by permission of Natasha Trethewey.

Quincy Troupe: "Poem for My Father (for Quincy T. Troupe Sr.)" from *Avalanche.* Copyright © 1996 by Quincy Troupe. Reprinted by permission of Coffee House Press.

Frank X Walker: "Li'l Kings" from *Affilachia.* Copyright © 2000 by Frank X Walker (Published by Old Cove Press). Reprinted by permission of Old Cove Press.

Afaa M. Weaver: "To Malcolm X on His Second Coming" by Afaa Michael Weaver, published in *"Power Lines: A Decade of Poetry from Chicago's Guild Complex,"* edited by Julie Parson-Nesbitt, Luis J. Rodriguez & Michael Warr (1999, Tia Chucha Press, Chicago). Copyright © 1999 by Afaa M. Weaver. Reprinted by permission of Tia Chucha Press.

Ronaldo V. Wilson: "For The Sky, in Which You Will One Day, Belong" from *Farther Traveler: Poetry, Prose, Other.* Copyright © 2013 by Ronaldo V. Wilson (Counterpath Press, 2015, and in *Callaloo,* Volume 36, Number 2, spring 2013). Reprinted by permission of Ronaldo V. Wilson.

Al Young: "Blues for Malcolm X" from *Sourcebooks.* Copyright © 2008 by Al Young. Reprinted by permission of Al Young.

ART

"Cover" for Of Poetry and Protest: From Emmett Till to Trayvon Martin. © 2015 Robert Hunt. Used by permission of Robert Hunt.

"American Folk Blues Festival '69" "American Jazz Tage '73," "Berliner Jazz Tage '75, "Jazz Life '75," "American Negro Blues Festival, '78." All copyright by Gunther Kieser; used by permission of Gunther Kieser, 1969, 1973, 1975, 1978.

Calligraphy by Ward Schumaker, used by permission of Ward Schumaker, 2015.

"Malcolm X" Original Poster, Artist Unknown, circa 1967. Public Domain.

"Rosa Parks Arrest Photo" From Montgomery County Archives, Montgomery, Alabama, 1956. Public Domain.

"Huey Newton" Black Panther Party Poster, circa 1967. Public Domain.

"Hoodie" by Chris Koehler. © 2014 by Chris Koehler. Used with the permission of Chris Koehler.

"Free Huey Rally" (With Betty Shabazz, widow of Malcolm X) Black Panther Party Poster, circa 1968. Public Domain.

"Nina Simone" Used by permission of RCA Records.

"Revolution, Revolution" Black Panther Party Poster, circa 1968. Public Domain.

"Mumia Abu Jamal" Poster, circa 1977. Public Domain.

Contributors

"Kathleen Cleaver" Black Panther Party Poster, circa 1968. Public Domain.

"Keep The Faith Baby" by David Nordahl. © 1967 by Pandora Productions. Used with the permission of David Nordahl.

"The New Age of Slavery" painting by Patrick Campbell. © 2014 by Patrick Campbell. Used with the permission of Patrick Campbell.

"Malcolm X Holding Glasses" and "Martin Luther King Standing By Wall" by Olivia Wise. © 2014 Olivia Wise. Used with the permission of Olivia Wise.

PHOTOGRAPHY

"Black Lives Matter" Photograph by David Goldman, 2014. Used by permission of AP Images.

"Children's Crusade" Photograph by Bill Hudson, Birmingham, Alabama, 1963. Used by permission of AP Images.

"Michael Warr" Photograph by Patricia Zamora, 2012. Used by permission of Patricia Zamora.

"A Partial List of Racial Murders from 1963 to 1965." The Poor People's Corporation collection. Wisconsin Historical Society, WHi-123038. Photograph used by permission of the Wisconsin Historical Society.

"Harry Belafonte on Stage" 1981. Photograph by Egon Steiner. Used by permission of AP Images.

"Muhammad Ali" Photograph by Thomas Hoepker, 1966. Used by permission of Magnum Photos.

"Mamie Till-Mobley" Photograph, 1955. Used by permission of *Chicago Sun Times*/AP Photo.

"The Reverend Barber II" Photograph by Tom Wolf, 2014. Used by permission of Tom Wolf.

COPY

"Children's Crusade" by Tamara Ginn. © 2015. Used by permission of Tamara Ginn.

"The Talk" by Jeannine Amber. From *Time* magazine, July 29, 2013. Copyright © 2013 by Jeannine Amber. Used by permission of Jeannine Amber.

"Harry Belafonte, The Interview" Copyright © 1989 by Washington University in St. Louis. Film and Media Archive, Henry Hampton Collection. Interview conducted May 15, 1989 for *Eye On The Prize*. Used by permission of Washington University in St. Louis.

"Protest Poetry" by Amiri Baraka, 2013. Used by permission of Amiri Baraka.

"Statement" by Reverend Barber II, 2014. Used by permission of Reverend Barber II.

PUBLISHER/EDITOR/CONCEPT:

Philip Cushway

POETRY EDITOR:

Michael Warr

ART DIRECTOR:

Bob Ciano

DESIGN & LAYOUT:

Beth Brann, Andrew Danish, Olivia Wise

POETS PHOTOGRAPHY:

Victoria Smith

ASSOCIATE EDITOR:

Tamara Ginn

PHOTO EDITOR:

Melissa Ciano Ellis

COVER ART:

Robert Hunt

CALLIGRAPHY/LETTERING:

Ward Schumaker

"HOODIE" (TRAYVON MARTIN):

Chris Koehler

MALCOLM X AND MLK ORIGINAL ART:

Olivia Wise